Wonders of the REEF

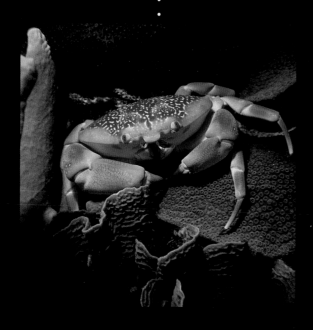

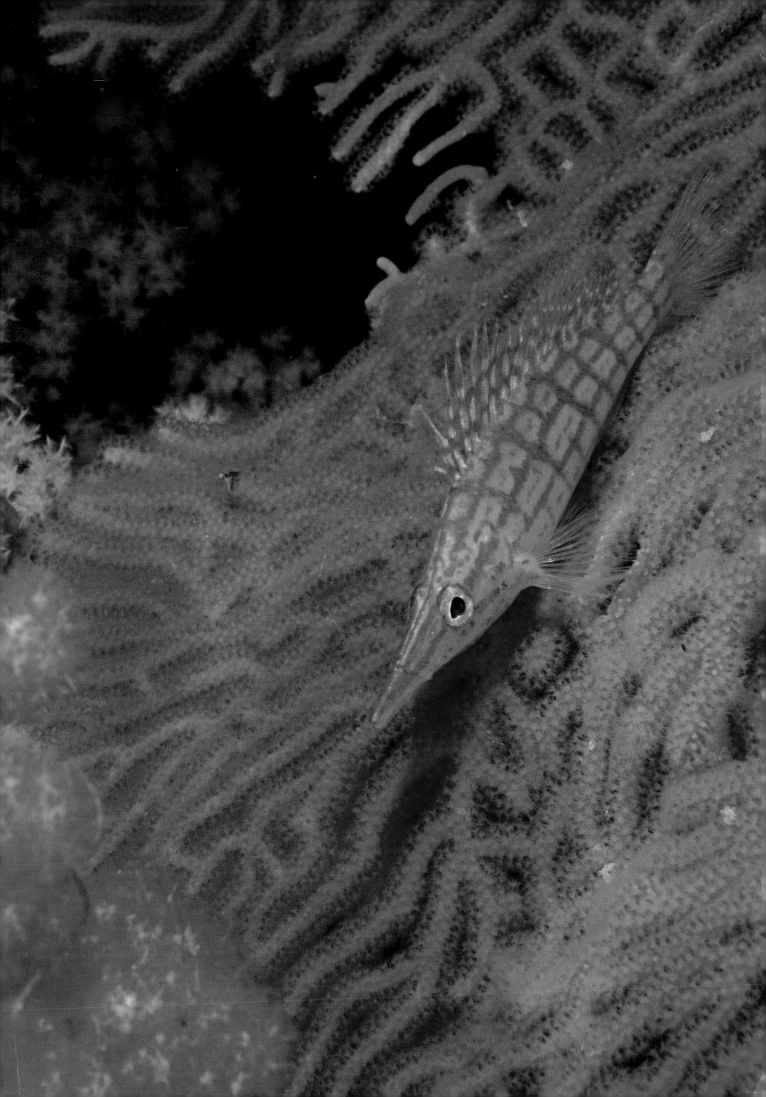

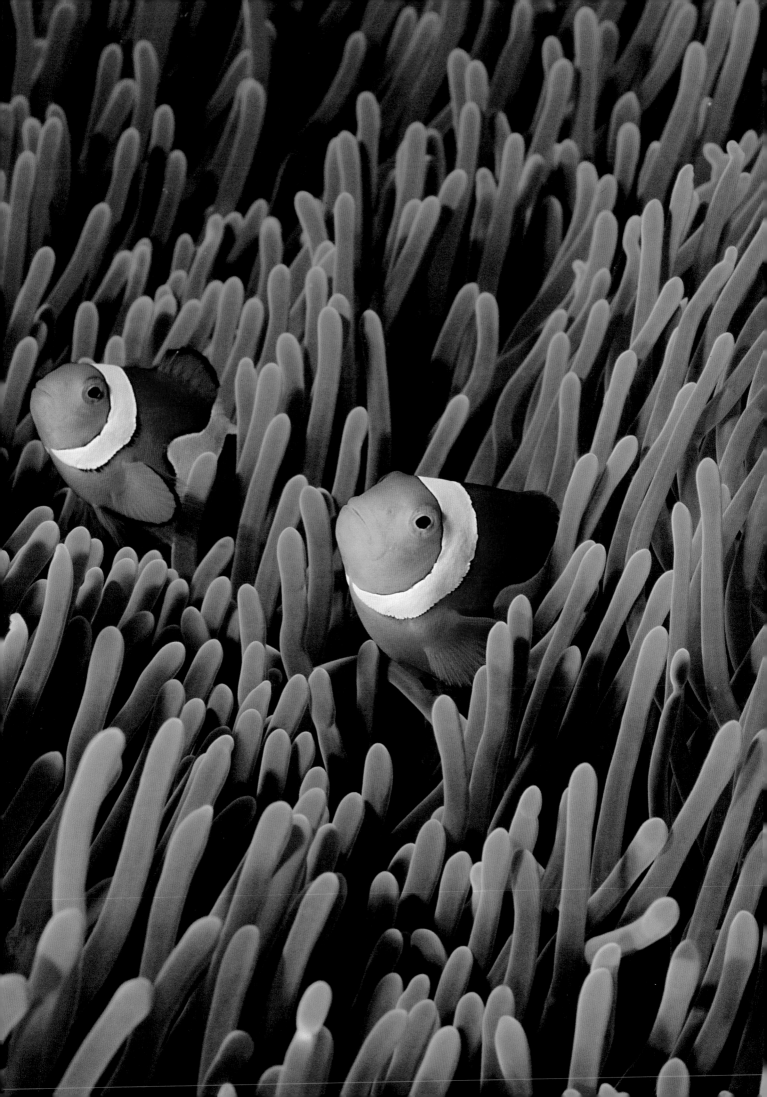

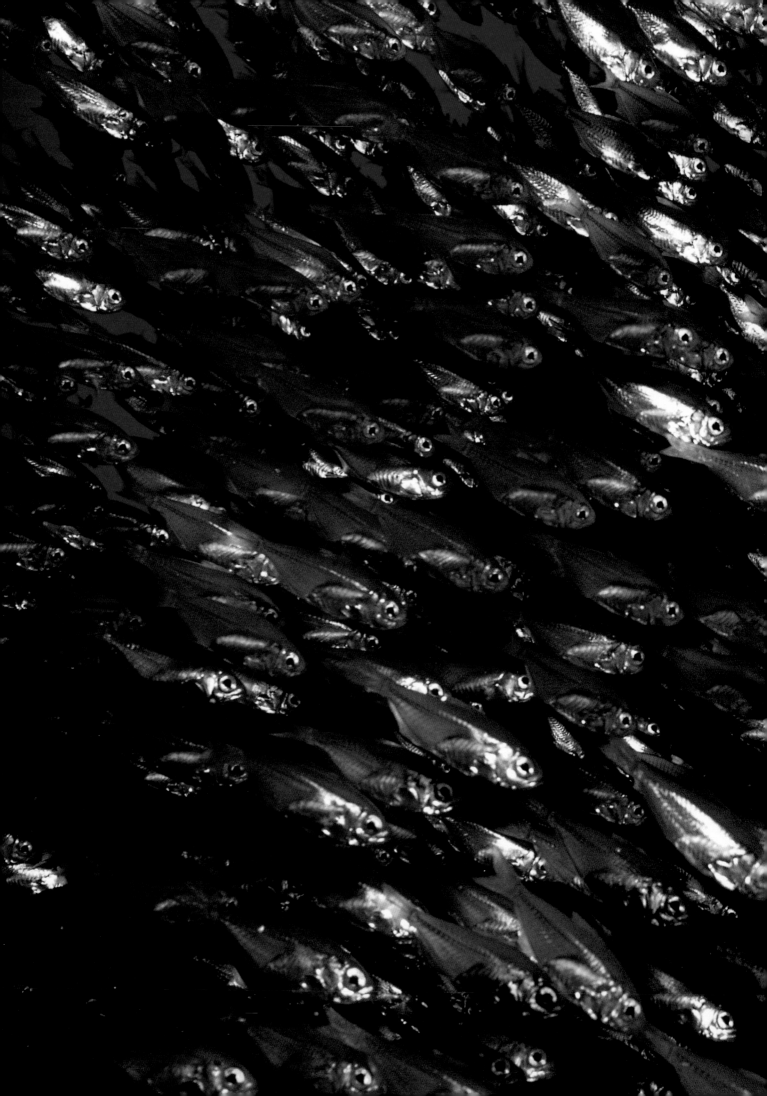

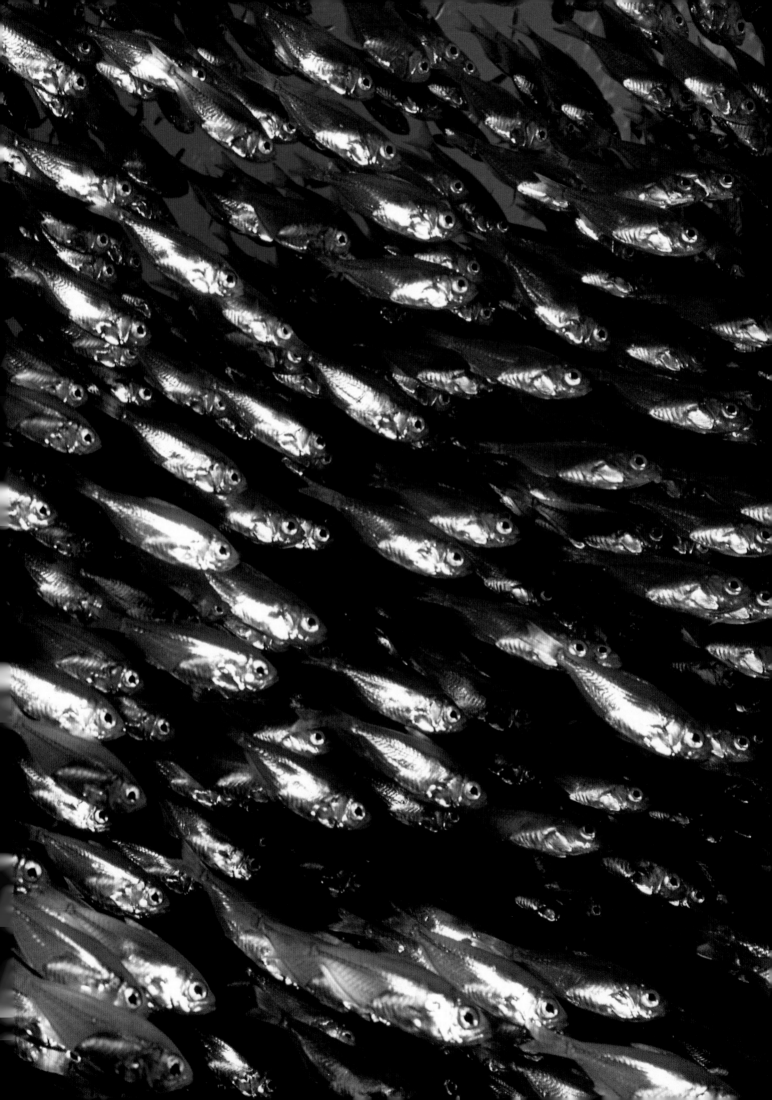

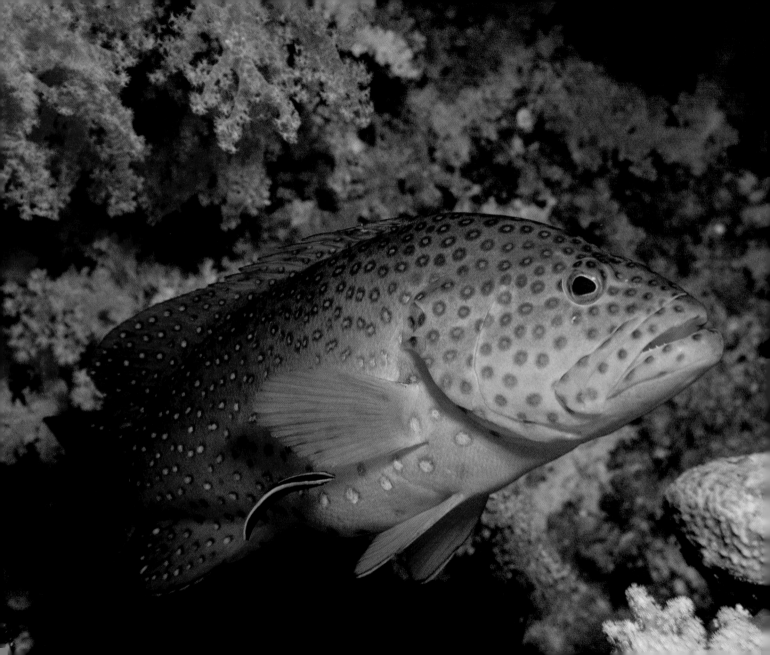

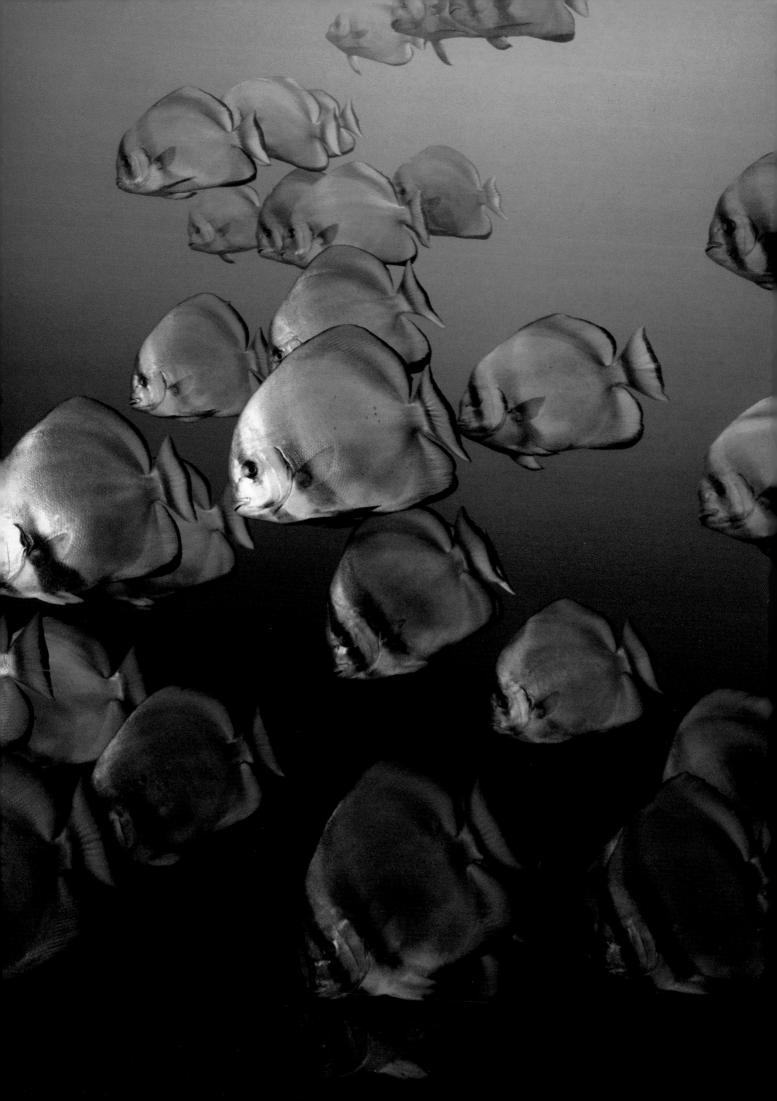

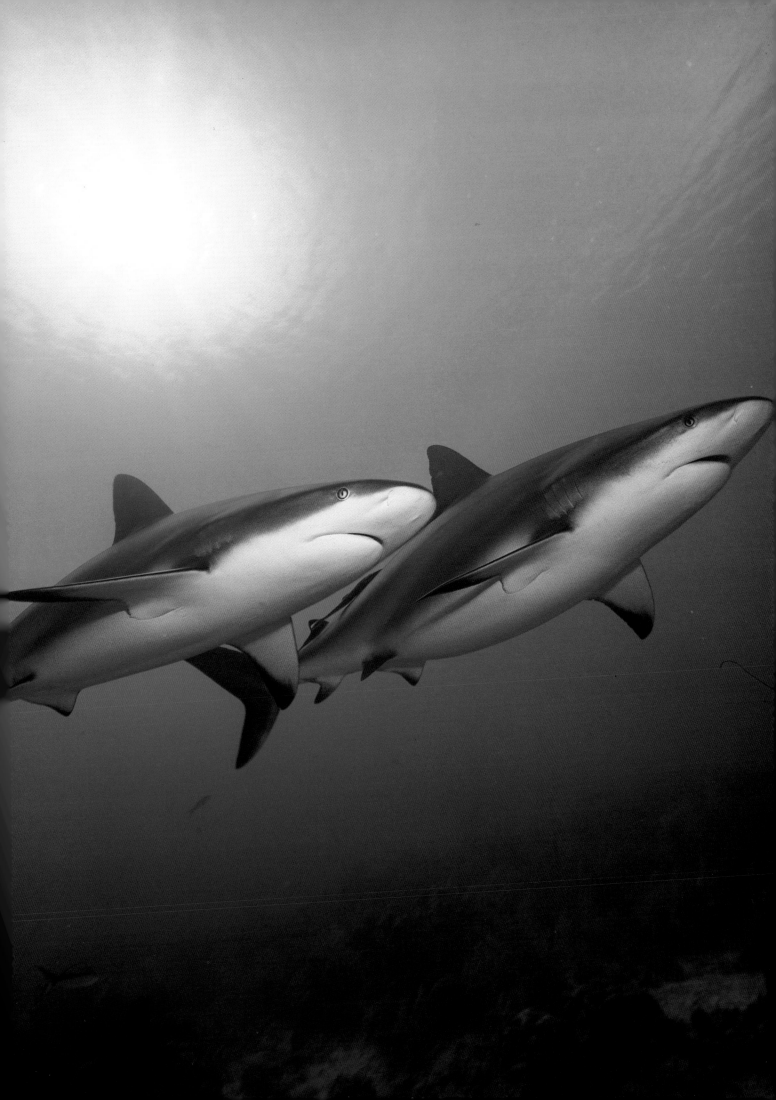

Wonders of the REEF

Diving
with a
camera

Text and photographs by Stephen Frink

Harry N. Abrams, Inc., Publishers

Page 1:
The delicate pastels of the Caribbean coral crab, photographed in Bonaire, contrast nicely with the greens of the lettuce coral background. *Rollei in Rolleimarin housing*

Page 2:
This species of hawkfish—less than two inches long—was photographed in the Red Sea. *Nikon F3, 55mm macro lens*

Page 3:
The delicate beauty and vibrant color of the clownfish and their host anemone are irresistible underwater subjects. *Nikonos RS, 50mm lens*

Pages 4–5:
Opal sweepers are often found at the mouths of caves in the Red Sea. *Nikonos RS, 28mm lens*

Page 6:
This coral grouper at a cleaning station was easy to approach, as it was reluctant to leave the benign ministrations of the cleaner fish. *Rollei in Rolleimarin housing*

Page 7:
While diving in the Galápagos Islands, I was attracted by the brilliant red sponge, and then I saw these tiny blennies occupying the shells left by the barnacles. *Nikonos RS, 50mm lens*

Page 8:
When the currents are right it is common to see large schools of fish, such as these batfish, near a dive site known as Ras Muhammad in the Red Sea. *Nikonos RS, 13mm lens*

Page 9:
These Caribbean reef sharks in the Bahamas were attracted by dive masters willing to hand-feed them. *Nikonos V, 15mm lens*

Pages 10–11:
Anthias school in massive profusion along the shallow reefs of the Red Sea. *Nikonos RS, 50mm lens*

To Barbara, my partner in life and business; and to our daughter, Alexa, with the sincere hope that the world's oceans remain a wilderness of wonder and bounty for her to discover when she's old enough to view it through a face mask.

PROJECT DIRECTOR: *Robert Morton*
EDITOR: *Lory Frankel*
DESIGNER: *Darilyn Lowe Carnes*

Library of Congress Cataloging-in-Publication Data
Frink, Stephen.
 Wonders of the reef : diving with a camera / text and photographs by Stephen Frink.
 p. cm.
 ISBN 0–8109–3785–9 (hc)
 1. Underwater photography. I. Title.
TR800.F73 1996
778.7'3—dc20 95–34173

Table of Contents

Preface and Acknowledgments

Underwater photography has been more than a job to me over the years—it has defined my life-style as well. It has broadened my travel horizons substantially and introduced me to many beautiful destinations and wonderful people who run the dive boats and resorts that make the photo opportunities possible. I owe special thanks to more dive operators from around the world than I could possibly list here.

I also appreciate the support I've received from Nikon. Not only is the company responsible for making the cameras, lenses, and submersible strobes I have used over the years, it has also been supportive of underwater photography in general, with consumer programs like the Nikon School of Underwater Photography and Nikonos Shootout.

Skin Diver magazine likewise has been an important ally. I have been fortunate in being sent on assignment extensively throughout the Caribbean and Florida Keys by the magazine, and much of my stock photo file from these destinations has evolved from our long and friendly collaboration.

Thanks go also to WaterHouse Photo Tours for its efforts in coordinating my often complex exotic travel and administering the educational and travel programs I host each year.

I'm especially appreciative of the efforts of our staff at Stephen Frink Photographic Inc. and WaterHouse Stock Photography. From our home base in Key Largo, Florida, these folks keep the wheels of commerce turning while I'm on assignment and do a wonderful job of processing the film and organizing life once I'm home.

My special thanks go to Bob Morton of Harry N. Abrams, Inc., who embraced and supported *Wonders of the Reef* from the very beginning; to Lory Frankel for her concise editing, insight, and ability to refine my thoughts into properly crafted paragraphs; and to Darilyn Lowe Carnes for her creative vision and sensitive design.

I am also grateful for the insights shared by Jerry Greenberg, both over the years and specific to this book.

Most important, thanks to my wife, Barbara, and daughter, Alexa, for they understand and support the often hectic life of an underwater photojournalist.

Opposite:
The vibrant colors of the delicate Indo-Pacific soft corals suffice to command the photographer's attention, and the addition of the nearby opal sweepers enhances the appeal of this composition.
Nikonos RS, 28mm lens

15

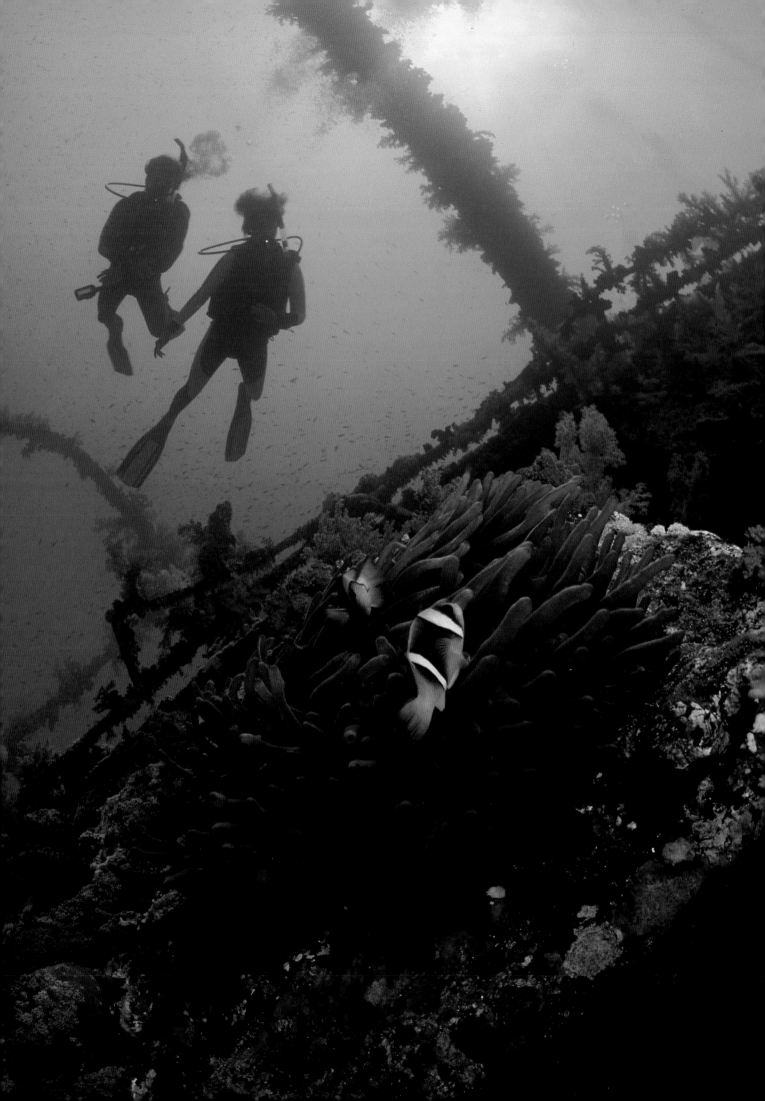

Introduction

U nderwater photography is what I do for a living, but more significantly, it's what I do for fun. There is a particular thrill that comes from being exposed to a world-class photo opportunity. While I always hope that a world-class photo will result, even if something goes wrong, the pursuit is every bit as meaningful as the capture. The places I go and the things I see are justification enough.

For instance, at this moment I'm sitting on a dive boat anchored off Big Brother Island in the Red Sea. It is late in the afternoon and I have just finished a magnificent dive on a coral-encrusted shipwreck, sloping down the wall to much greater depths than I should explore on this fourth dive of the day. What I managed to see was enough to remind me why underwater photography is so compelling and addictive.

In water clarity in excess of 120 feet, the scattered remains of the ship were clearly visible: a huge spoked wheel from some deck machine; twisted cables and pipes; indiscriminate shapes now overgrown with coral, transformed from objects of useful commerce to a place where a coral grouper might hide. Near the edge of the wall, the bow section materializes from the gloom. What I take to be a bit of superstructure turns out to be thousands of opal sweepers, iridescent in the afternoon light. Vibrant soft corals decorate the davits and ribs of the ship, and clownfish guard their host anemone along the deck plates. While I know nothing about the history of this vessel, my mind wanders for a moment from the mechanics of trying to capture the grandeur and beauty of this artificial reef to the moment of terror in which this ship was doomed.

I see all the davits for what must have been lifeboats, and I figure it for a troop transport. In my fantasy it is now World War II and this is a British ship that has passed down the Suez Canal and is sailing the Red Sea en route to some military rendezvous in the Indian Ocean. A German U-boat captures the hapless ship in its periscope and unleashes a single torpedo that explodes suddenly and devastatingly amidships. The captain and crew scramble to assess the damage and instantly realize their ship is mortally wounded. Water pours into the holds, and there may not even be enough time to launch the lifeboats.

In this desperate situation, off in the distance is sighted a blinking light—the lighthouse marking the Brothers Islands. Suddenly, these small, inhospitable clumps of rock signal salvation. The captain changes course and charges full ahead for the Brothers. The ship continues to take on water and wallows sluggishly. In a life and death race, the valiant ship barely strikes the western tip of the island with her bow. Yet instead of plunging into the bottomless shark-infested depths, bringing about the loss of all hands, she is grounded and settles slowly along the slope, allowing the crew and passengers to swim safely ashore, where they are picked up by a passing Egyptian freighter the next day.

Opposite:
The wreck of the *Aida* II on Big Brother Island in the Red Sea presents a wealth of photo opportunities, including these clownfish on the deck plating at about 95 feet. *Nikonos V, 15mm lens*

Since this is my fantasy I have given it a happy ending, although I know the true story may well have turned out differently. No matter—for a brief moment I'm a witness to history and a spectator to the glory that is the sea, thanks to the pursuit of underwater images.

Most photographers will probably recall the moment that shaped their decision to make the capture of a "moment in time" their life's work. As glorious as I find the coral reef today, my initial inspiration came not on a high-adventure dive but in a classroom in the early 1970s in Long Beach, California. I had finished up my course work for a master's degree in psychology but was still working on my thesis, and I had time to take some classes of interest. I enrolled in Photography 101.

I was not particularly compelled to take pictures at that time. My photographic arsenal consisted of a Kodak Instamatic and an old Argus range finder. I probably shot fewer than ten rolls of film a year, whereas today I might shoot forty rolls in a single day. Whatever the mysterious motivation that got me involved in this course, I was at once captivated with the process of black-and-white photography.

We learned photography as a technique, a means of communication, and an art. It was all quite fascinating, but my personal revelation occurred the moment we went in the darkroom for the first time and I saw the image on the print gradually emerge from the developer. This process, with its alchemy and wonder, has shaped my life ever since.

About the same time that I was discovering photography, I was finding out about scuba diving. I had been a competitive swimmer as a kid, and I loved all manner of water sports, but living in Illinois I was far removed from any dive opportunities. What I knew about diving was from television, as each week my hero Mike Nelson experienced the thrill and peril of his scuba world, and through the vicarious excitement of "Sea Hunt," this sport became my secret fantasy.

Yet this dream remained dormant for many years. It was not until I wanted to get a part-time job cleaning yacht hulls underwater that I finally became certified in order to satisfy the insurance requirements. The job did not last long, but my amusement with the ability to breathe underwater and my fascination with the world underwater were very powerful. It was a small but inevitable step to carry my interest in topside photography underwater.

Now, twenty years after I took my first underwater photograph, the pursuit of underwater images is not only as inspiring as ever for me, it has become a profession as well. It changed from a hobby to my career about the time I moved to Key Largo, Florida, in 1978 to open a studio for underwater photography.

I knew I wanted to take underwater photos for my own gratification but I was not convinced I could pay the bills with a click of a shutter. However, I had visited the Florida Keys on vacation and noticed that they had no business that processed slide film. I was already doing color darkroom work for a Denver photo studio, so I looked at this new market and did some totally unscientific and naive number crunching to determine I could make a living processing film for underwater photographers.

Not surprisingly, my entrepreneurial analysis was wrong by a long shot. But since I was young and had little to lose, I moved to Key Largo to give this career in underwater photography a try. I was far from being a professional-quality underwater photographer when I opened my studio. In fact, my initial efforts at underwater photography were so embarrassingly modest that I didn't have a photo good enough to hang on the wall, and instead settled for a rather incon-

gruous picture of a mountain stream. Fortunately, the state of the art in underwater imaging was also less sophisticated in those days, and I had the opportunity to learn and grow.

My program in those formative years was to rent cameras to tourists in the morning and go out to shoot my own pictures in the afternoon. After processing my film, I would try to decide what worked and what didn't. Even though I had a good background in photographic theory and darkroom technique, I learned underwater photography primarily by trial and error. By sheer persistence I began to get an ever higher percentage of acceptable images.

I figured out the basic principles of underwater photography by reading what few books were available at the time and shooting lots of film. I discovered how crucial artificial light was in terms of generating color in an underwater image, a lesson that remains fundamental today. I found out that getting closer to my subject resulted in sharper photos. I learned specific optical tools were essential to capture specific subjects, and that I had to restrict my vision to the kinds of subjects appropriate for the lens in use. If I was shooting the tiny macro creatures of the reef with an extension tube, the fact that schooling hammerheads were over my left shoulder had to be ignored. Likewise, if I was equipped with a wide-angle system, mating nudibranchs were photographically irrelevant to me (although significant to them). I learned the value of both the single-lens-reflex and Nikonos systems, and practiced with both 35mm and medium-format films.

All the while I was learning to shoot underwater, I was accumulating a file of photographs. I may not have known what a stock photo was, but keeping my best photos on file and protecting them archivally served me well later, as clients began asking for the rights to lease them.

After I was in business for a few years, one of the dive magazines called to ask if I could shoot an assignment down the road in the Middle Keys. Of course I accepted, then borrowed a wide-angle lens (by then I had shot a grand total of one wide-angle roll underwater) and went off to shoot the underwater wonders of Marathon. I guess it turned out all right because the magazine called back with more assignments. One thing led to another, and before I knew it I was considered a photojournalist, writing about the technical aspects of underwater photography and traveling to the far regions of the dive world to report on dive resorts and live-aboard boats.

Now, several hundred articles and scores of dive destinations later, underwater photography is still what I do for a living and for fun. Between a greater emphasis in stock photography, underwater photography for advertising clients, and continuing editorial projects, it is still a challenge to photograph something new or to do it better. There are still plenty of places I have yet to dive. Even the familiar places constantly reveal something novel to the underwater lens. It is this joy of discovery, appreciation for the beauty of the underwater world, and the technical considerations of underwater photography that transfer the mind's eye to film that I'd like to share with you here.

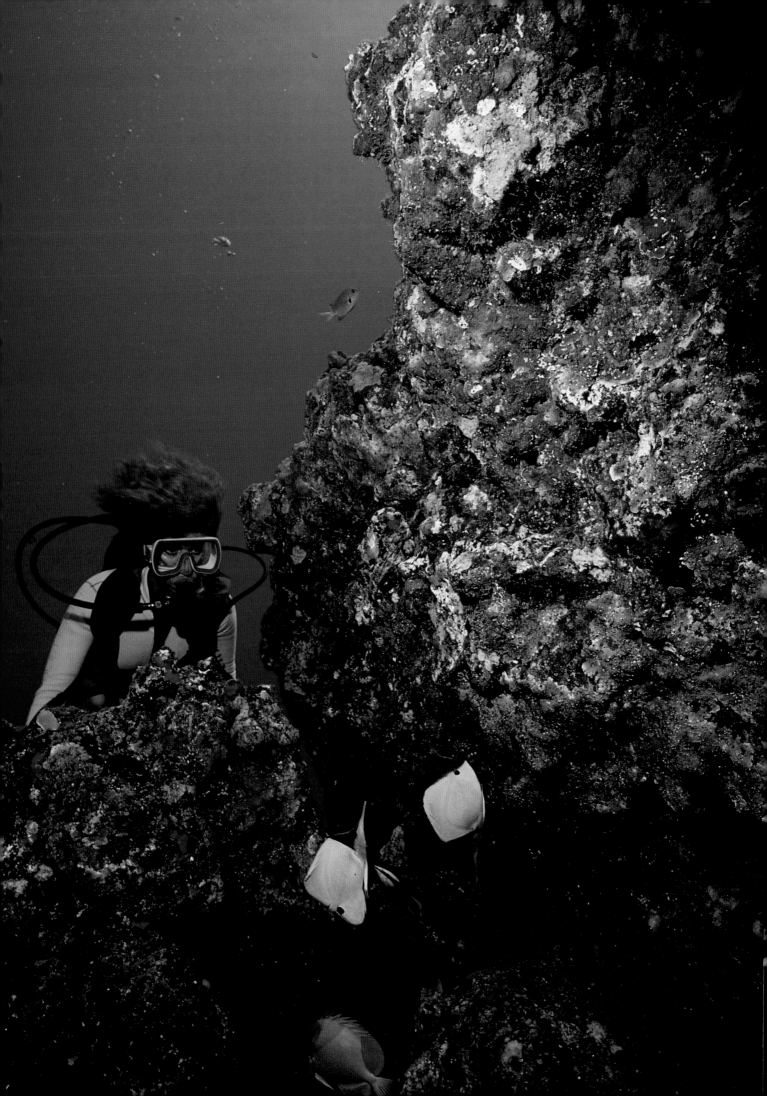

I. *Photo Opportunities for the Dive Traveler*

O ne of the abiding joys of underwater photography is the beauty of the places where I must travel to capture the images. This is not to say that the lakes and quarries near home do not offer interesting material, but certainly there are more colorful, fascinating subjects beneath the world's oceans. Another consideration is that underwater photography requires reasonably clear water, far from heavy industry and pollution, which is where I'd prefer to be in any case.

Certainly, the most hospitable underwater photo opportunities are within the world's tropical seas. While cold waters—such as the California coast, the Pacific Northwest, or even the Arctic and Antarctic—harbor a wealth of colorful marine life, both vertebrate and invertebrate, they are hardly hospitable to the scuba diver. I have the greatest respect for photo specialists who don dry suits for thermal protection and operate their cameras through bulky gloves in order to capture the glory of the kelp forest or the world beneath the ice. I prefer to dive in warm, comfortable water, and the explosive growth in dive travel worldwide is directed toward these kinds of tropical destinations.

Tropical Domestic United States

HAWAII. While I took my first underwater photographs in California, my true involvement with underwater photography came about once I got out of graduate school and moved to the Big Island of Hawaii, looking for something to do with photography and a nice place to live.

Opposite:
The lava tubes of underwater Hawaii make for strong graphic compositions, but they are not as colorful as the walls dripping with soft coral found in the Red Sea or warmer Pacific waters. The addition of fish and a diver make the underwater photo more appealing. *Nikonos V, 15mm lens*

Left:
Species of hawkfish are found in virtually every tropical ocean, and this is their normal posture as they lie patiently amid the corals, waiting for prey to pass. *Nikon F3, 55mm macro lens*

21

Right:
The macro capability of the extension tube captures color and detail that might otherwise go unnoticed, like the vibrant saffron hues and bristled texture of this hermit crab, photographed in Kona, Hawaii. *Nikonos V, 35mm lens with 1:1 extension tube*

Below:
The brilliant colors of the macro world, including this pencil urchin in Kona, Hawaii, are intensified for the underwater photographer by working close, thereby minimizing the blue filtration inherent in seawater. *Nikon F3, 55mm macro lens*

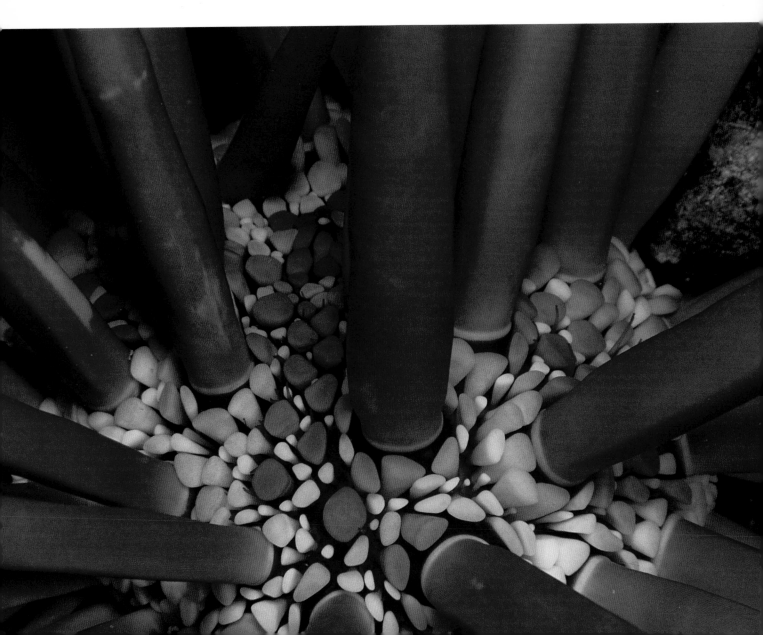

It was a beautifully sunny day with slick calm seas when I arrived in Kona on the big island of Hawaii, and it revealed an ocean I'd never seen before. Neither turbid and rough, like the waters off California, nor muddy, like the Mississippi River, where I'd grown up, it was vast, tranquil, and crystalline turquoise, with masses of coral visible just below the translucent surface. I could see myriad bizarre tropical fish flitting about even from the seawall. But I think it was the moment I peered below the surface of this water and saw my first tropical reef through a face mask that changed my life.

In those days I still had my original Nikonos but had given up the bulb flash in favor of a Vivitar 283 strobe in an Ikelite housing. It gave a very narrow beam flash, but since all I had was a 35mm lens it was good enough, at least for the little I knew about underwater photography at the time.

The myopic viewfinder of my Nikonos I opened onto a fabulous new world. I never knew such colorful and diverse life forms existed on earth, and I shot roll after roll trying to emulate the photos I had seen in a fish identification book, never succeeding particularly well. In retrospect, it seems to me that developing a reverence for the coral reef was more important than shooting wonderful photos back then.

I saw delicate cauliflower corals and broad antler corals decorating the submarine ridges amid pinnacles, archways, and caverns formed by the volcanic forces that created these islands. I experienced true 100-foot visibility for the first time in water warm enough to dive without a wet suit (I was either tougher or more foolish in those years). I drifted out over my first vertical wall and felt the weightless vertigo of the bottomless abyss. I found ferocious (I thought) moray eels lurking in crevices, cone shells buried in the sand, turtles swimming peacefully along the reef, and more varieties of butterfly fish than I could imagine existed. I even heard the plaintive wail of the humpback whale. I became convinced that the challenge of capturing the majesty of the ocean on film would never fade.

I left Kona after only about six months, many years and many dives intervening before I returned to shoot a travel article about a live-aboard dive boat. Revisiting the photo opportunities of my youth armed with enhanced photographic experience, better equipment, and considerably more seasoning as a dive traveler was fascinating.

One of the first things I noticed was that a luxury live-aboard is a far better way to reach the best dive sites than the shore diving I did originally from my primer-gray Chevy wagon. Then I discovered the water was much cooler than I'd remembered, a discomfort that a good wet suit cured in a hurry. But the Pacific was still very clear and tranquil, and the photo opportunities even more exciting.

Kona did not offer the sweeping reef panoramas that I'd come to know in the Red Sea or Micronesia. It featured a low-profile reef with a wealth of photo subjects available to those in tune with the reef minutia. People interested in wide-angle subjects have wonderful opportunities to work with magnificent pelagic life, including whale sharks, pilot whales, dolphins, green sea turtles, and, of course, the star of the Hawaiian marine constellation, the seasonal appearance of the humpback whale. However, these kinds of encounters require luck, timing, and/or countless hours in the water. The more typical scene might involve wide-angle scenics of divers and lava tubes, a discipline far different from shooting the soft-coral-decorated reefs of the tropical Pacific.

Photographing the lava tube formation is a classic example of blending strobe and ambient light. Formed as molten lava from the Mauna Loa and Kilauea

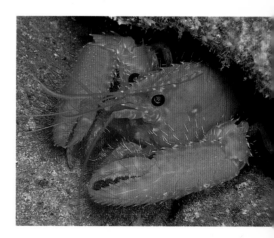

At first glance, the lava tubes of underwater Hawaii suggest a broad wide-angle scenic, but on closer inspection, a whole world of small creatures, such as this lobster, is revealed within. *Nikon F3, 55mm macro lens*

23

volcanoes flowed into the sea, they cooled into long tunnels, which eroded and became embellished after years of submersion. Shafts of sunlight pierce the openings, fodder for available-light distance shots, and vibrant encrusting sponge decorates the interior, a perfect subject for strobe illumination. Directing a model to become an element of composition in the midwater can complete a compelling composition, and balancing both the ambient light and artificial light adds to the challenge.

During my brief return to Kona I concentrated more on the colorful marine life so prevalent along these reefs. The Arc-eye hawkfish waiting patiently in ambush from a coral knob, a conger eel being groomed at a cleaning station as if relaxing at some marine health spa, a brilliant crimson target lobster hiding in a cave, a delicate Hawaiian turkeyfish gliding upside down beneath the domed roof of a lava tube, and the impossibly bristled appearance of a hermit crab were all new targets for my macro lens.

The beauty of these reefs was more subtle than some places I had visited in recent years, but the small marine life, combined with the possibility of an unusual encounter with larger creatures, makes Hawaii a viable choice, especially for divers who want to stay in the United States. In addition, the islands are very beautiful topside, which is not necessarily true of all scuba destinations. Many small, arid islands offer very good diving, with the advantages that a small island cannot support much of a population to overfish or pump excessive sewage to the sea, and on an arid island freshwater runoff from rain or rivers does not degrade visibility. The Hawaiian Islands, however, are lush and mountainous, balancing ample above-water tourist attractions with areas like the South Kona coast that are less developed and retain a sense of terrestrial wilderness.

FLORIDA KEYS. When I was in college in California and had just begun scuba diving, one of my classmates told me of a place called the Florida Keys where he had dived the previous year. He described a scene with incredibly clear water and tropical coral reefs only fifty miles south of Miami, an alien environment populated by silvery barracuda and garish queen angelfish, massive schools of yellow fish he called grunts, and coral heads that rose twenty feet from the sand floor. I assumed much of his raving was hyperbole, but the memory remained.

Years later, my dive buddy from Hawaii, who had moved to the Florida Keys, repeated many of the same stories of these amazing reefs at the southern end of the Florida peninsula. In the spring of 1978, I visited the Florida Keys for the first time and found there was substance to these fish tales.

Along the reefs of Key Largo, I discovered an environment far different from those I knew in Hawaii. There were spur and groove coral formations in only twenty-five feet of water, but these fringing reefs were located four to six miles from the island, whereas Hawaii's corals were right offshore. This was probably why Key Largo had so many dive shops. Even in those days a sophisticated infrastructure of retail dive stores selling instruction, dive gear, air fills, and, most important, transportation to the reef had evolved.

Over two hundred islands and cays comprise the 120-mile chain known as the Florida Keys, but only about thirty islands support the population and commerce of the Keys, and these are all connected to the mainland via the bridges and highway known as U.S. 1. The largest land mass is Key Largo, and its bulk provided a barrier for tidal transfer of the more turbid waters from Florida Bay and the Gulf of Mexico, significantly contributing to the reef development offshore. This, plus the

Opposite:
The French grunt is an icon of the Florida Keys, seen on most of the shallow reefs in prodigious numbers, here with pillar coral. *Nikonos RS, 50mm lens*

24

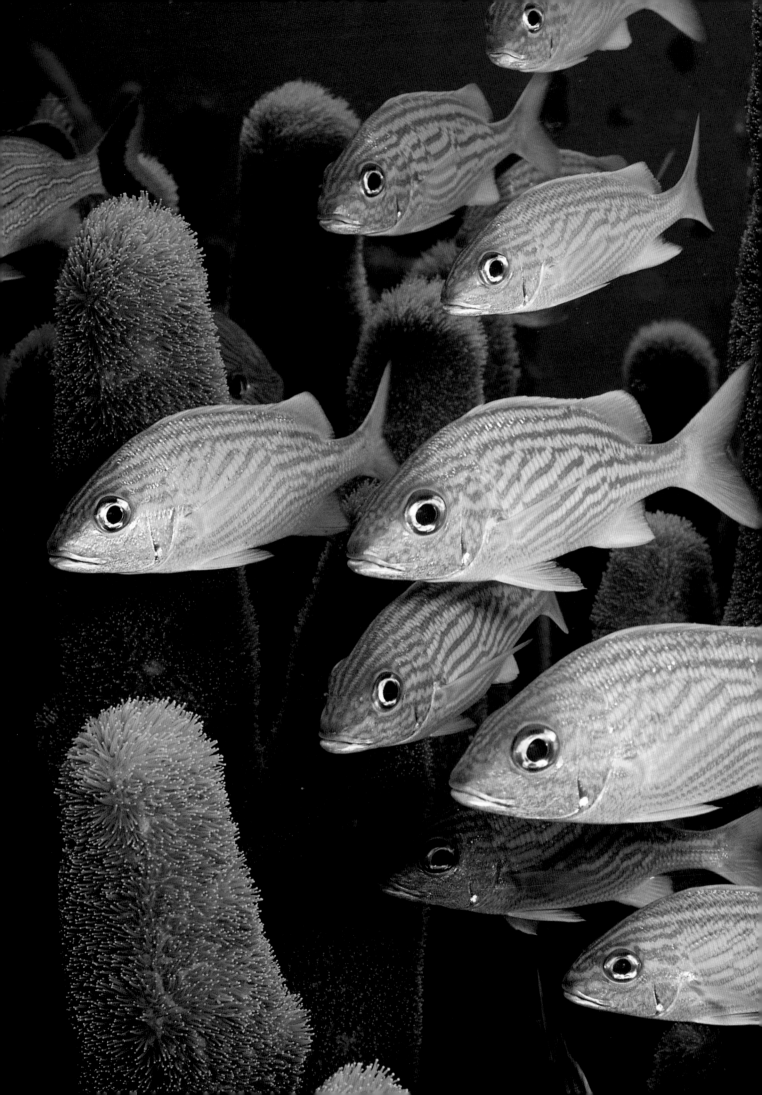

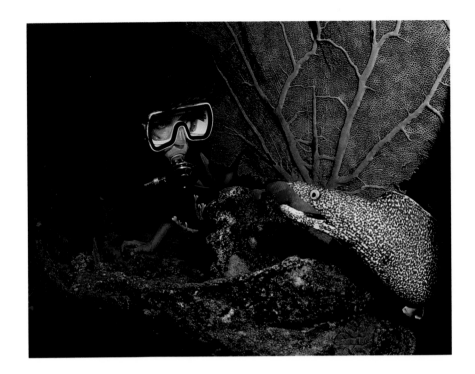

island's position near the path of the Gulf Stream, a giant oceanic current that carries warm, clear water and embryonic coral and marine life, combined to create an environment propitious for the evolution of extravagant coral growth and abundant fish life.

Yet the reason Key Largo was still attractive to scuba divers in 1978 had as much to do with conservationist zeal as geologic serendipity. In the early years of Florida tourism, the sea-life novelty trade was systematically stripping the Keys of its coral and shells. A number of individuals with the vision to see that the sea was not an infinite resource, supported by organizations such as the National Audubon Society, the University of Florida, and the *Miami Herald*, under the direction of editor John Pennekamp, proposed to protect the reefs off Key Largo by means of the nation's first underwater park. They prevailed, and by 1960 John Pennekamp Coral Reef State Park was born. No longer would it be legal to collect coral or spear fish within these waters.

Since the marine animals had been protected from spear fishing since 1960 and had long become used to the presence of divers, it was easy to approach them without scaring them beyond camera range. As the Keys contained many of the same fish species found throughout the Caribbean, it served admirably as a place to build a portfolio of reef scenics and fish portraits.

Key Largo diving still provides wonderful material for the underwater photographer today. The primary appeal remains the sheer quantity of marine life: angelfish, butterfly fish, barracuda, chub, damselfish, eels, filefish, grouper, grunt, hogfish, jack, lizard fish, octopus, parrot fish, stingrays, scorpion fish, snapper, snook, spadefish, squirrelfish, triggerfish, trumpetfish, and wrasse. A veritable alphabet of species populates these reefs and becomes fair game for those wishing to refine their underwater photographic skills.

Macrophotography and close-up work here is also reasonably productive, and wide-angle reef scenics work well, due to the colorful schooling fish that populate the reef and the tolerance of the fish for the intrusion of divers, which makes close-focus wide-angle shots viable. For advanced divers visiting the Key Largo

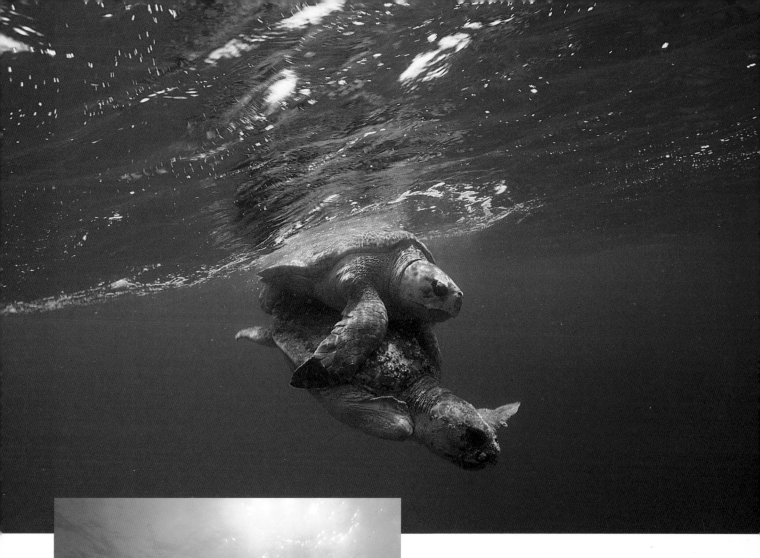

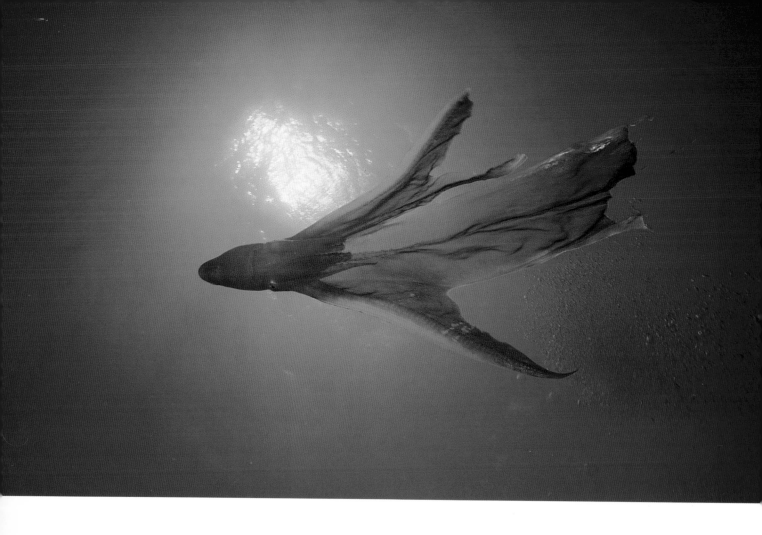

While doing a dive along the edge of the reef slope off Key Largo I spied what I first took to be a trash bag floating in the current. Thinking I'd haul the rubbish out of the water with me, I swam nearer and discovered this unusual octopus. I had never seen one before and could not find a similar one in any of my fish identification books. So I sent the slide to the Smithsonian Institution in Washington, D.C., to see if someone there could help. It was identified as a blanket octopus, *Tremoctopus violaceus*, possibly the first ever photographed in the wild. *Nikonos V, 15mm lens*

area, there are also a couple of great shipwrecks that have become outstanding artificial reefs.

These wrecks, the 327-foot U.S. Coast Guard cutters *Bibb* and *Duane*, sister ships that had served the country valiantly in years of war and peace, were acquired in 1987 to provide variety to attract advanced divers and compete with similar attractions already offered off Miami, Fort Lauderdale, and elsewhere in the Keys.

The job of cleaning the ships, making them safe for divers in the ocean, and sinking them at sites preapproved by the Army Corps of Engineers, which I had a hand in, turned out to be difficult, exasperating, and time-consuming. But thanks to a tremendous cooperative effort from local dive shops, businesses, and county government, two days after Thanksgiving 1987, Key Largo finally had two world-class shipwrecks.

Shipwrecks are very efficient in attracting marine life, and the *Bibb* and *Duane* now host schools of barracuda, clouds of grunt, and consistent visits by other marine tropicals, particularly angelfish and parrot fish. Due to the proximity of the Gulf Stream, the visibility is often outstanding. However, the current can occasionally be strong enough to make diving these wrecks a hazard. Local dive operators can best apprise of daily conditions.

The wide-angle potential on these wrecks is extraordinary, and fish and macro shooters will find plenty of subjects as well. What makes these sites a challenge is the depth. The *Duane* can be easily done as a 100-foot dive, with the wheelhouse at 80 feet and the weather decks at 100, but the *Bibb* is first encountered at 90 feet and probably should be figured as a 110- to 120-foot dive. That does not

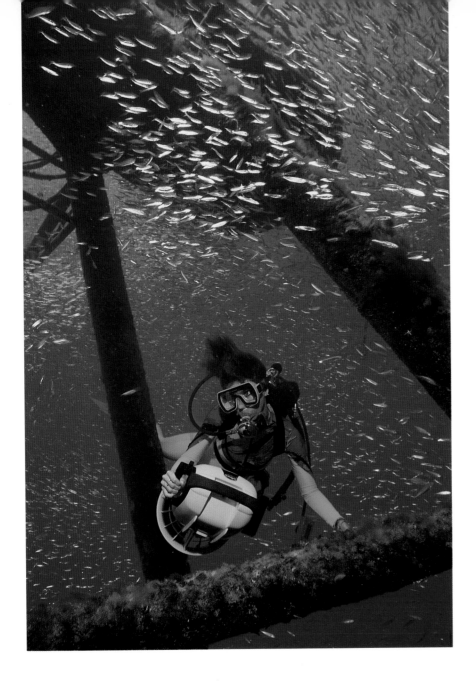

leave much time to set up shots. A strobe that recycles quickly and a dive computer that figures multilevel time limits are important photo accessories for these dives.

The popularity of the Florida Keys is both a boon and a curse. Thousands of divers and snorkelers gain their first glimpse of the beauty of a coral reef here, and it is hoped that it cultivates in them a sense of respect. However, the sheer number of people in the water create greater opportunity for diver impact on the coral and misplaced anchors dragging through the reef. A growing local population and increased tourism that now brings over six million visitors to the Keys annually has created a conservation imperative that has been expressed over the years with the creation of John Pennekamp Coral Reef State Park in 1960, the Key Largo National Marine Sanctuary in 1975, and the Looe Key National Marine Sanctuary in the Lower Keys in 1981. In 1990 the Florida Keys National Marine Sanctuary and Protection Act was signed into law by President Bush, establishing increased protection for 2,800 square miles of coastal waters on both the Gulf and Atlantic sides of the Keys. In addition to government controls designed to preserve the coral

Schools of glass minnows occasionally show up on the reefs and wrecks of the Florida Keys (this is the *Duane*). Between the grouper and jacks that voraciously attack them, the schools soon dwindle, but until then, they create a beautiful composition. *Nikonos V, 15mm lens*

29

reef, certifying agencies, dive publications, and local dive operators are making a concerted effort to educate divers before they ever enter the water that the coral reef is a living entity and must not be touched. In the Florida Keys it is not only unconscionable but illegal to damage the reef.

The Caribbean

In the late 1970s many of the islands in the Caribbean were discovering that their greatest marketable natural asset was found beneath the sea, in dive tourism. They had the clear water, tropical climate, pristine coral reefs, colorful reef "critters," and vertical drop-offs that excited scuba divers, and they were beginning to develop the infrastructure of hotels and airports that could sustain tourism. Of course, islands like Jamaica and parts of the Bahamas, such as Nassau, already had an established general tourism, but the islands of Grand Cayman, Cozumel, Bonaire, Belize, the Turks and Caicos, Roatán, and the Out Islands of the Bahamas received only a small stream of visitors. Perhaps scuba diving would open the floodgate.

Opposite:
The perspective distortion inherent in the full-frame fish-eye is apparent here, as the Nassau grouper appears to loom as large as the diver, photographed in Grand Cayman. *Nikon F3, 16mm lens*

Below:
The stunning visibility on the vertical dropoff of the Little Cayman wall, decorated by an azure vase sponge, is demonstrated by the diver silhouette in the distance. *Nikonos RS, 13mm lens*

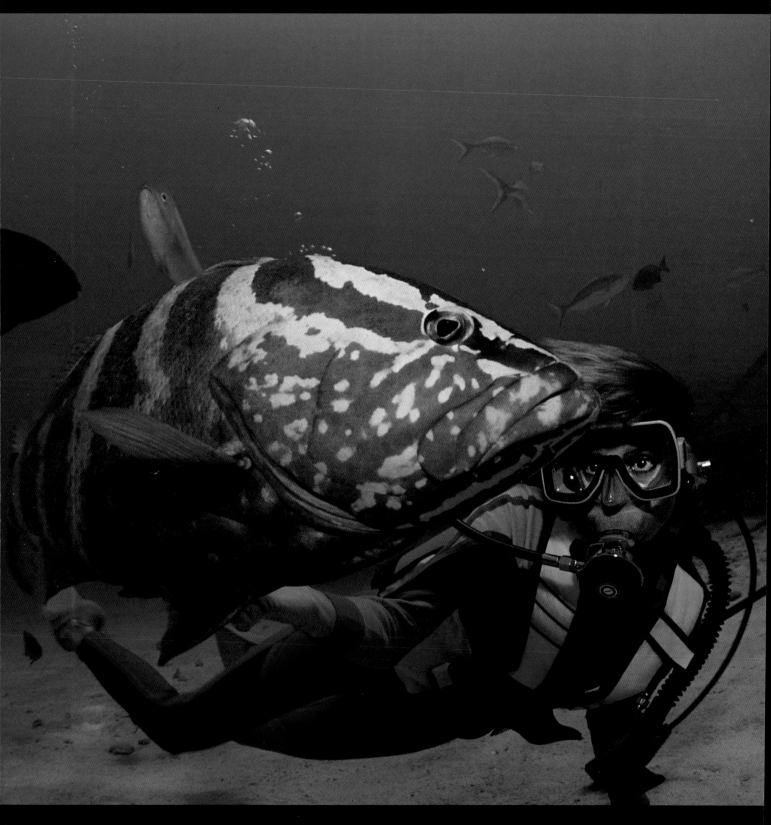

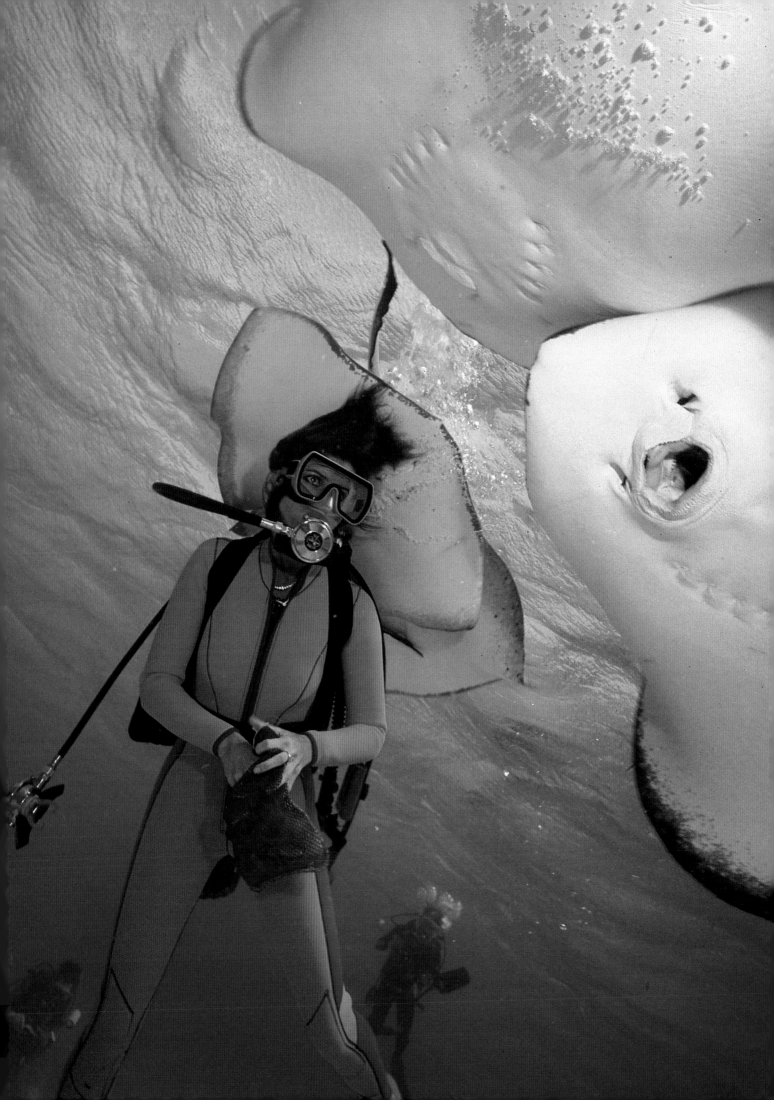

The first thing I noticed on my first trips to the Caribbean was the clarity of the water. It may not have been much better than the Keys on our best days, but the areas I visited in the Caribbean was more consistently clear, with 100- to 150-foot visibility not unusual. It seemed as if particulate matter (backscatter) ruining the look of the underwater photos would no longer be an issue on many of these dives.

The bottom structure was also different. On my first dive along the walls of Little Cayman I was absolutely astounded to note the vertical wall beginning in only twenty feet of water, yet it was lavishly decorated with massive tube sponge, brilliant elephant ear formations, giant black coral trees, and tame Nassau grouper that would come right to the dome port to stare at their reflection. Over on Cayman Brac, broad expanses of elkhorn coral decorated the top of the spur and groove channels. It also presented dramatic walls and a great variety of marine life to intrigue divers. Unfortunately, much of the shallow elkhorn here and along the south coast of Grand Cayman was devastated during Hurricane Gilbert. Even back then, Grand Cayman drew more dive tourists than the rest of the Cayman Islands.

GRAND CAYMAN. With sixty miles of drop-off diving available and ample shallow reef, Grand Cayman already had the dive sites. Wall dives like Orange Canyon, Trinity Caves, and various sites along the North Wall, along with shipwrecks like the *Balboa* in Georgetown Harbor and later the intentionally sunk *Oro Verde* off the powdery white Seven Mile Beach, became the new standards of exotic dive adventure for North Americans. Shallow reefs like Bonnie's Arch became known for unusual marine life such as schooling tarpon, and by fortuitous accident one of the Caribbean's most unusual marine life encounters was being developed over in the North Sound.

Fishermen had made a habit of coming back into North Sound after a day of fishing to clean their catch and dump the refuse along the shallow sandy reef. Snorkel boats also stopped in these protected waters to let their guests swim amid the scattered coral heads and watch the tropical fish. They, too, would throw their biodegradable scraps overboard, where they would sink to the bottom to be scavenged by southern stingrays.

Soon the snorkelers began commenting on the strange proliferation of stingrays here, and their curiously docile behavior. It did not take long for these stories to begin circulating within the dive community, and a few enterprising dive masters wondered if these friendly rays could be fed by hand. The rest is history: Stingray City is home to twenty-five to thirty-five tame stingrays that can be petted, stroked, and easily enticed into taking bait such as squid or ballyhoo from a diver's hands. The water here is only eight to twelve feet deep, so it is good for both snorkeling and diving. This is probably the single most popular underwater marine-life attraction in the world, and almost every diver or snorkeler who visits Grand Cayman makes the odyssey to Stingray City.

In the past decade the Cayman Islands have encouraged their development as a dive destination. There are now 119 dive sites marked with mooring buoys on Grand Cayman alone, and all three of the islands offer resort hotels with dedicated dive services to facilitate the special interests of their visitors. Underwater photographers are well served with knowledgeable local photo pros who can teach techniques, shoot custom stills or videos, rent them equipment, or process their E-6 compatible films. Many things have changed with the increased popularity of

Opposite:
Even though much of the action at Grand Cayman's Stingray City takes place in only 12 feet of water, I used a strobe to add color to the diver's wet suit and light the white underside of the stingrays. While this is a wonderful place to shoot "fish identification" pictures of the rays, I prefer to show the benign interaction between these friendly (actually, greedy) stingrays and divers. *Nikonos V, 15mm lens*

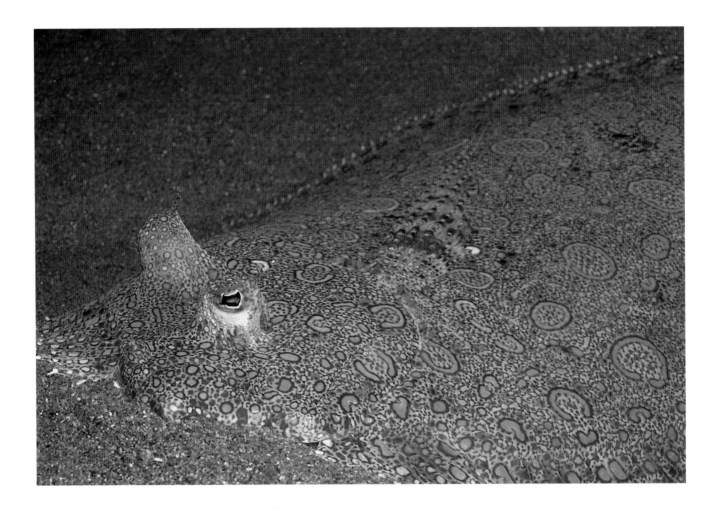

Above:
One of the unique aspects of the peacock flounder is the position of both its eyes on one side of the head, as befits a bottom dweller. On location in Saint Lucia, I placed the camera along the sand bottom, aiming for the lowest possible angle to show the eye stalks. Since the sand is more brown than white, in this case no exposure compensation was required. *Nikon F3, 55mm macro lens*

Opposite:
The Underwater Explorers Society (UNEXSO) on Grand Bahama has popularized a shark feed in which Caribbean reef sharks eat baitfish from the dive master's hands. Here, Ollie Ferguson coaxes a shark in front of my full-frame fish-eye, the perspective distortion making an already big shark seem massive. *Nikonos RS, 13mm lens*

the islands, some for the better—including a more sophisticated fleet of dive boats and improved diver services, a recompression chamber, better hotels, and more diverse topside attractions—and inevitably some for the worse. The larger the population, the greater the probability of diver impact, and the nutrification that comes with increased urbanization is a constant threat to the reefs. Yet these islands remain outstanding attractions for visiting divers, and the photo opportunities here are among the best in the Caribbean.

OTHER AREAS. Other areas of the Caribbean have their own dive attractions and host thousands of divers each year. The fabulous drift diving along Cozumel's walls, the coral atolls of Belize, and the rich marine life of Bonaire are all favorite destinations I visit repeatedly. Each has its own specific beauty and unique characteristics created as a result of the concentration of the 70 forms of hard coral and 430 species of fish indigenous to the Caribbean.

THE BAHAMAS. While geographically situated in the Atlantic, the Bahama Islands are Caribbean in flavor and certainly a viable destination for Caribbean-bound dive enthusiasts. In fact, it was at Freeport on the island of Grand Bahama that destination dive travel really got its start, with the Underwater Explorers Society in 1966. The celebrities of the day, like Lloyd Bridges (whose role in the television series "Sea Hunt" was probably second only to Jacques Cousteau in terms of convincing people to try the sport of scuba diving), Arthur Godfrey, Kim Novak, Buster Crabbe, Prince Rainier of Monaco, Orson Welles, Hugh O'Brien,

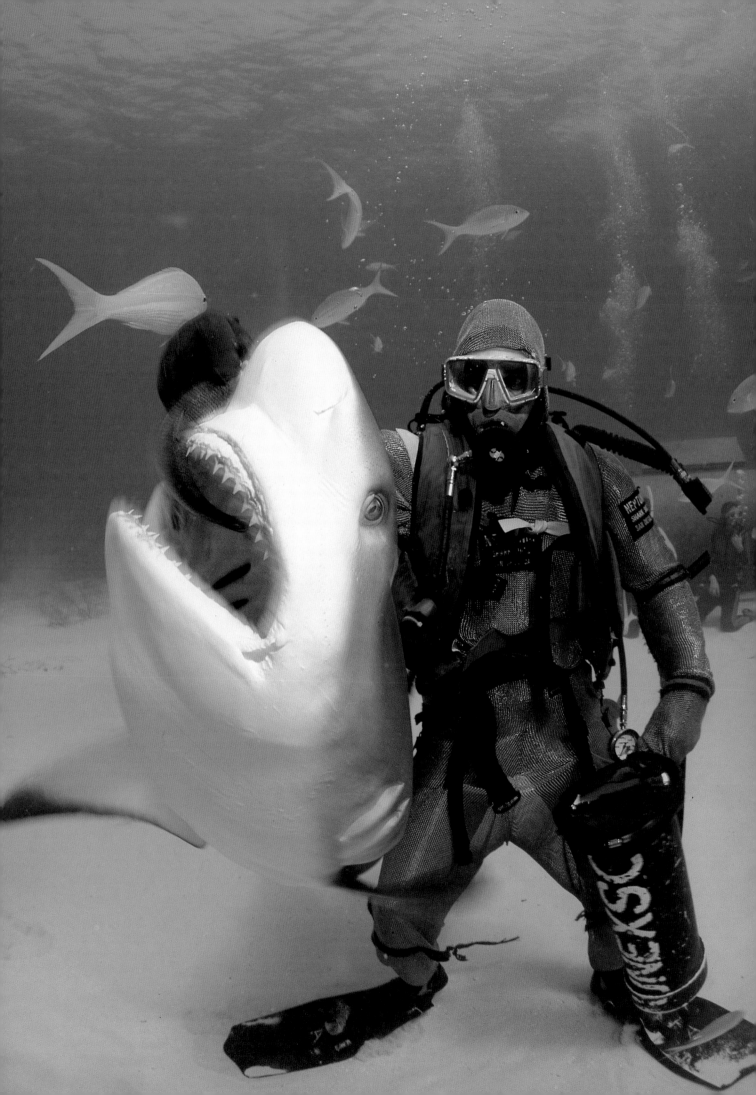

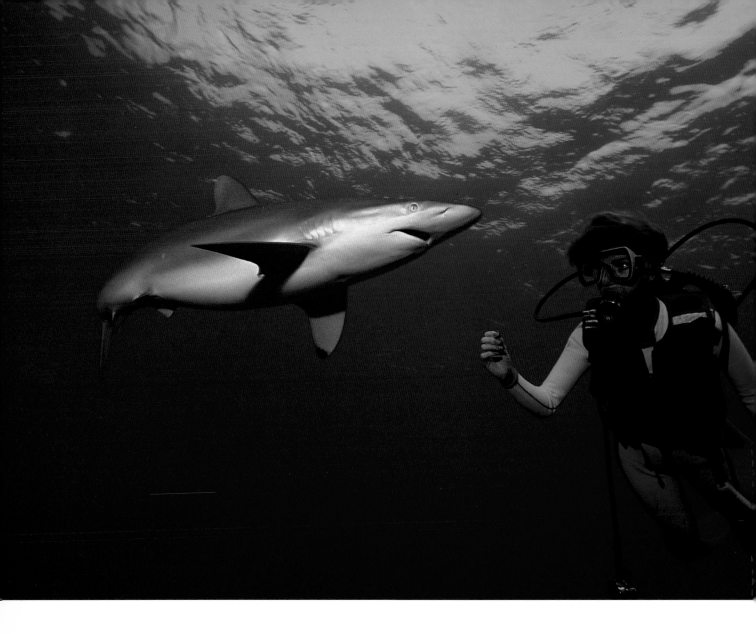

Silky sharks are commonly encountered beneath the Deer Island Buoy off New Providence in the Bahamas. Over several visits to the site I have accumulated plenty of fish portraits, but since the buoy is tethered in 6,000 feet of open ocean, there is no reef background for scale perspective. Hence the addition of the diver in this photograph. *Nikonos V, 15mm lens*

Walter Cronkite, and Marlin Perkins all visited UNEXSO to try out this exciting "new" sport. Among the visitors of the time was a young writer named Peter Benchley, future author of *Jaws*. Perhaps he saw a shark, and perhaps it planted a seed about his future best-selling novel.

Actually, sharks play a major role in Bahamas diving, at special dive attractions where these ultimate predators are enticed into camera range. The first of these, created by the Stella Maris Resort off Long Island in the southern Bahamas, was the famous "Shark Reef" attraction, which baited bull and Caribbean reef sharks. Years later, the UNEXSO dive staff unintentionally started another one off Freeport while trying to establish a more conventional fish-feeding dive for their customers. Called Shark Junction, it is a high-voltage, guaranteed photo opportunity for Caribbean reef sharks. Since seeing a shark in the wild is normally very unusual, and getting one near enough to photograph is exceptionally rare, underwater photographers book this dive months in advance.

Other parts of the Bahamas offer shark encounters as well, most notably off Walker's Cay, where literally hundreds of sharks gather to consume a frozen bait ball dropped by the dive operator along the reef, and off New Providence, where people like shark wrangler Stuart Cove have had long experience in attracting sharks for both dive tourism and Hollywood film production.

The deep water of the Tongue of the Ocean lies just off New Providence, with a healthy shark population in residence, mostly silkies, bull, and Caribbean reef sharks. The silky sharks can be found beneath a deep-water buoy known as the Deer Island Buoy, deployed by the U.S. Navy for submarine sonar research. With the nearest bottom 6,000 feet below and dozens of three- to five-foot sharks hanging about, this is not a good place to lose your grip on either your camera or your diving skills. The bulls and Caribbean reef sharks turn up along the reef near the drop-off, at special locations where dive operators have long baited them in.

The combination of consistent shark activity and high visibility in the diving press unfortunately creates a two-edged sword for a dive destination. On the positive side, it makes for an exciting dive experience and helps people learn more about the grace, beauty, and power of these majestic predators. Thousands of divers will travel there to have their adrenaline pumped a little by being in close proximity to sharks, and if it is a controlled situation with a long record of absolute safety, so much the better. No one wants to get hurt, but to bring home a close-up photo or video of a shark implies we cheated death, making life all the sweeter. On the negative side, fishermen learn about the sharks as well, and a single night of long-lining can wipe out years of loving hand-feeding and classical conditioning.

It happened off Stella Maris, and it happened off New Providence. In both cases the resident population of sharks was initially devastated by this ruthlessly efficient fishing technique. Months later new sharks responded to the feeding, and some of the original sharks that may have been scared off rather than killed also returned. However, it took a while for the shark-feeding activity to build to its former frenetic pace. Local divers found it heartbreaking that the sharks they had seen every day for the past few years were all wiped out by a selfish commercial fisherman looking to make a few bucks selling shark fins for soup.

Of course, the Bahamas has more than just sharks. It is in fact a vast sport diving resource, with walls, shipwrecks, and wonderful shallow reef. I have done scores of dive trips to the Bahamas, both from land-based dive resorts and the live-aboard *Sea Fever*, yet one of my favorite trips is to the shallow banks off Grand Bahama to snorkel with the resident pod of Atlantic spotted dolphins at the White Sand Ridge.

I have had opportunities to photograph dolphins before, but open-water encounters in the wild are quite rare. My most productive photo shoot of trained dolphins was probably from a series of editorial projects I shot for the "Dolphin Experience" at Freeport's UNEXSO, where bottle-nosed dolphins have been trained to swim out to a nearby open ocean coral reef to interact with scuba divers and then swim back to their pens. A similar program has been developed off Roatán (Bay Islands, Honduras), at Anthony's Key Resort, and in both cases the dolphins can easily be enticed within camera range, that is, within three to five feet using a 15mm wide-angle lens.

At White Sand Ridge, the pod of spotted dolphins comes to root in the sand for small crustaceans, and maybe to play with the pod of snorkelers who can almost always be found there. The latter come to observe or photograph these beautiful marine mammals, and when the weather is good, there may be two to six live-aboards along the bank. The best action happens while on snorkel, for scuba is too cumbersome and slow. The dolphins will dart about the snorkelers, and those with sufficient water skills and endurance can have a very significant and photographically meaningful close encounter with *Stenella plagiodon*.

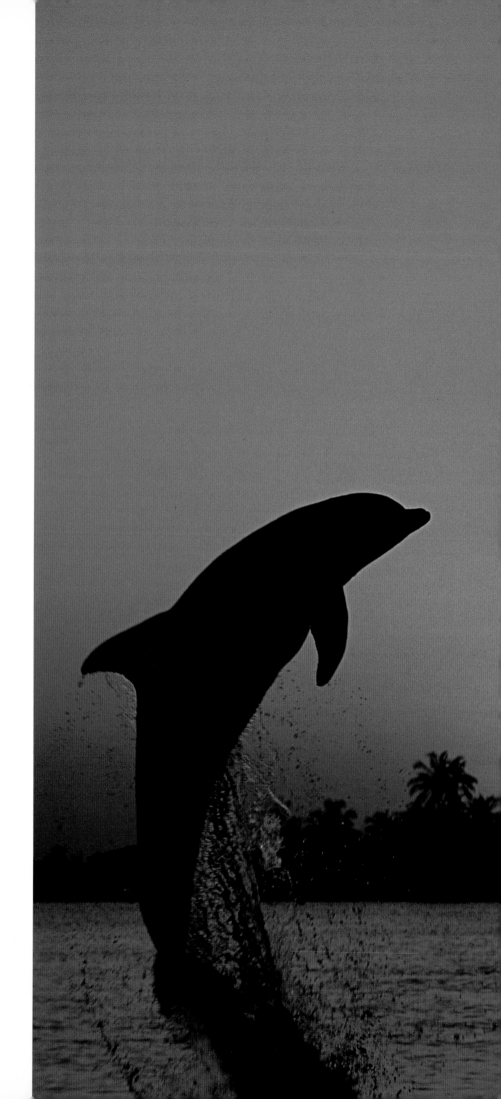

One of the joys of underwater photography is the beauty of the places we visit and the glory of the coral reef's inhabitants. These bottle-nosed dolphins at Anthony's Key Resort in Roatán, Bay Islands, Honduras, participate in an open ocean dive encounter, making for productive photo opportunities both underwater and topside. *Nikon F4, 28–85mm zoom lens*

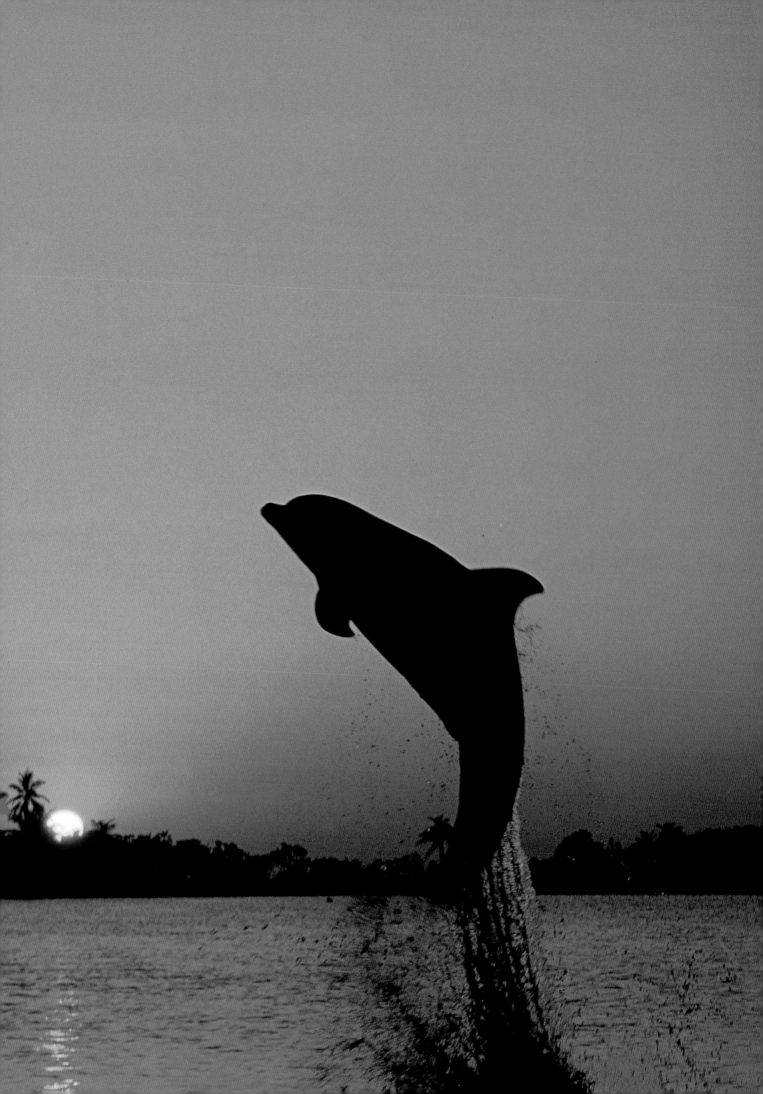

The Red Sea

A traditional question asked of underwater photojournalists is, "Of all the world, where is your favorite place to dive?" While I haven't dived everywhere yet, I have been around, and my traditional answer remains: the Red Sea. This was my first exotic dive destination, and it is the one I have returned to most often since.

Stretching some 1,300 miles from Bab al-Mandab at the southern end to the Sinai Peninsula and the Gulfs of Suez and Aqaba in the north, the Red Sea is only 190 miles at its widest point. It was formed over 25 million years ago as part of the Great Rift Valley, created by the geological forces that parted the continents of Africa and Asia. The continental shelves drop off precipitously just a few feet to a few hundred yards from shore. While the maximum depth of the Red Sea exceeds 7,000 feet, it is the shallow reef near the top of these walls, where the light is strongest and life most prolific, that holds the most interest for divers and underwater photographers. From nearly the surface to a depth of about 150 feet, the Red Sea is a wonderland of color and life.

No one knows with certainty how the Red Sea got its name. Perhaps it is from the rose and amber sunsets as they reflect off the sand and rock ridges lining the shore that color the sea and lend the name. Perhaps it is from the red soft corals and crimson coral grouper that decorate the reef, but since this body of water was known as the Red Sea long before Moses was supposed to have parted it, it is unlikely that the beauty of its coral reef was known to man when it was named. Another theory holds that the name derives from one of the algae, *Trichodesmitum erythraeum*, which can turn the water a reddish brown when it dies.

Regardless of the origin of its name, this sea is of a brilliant crystalline blue, unaffected by freshwater runoff, as would be expected of a body of water bordered by desert. The high temperature of the region coupled with the lack of rainfall also conspires to increase evaporation. Since freshwater rivers do not replenish the sea —the flow of seawater comes from the Indian Ocean—the Red Sea boasts the highest salinity (41 parts per thousand) of any major saltwater body. A casual glance beneath this sea with a face mask confirms that marine life thrives in this environment. On the other hand, divers will have to add a bit more weight to their belts to counteract the increased buoyancy.

I first visited the Red Sea in 1980. This was my first live-aboard dive adventure as tour leader, and I felt nervous to be responsible for fifteen other divers while traveling through such a volatile part of the world. As soon as we decided to travel to the Red Sea and committed our deposits, it seemed that the newspapers were full of stories of unrest. Israelis and Palestinians were fighting along the Gaza Strip, snipers were disrupting Cairo, and in general the prevalent antagonism did not seem a welcome beacon for American tourists. I've since led three more photo tours to the region and discovered that political unrest is part of the local conditions.

This is not to say that one should not pay attention to the tone of regional politics when planning a dive trip to the Red Sea, but since most dive excursions start from Eilat, Sharm el-Sheikh, or Hurghada, all tourist areas far removed from the antagonisms concentrated around Tel Aviv, Jerusalem, or Cairo, problems are unlikely.

Sharm el-Sheikh especially has evolved into a major resort center, with thousands of hotel rooms and dozens of dive operators. Sixty-five live-aboards of varying degrees of sophistication already operate out of Sharm and Hurghada, with

more under construction. These are fun-in-the-sun destinations for much of Europe, and scuba diving is a mainstream activity for visitors.

In fact, the burgeoning popularity of the Sinai Peninsula for scuba diving has created problems on some of the reefs. During my first visit to the region, Sharm el-Sheikh was sparsely developed, with only a few day dive boats and two live-aboards. We would rarely see another boat and the reefs were absolutely pristine. These days, at the most popular sites, like Ras Muhammad, the day dive boats must make a reservation to arrange access, and dozens of boats might raft off to a single vessel tied up to the mooring buoy.

Surprisingly, the reefs are still incredibly beautiful. Perhaps it is because the walls are so vertical it is hard for divers to stand on the coral. Or perhaps because the water is still so rich and free of pollution, the reef is able to heal and replenish. Whatever the reason, the Red Sea remains a remarkable place for the underwater photographer, and the photo opportunities from my most recent tour actually exceeded those from my first.

Like most tours, ours began at a dive site known as the Temple, chosen because of its shallow depth and protected anchorage. This allowed our rusty divers to brush up on their water skills in a safe environment, and all of us had the opportunity to trim our buoyancy from the increased salinity of the Red Sea. While the area shows the obvious effects of diver impact and misplaced anchors to those who have visited in years past, new visitors will only see beautiful soft corals, immense gorgonians, and extremely friendly marine life. The lionfish will swim right to the diver's mask and the resident lemon butterfly fish are completely unafraid.

The rich, shallow reef adorned with soft coral and *Anthias* is a Red Sea trademark. The late afternoon light provided the sunburst in this photo, and the diver with flashlight adds further dimension. *Nikonos V, 15mm lens*

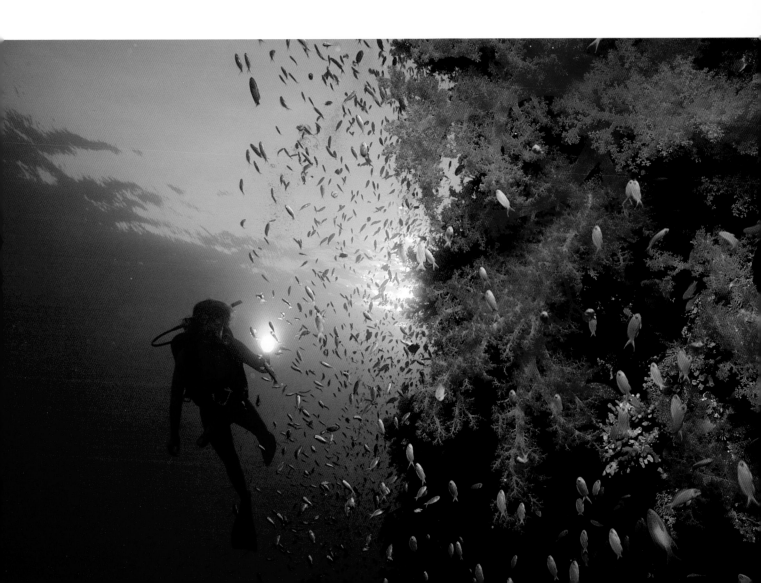

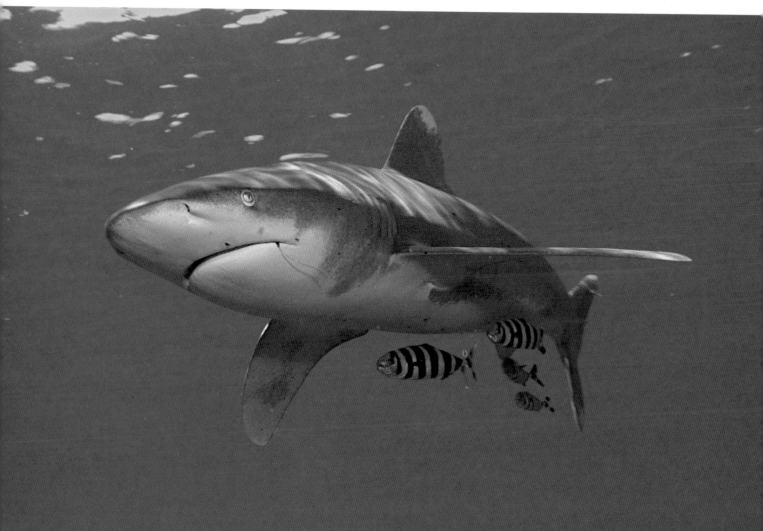

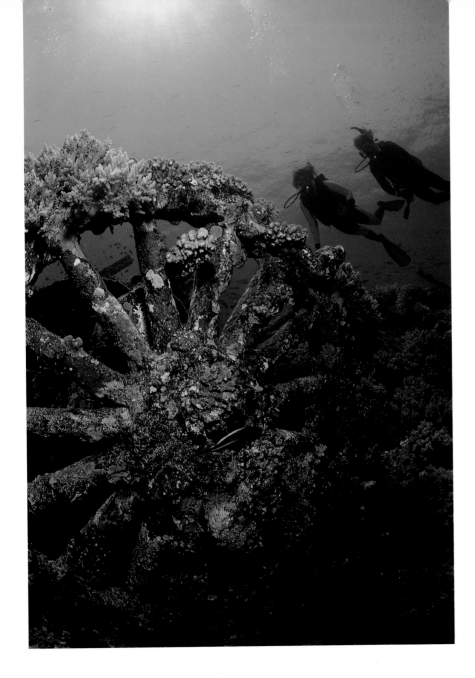

It's as if they know they are in a marine preserve and the presence of divers is a fact of life. This was one of the most productive night-dive locations of our expedition.

Other areas in close proximity to Sharm el-Sheikh were equally resplendent, despite their frequent visitation. At Fisherman's Bank we found coral caves filled with opal sweepers and an exquisite coral garden with pristine hard corals in only twenty feet of water. *Anthias* swarmed the reef and bizarre tropicals like the crocodile fish enthralled our fish photographers. At Ras um Sidd I found a large coral pinnacle cloaked in soft coral and dotted with lionfish that cried out for the perspective of the wide-angle lens. And at Anemone City the sight of the red mantle on dozens of anemone colonies closing around the brilliant saffron two-band anemonefish in the late afternoon light remains one of the more inspirational sights in the sea.

During the course of a ten-day cruise we saw plenty of other amazing underwater attractions in the Red Sea, many far removed from the range of the day dive boats and consequently rarely visited. At Little Brother Island our group encountered a *Mola mola* at a cleaning station and then had the opportunity to snorkel with an oceanic white-tipped shark on location to scavenge scraps of fish thrown

Left:
Along the wreck of the *Aida* II off Big Brother Island in the Red Sea are a number of artifacts that make excellent wide-angle subjects. In this case, the spoked wheels of some giant deck machinery provide a foreground for a diver silhouette.

Opposite above:
The contrast between the bright orange of the *Anthias* and the lime green of the background lettuce coral in the Red Sea gives this composition its interest. *Nikon F3, 55mm macro lens*

Opposite below:
While anchored off Little Brother Island in the Red Sea we found an oceanic white-tipped shark swimming beneath the boat. The fact that an Egyptian fishing boat was cleaning its catch just up current contributed to the bold presence of the shark, which tolerated a near approach. In fact, it seemed rather interested in the sound my strobe made as it recycled, darting in and out of frame very quickly. *Nikonos V, 15mm lens*

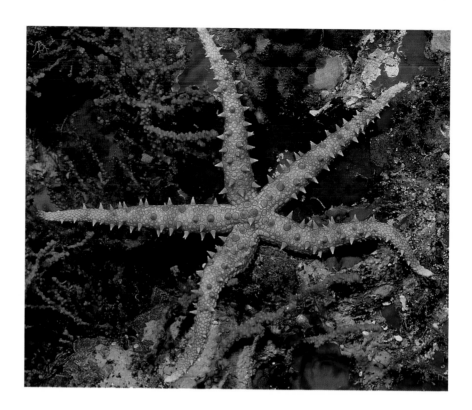

While the wide-angle scenery of the Red Sea is most compelling, there are still plenty of small subjects, such as this starfish, to be found along the coral reef. *Nikonos RS, 50mm lens*

overboard by a nearby Egyptian fishing boat. At Big Brother the hot dive was to a World War II vintage wreck lying along the sloping wall from twenty-five feet to probably in excess of two hundred feet, or certainly deeper than anyone in our group felt comfortable diving. At Daedelus Reef we found a huge hard-coral colony rising nearly forty feet and an incredible carpet of commingled anemones giving the appearance of one giant colony twenty feet long and eight feet wide. Yet it was revisiting Ras Muhammad that restored my confidence in the Red Sea as a world-class dive destination.

I'll never forget my first visit to these twin pinnacles located at the very tip of the Sinai Peninsula. There, in water clarity in excess of 150 feet, I encountered my first hammerhead shark and saw humphead wrasse that must have been five feet long. Swept by daily currents, the outer walls of the pinnacles were decorated by lush concentrates of soft corals and gorgonians. Clownfish and coral grouper seemed to inhabit all the nooks and crannies, and moray eels, crocodile fish, and blue spotted stingrays lived amid the coral rubble separating the two towers. In the blue water offshore schooled hundreds of barracuda, and massive clouds of batfish and jack swarmed the nutrient-enriched water.

Fourteen years later, the current was running and the soft corals had extended their polyps for feeding in a riot of color and texture. The visibility was still in excess of 150 feet, and the marine life was, if anything, better. The fish were easier to approach photographically, and the schooling jacks, batfish, and barracuda were possibly more abundant. The wreck of the *Yolanda* had been swept over the edge of the wall by a huge storm and disappeared, and the saddle between the two islands showed signs of anchor damage that had occurred before the present mooring buoys were installed, but overall it remained an incredibly rewarding dive. If Molasses Reef in Key Largo is the world's most oft-visited reef, Ras Muhammad must run a close second. That it has remained this spectacular despite the diver pressure and urbanization of Sharm el-Sheikh is part of the wonder that is the Red Sea.

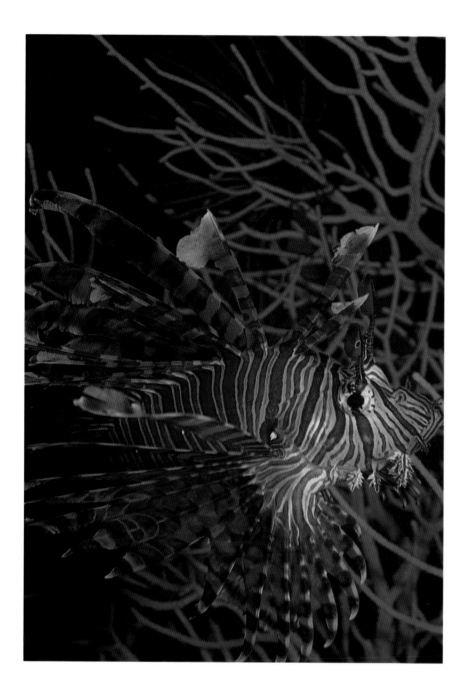

The Pacific

The Pacific Ocean is a vast resource covering nearly half our planet. Some of it is tropical, some temperate, and some absolutely frigid, but within its boundaries is contained a lifetime of dive adventure. My first open water dive was in the Pacific, from a sandy shore off Laguna Beach, California, in 20-foot visibility and considerable surge. I made it as far as a few kelp-bedraggled rocks in thirty feet of water before my air-pressure gauge told me it was time to return to shore, but I still remember the thrill of simply being able to breathe underwater and to have the mobility to move along with the fish.

Like a first kiss, there can only be one first open water dive, both memorable for the novelty, if nothing else. Fortunately, the world of Pacific diving is far better than that first turbid glimpse, confirmed first during my sojourn in Hawaii and then with later trips to such mythic dive destinations as Australia, Truk Island,

The lionfish, photographed here in Australia, is generally a fairly easy subject to approach, relying on its poisonous dorsal spines to protect it rather than rapid retreat. This allows the photographer to experiment with different compositions and exposure brackets. *Nikon F3, 60mm macro lens*

45

Right:
The potato cod is a large, friendly resident of the Cod Hole along Australia's Great Barrier Reef. Once threatened with extinction by spearfishing, it is now protected and thriving. *Nikonos V, 15mm lens*

Opposite above left:
The Great Barrier Reef is rich with nutrients that cause all manner of hard and soft corals to flourish. *Nikonos III, 15mm lens*

Opposite above right:
The Australian sea lions make a beautifully compelling underwater subject, but somehow it is hard to forget that they are the primary prey of the great white shark. Floundering around the shallows, feeling like a particularly slow and clumsy sea lion, makes photographing them somewhat nerve-racking. *Nikonos V, 15mm lens*

Opposite below:
The profusion of soft corals along this Coral Sea "bommie"—the Australian term for an isolated coral head—illustrates the photo potential of this destination, in Australia. *Nikonos V, 15mm lens*

Fiji, Palau, New Zealand, Vanuatu, the Solomon Islands, Cocos Island, and the Galápagos Islands. The diversity experienced within such an itinerary is greater than that presented by traveling the Caribbean. While travel time and expenses are also greater for an underwater photographer based in North America, the photo opportunities are outstanding.

AUSTRALIA. Australia exemplifies this diversity. Here we find a wealth of dive options along the shores of this island continent, both tropical and subtropical. My first exposure to the diving "down under" was with a trip to the Great Barrier Reef and the Coral Sea. I quickly discovered, however, that not all Australia dive attractions are equal. In the Whitsunday Islands, I experienced very marginal visibility (rarely greater than 30 feet), and even though there were interesting things to photograph, the turbidity made quality photos difficult. Then, at Number Ten Ribbon Reef my confidence and admiration were restored as I had an opportunity to photograph several 150-pound potato cod at the famed Cod Hole and document the lush marine life at the nearby Pixie Bommie. This was the underwater Australia I had imagined.

Australian photographers Ron and Valerie Taylor discovered the Cod Hole in the mid-1970s and quickly became emotionally attached to these docile, trusting behemoths. In a country where spear fishing was an accepted sport at the time, the potato cod made ridiculously easy prey for a selfish few who were quickly decimating the resident population. Appalled, Valerie lobbied hard and long to get public support for protection for the potato cod. Now the Cod Hole is a million-dollar dive attraction for operators out of Cairns, with dive masters hand-feeding the fish daily and the cod growing ever fatter and happier.

The Great Barrier Reef stretches over 1,250 miles along the north coast of Queensland, not as a single reef but as a patchwork of coral canyons and pinnacles. The rain forests of north Queensland and Cape York Peninsula nourish the broad lagoon separating the outer reefs and the coast, and it is this nutrient-rich broth that sustains the incredible diversity of life. The downside to density of marine life along the Great Barrier Reef is decreased visibility, but so long as the outer reefs are the dive destination of choice, clarity is reasonable.

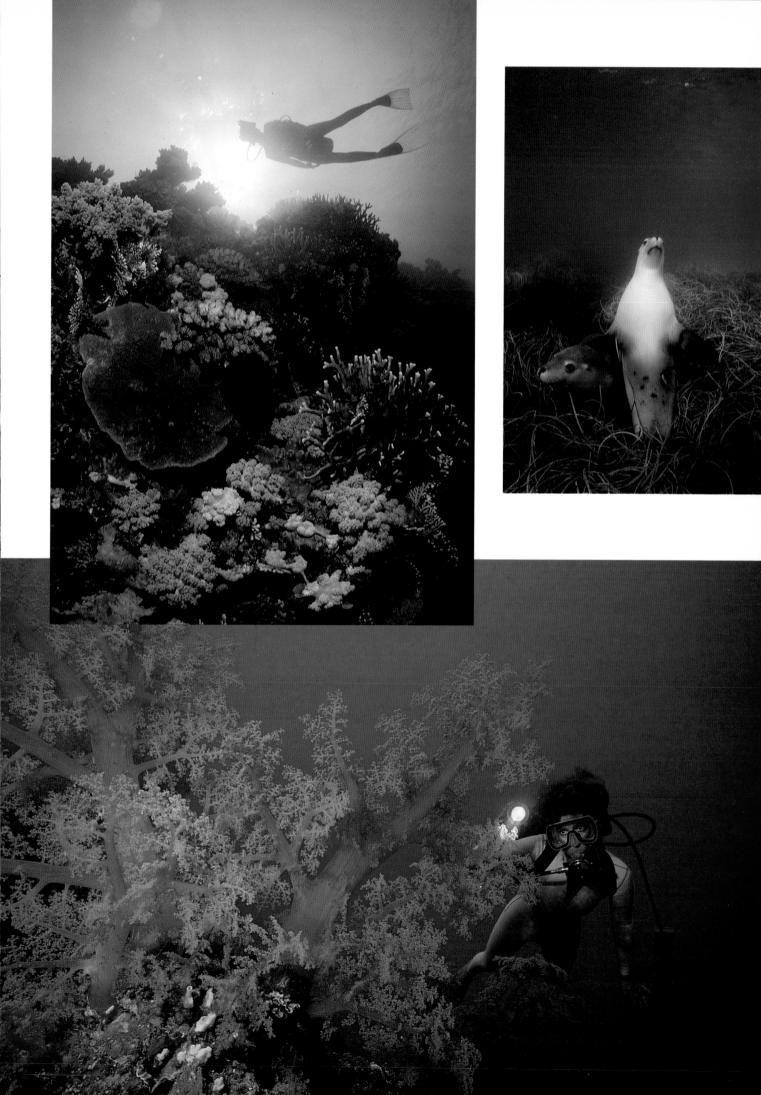

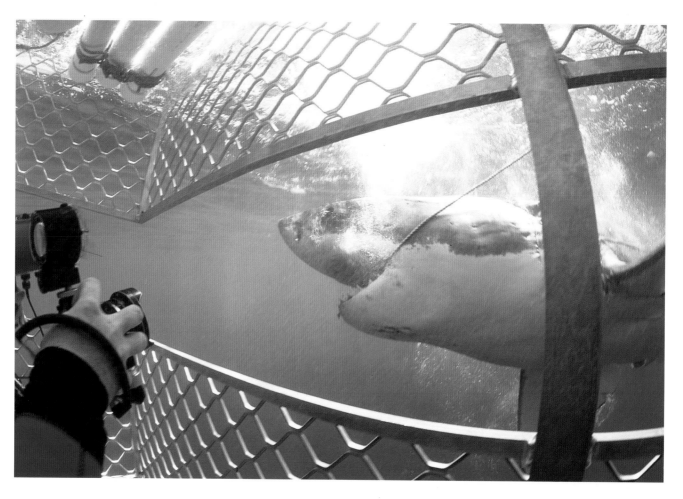

Above:
Most shark photos taken from within a cage purposely exclude the bars of the cage, but in this case I wanted to show the proximity of the shark to the diver. The 170-degree coverage of the 13mm lens allowed me to capture the view from inside to give a better sense of the adventure from the diver's perspective. *Nikonos RS, 13mm lens*

Right:
The great white shark can rarely be mistaken for any other fish in the sea. With its pointed snout, white belly, and thick, muscular body, the white shark is the ultimate predator. *Nikonos V, 15mm lens*

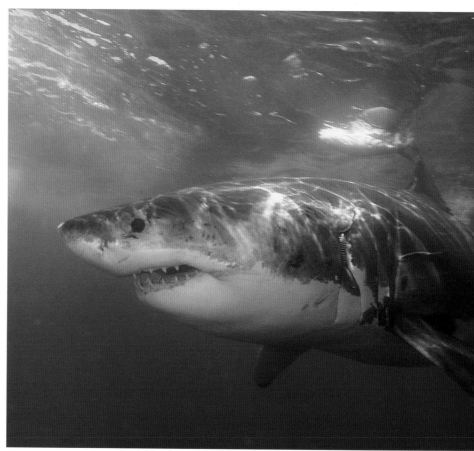

I. PHOTO OPPORTUNITIES FOR THE DIVE TRAVELER

For those seeking absolutely stunning water clarity, two hundred miles out to sea from the outer parts of the Barrier Reef lies the Coral Sea, noted for its shark populations and true 200-foot visibility. The Coral Sea offers great diving, although with less concentration of coral growth and variety of marine life typical of the Barrier Reef. Faced with choosing between a wealth of life to photograph or super-clear water, I usually pick the former. That gives me the option of using close-up and macro techniques to minimize backscatter, even if the wide-angle potential is marginal. The combination of abundant marine life and stunning clarity can also be found in Australia, so long as you (or your charter boat captain) know where to look.

The most famous marine creature in Australia is the great white shark, but it is not likely to be found along the Barrier Reef. It prefers the cooler waters of South Australia, where its favorite prey, the Australian sea lion, resides. This was a photo opportunity I had coveted for many years and finally arranged, perhaps too late, in March 1994. It was just my luck that this was the worst season ever when it came to attracting great white sharks to the cages for underwater photography.

Any wildlife photography involves risk. With great white sharks, the risk of being eaten by the subject, although it is always in the back of one's mind, is usually overshadowed by such circumstances as bad weather, boat problems, or camera malfunctions that may interfere with bringing home the shot. The biggest problem is that they simply might not show up, and if they do appear, the second biggest problem is getting them close enough for a photo.

Those who arrange white shark expeditions in South Australia have had long and successful experience in attracting this apex predator and getting it close enough to the shark cages so that still photographers and video buffs can get their shots. In years past that meant running a chum line (in Australia they call it "berley") baited with large chunks of horsemeat tied off to lines. In his book *Light in the Sea*, David Doubilet recounted his experience in 1980 with a sixteen-foot white shark attracted in this manner: "I leaned through the cage's camera port. The shark approached. I backed into the cage, but my tank caught on the camera port's upper bar. I was trapped. I pushed the shark away with my camera housing, wiggled like a crazed badger, and managed to pull my head inside. On the next pass, the shark bit tentatively at the cage's float, sank a foot, and looked at me. . . . It opened its jaws and banged its snout against the bars. I looked down its throat as its bottom teeth scraped against the dome of my camera housing."

To me, having the serrated teeth of a sixteen-foot shark banging at the bars of my shark cage seems a wonderful way to spend an afternoon, and this was the kind of action I went to Australia to find. But in 1994 the Australian government decided that it was not a good idea to continue to condition white sharks to eat mammal meat, being too close in consistency to divers. The fact that the white shark's natural prey, the sea lion, is mammal meat seems to have escaped the government's notice. This left the tour operators the option of using tuna as their primary bait, since it is readily available from the tuna farms around Port Lincoln.

For the four groups that preceded ours during the 1994 season that meant no great white shark encounters at all. Maybe it was just bad luck, or maybe the change in the bait made a difference, or maybe there are just fewer white sharks out there. For our group, blessed by the long experience and hard work of world-class photographers and shark experts Ron and Valerie Taylor, it meant chumming for two solid days at Dangerous Reef before our first shark appeared. Finally I was in the water, in a shark cage, with a great white shark. At the time, I wrote in my trip

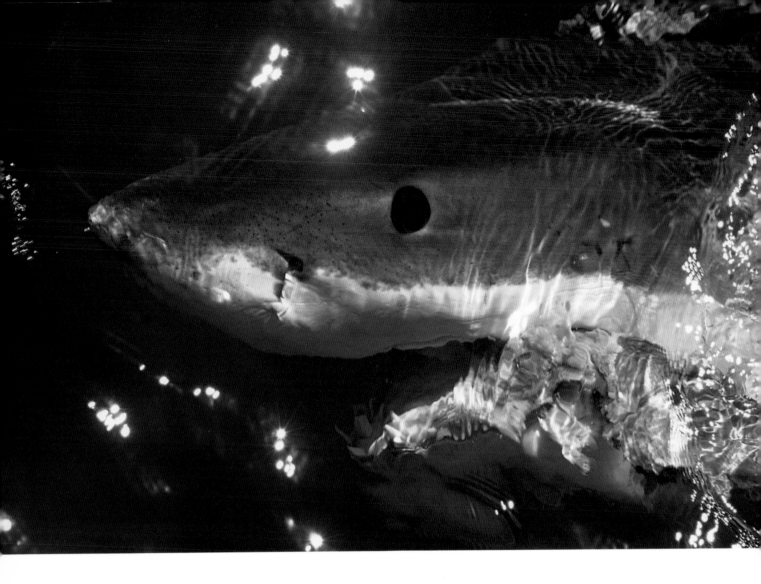

While most divers travel to South Australia to see the great white shark from the safety of a shark cage underwater, the passes they make near the boat are equally impressive from above. *Nikon N90, 28–85mm zoom lens*

log: "For the first time I saw a great white shark in the wild, and my first impression was that this is a very *big* animal. Ron Taylor reckoned it was a fourteen-footer, and having been around a lot of six-foot sharks, I'd have no problem agreeing this was more than twice as big as anything I'd seen in the Caribbean. Beyond the size, this is a distinctive shark with a pointed snout (they call them white pointers in Australia) and a cream-colored underside. The eyes are cold and featureless. Every account I've ever read of white shark encounters mentions the eyes, usually in the context of lacking sympathy. Even though this one was not aggressive toward the cages or the bait, it was clear that this was not an animal with whom to trifle."

However, I was looking for an "in my face" (preferably in my lens) encounter with an aggressive shark. I returned to South Neptune Island in 1995 to try again, this time with shark expert Ian Gordon, the curator of the Oceanworld Aquarium in Manley, Australia, and one of the scientific advisors from the Cousteau great white shark expedition.

On the fourth day out, the distinctive triangular snout of the white pointer broke the surface. As we anxiously donned our suits to enter the cages, we saw something obviously amiss with this shark. Her posture in the water was too low at the tail, and when she raised out of the water to hit a bait, we saw she was horribly disfigured. This shark had recently been caught in a drift net, and the mesh had severely cut her along the gill slits and mouth. Once more the white shark had suffered at the hands of humans.

This shark stayed with us all day, coming close to the cage, peering inside

with an eye that I now saw carried more personality than I had previously perceived in the distant passes. She came close to the swim step, allowing close-up topside photos, and actually ate a piece of tuna from the hand of one of the crew inside the cage. All in all, it was a terrific encounter, except that when I looked at the processed film I felt more pity than awe. These were not images that would communicate the terror of an in-water encounter with one of the planet's most efficient predators. I guess I'll be back again next year, still looking for my "ultimate" photo opportunity of a cooperative but aggressive great white shark in clear water.

TRUK LAGOON. One of the most unusual destinations in the tropical Pacific is found off the island of Truk (now known as Chuuk). Fifty years ago in Operation Hailstorm, American bombers sank a significant portion of the Japanese Imperial Fourth Fleet at this spot in one of the pivotal engagements of World War II.

The shipwrecks of Truk Lagoon, fascinating artifacts from World War II's Operation Hailstorm, have become rich artificial reefs, here harboring baitfish, as well. *Nikon F3, 16mm lens*

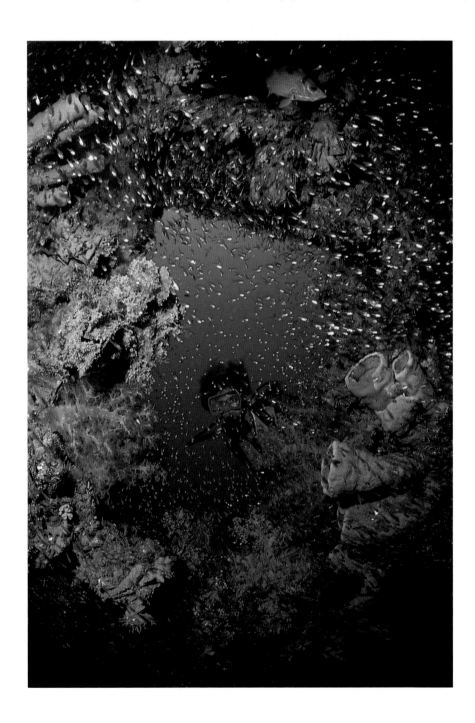

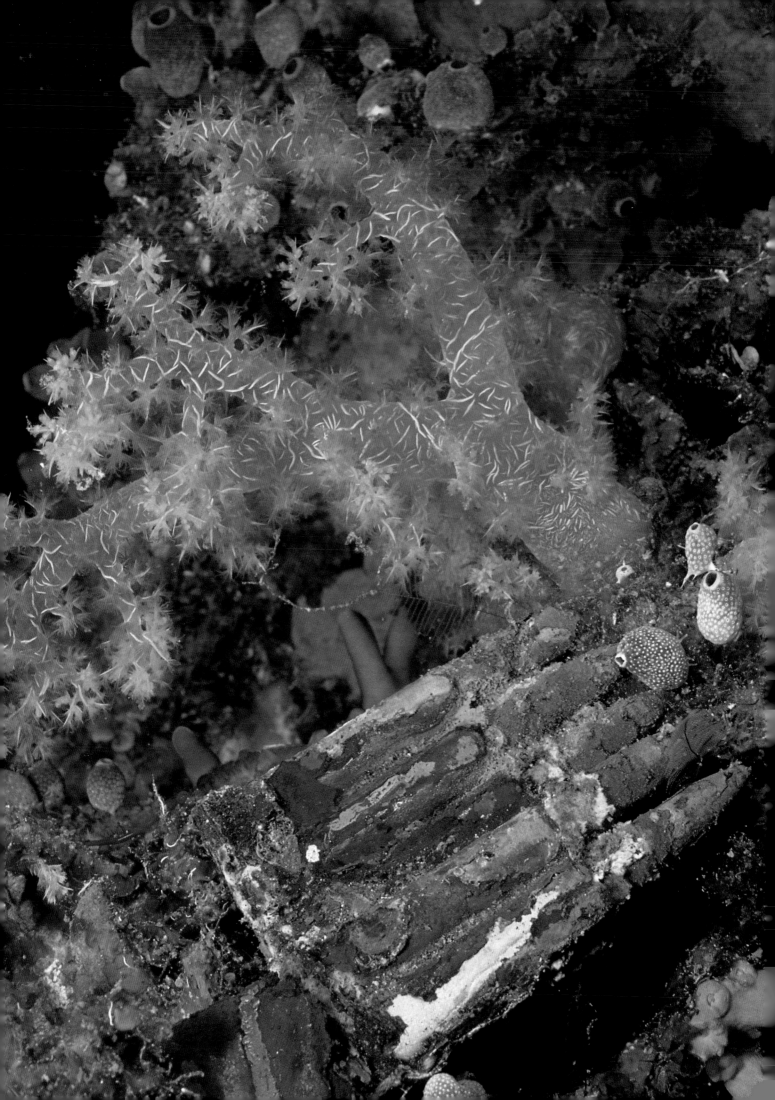

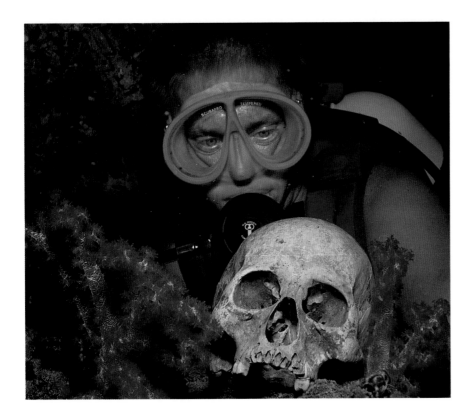

Truk Lagoon is thirty-eight miles across and offers depths of up to three hundred feet. With just five entry and exit points along a 125-mile fringing reef that could be guarded by mines and gun emplacements on shore, Truk was considered the "Pacific Gibraltar" by the Japanese. Just twelve days before Operation Hailstorm attacked Truk Lagoon on February 18, 1944, two U.S. Marine reconnaissance aircraft flying at 20,000 feet recorded the *Musahi*, a 863-foot battleship that was the crown jewel of the Japanese fleet, as well as two aircraft carriers, twenty destroyers, ten cruisers, twelve submarines, and more than fifty surface vessels ranging from cargo ships to tugs, all at anchor within the lagoon.

The aerial reconnaissance suggested to Fleet Commander Admiral Koga that the Fourth Fleet might come under attack, and he ordered many of the ships away. However, a significant portion of the fleet remained conveniently at anchor while the American bombers and fighters strafed and dropped explosives among the ships and airstrips. According to *The Ghost Fleet of Truk Lagoon* by William Stewart, published in 1985, Radio Tokyo reported on February 18, "A powerful American task force advanced to our Caroline Islands Thursday morning and repeatedly attacked our important strategic base, Truk, with a great number of ship-based planes. The enemy is constantly repeating powerfully persistent raids with several hundred fighters and bombers, attacking us intermittently. The war situation has increased with unprecedented seriousness—nay, furiousness."

"Furious" was a good description for the attack that sank more than fifty warships in Truk Lagoon, not all of which have yet been found. Of the thirty-five that have been charted and explored, some two dozen are dived regularly by the liveaboard dive boats and shore-based dive shops servicing Truk Lagoon.

In the five decades that these ships have resided on the bottom, many have been transformed into lush artificial reefs with railings cloaked by soft corals and decks festooned with clownfish and anemone. Clouds of opal sweepers swirl be-

Above:
Most of the remains of the Japanese sailors who perished in Truk Lagoon during Operation Hailstorm have been removed from the wrecks and buried with honor. However, some are still found among the less accessible portions of the ships and serve as grisly reminders of the horrors of war. *Nikonos V, 15mm lens*

Opposite:
The contrast between the weapons of war and the beauty of the coral reef is poignantly demonstrated at Truk Lagoon. *Nikonos RS, 50mm lens*

53

neath the shade of deck guns, and all manner of exotic reef tropicals flit among the bullets and bottles that still litter these decks.

Depending on the depth and prevailing currents, some of the wrecks, like the *Nippo Maru*, have acquired little incrustation. In 140 feet of water, this 353-foot cargo vessel, a Japanese medium tank and three field artillery cannon lashed to her decks, sits upright with a 30-degree list to port. Others, like the 437-foot *Fujikowa Maru*, lie in shallower water and provide a prolific substrata for the growth of coral and sponge, which in turn attract prodigious concentrations of marine life. A family of lionfish are commonly found inhabiting the stern decks, and carpets of anemone dot the superstructure. Bizarre tropicals like the clown triggerfish provide constant challenges for marine life photographers, and explorers more intrigued by the artifacts of war will find holds filled with Zero fighter fuselages and propellers, machine guns, bullets, uniforms, and even sake bottles.

The visibility in Truk Lagoon varies from day to day, season to season, and between different parts of the lagoon, but rarely is it exceptional. Fifty feet is a reasonable expectation on most wrecks most days, but I have seen it as bad as twenty and as good as one hundred feet. This makes it difficult for wide-angle, for the wrecks are very large, and in marginal visibility all that can really be captured are vignettes of the wreckage. Some of the most effective superwide perspectives will probably be in available light, thereby eliminating the possibility of backscatter. But even when the clarity is poor, the wrecks are so rich in both marine life and fascinating artifacts that there are ample subjects for standard lens, close-up, and macro shooters.

The wreck with the greatest photographic potential, at least in terms of soft-coral incrustation and sheer quantity of marine life, is probably the *Shinkoku Maru*, a 500-foot tanker now sitting completely upright in 110 feet of water. Unfortunately, it is an unusual day that finds this wreck bathed by clear water. The *Sankisan Maru*, on the other hand, offers consistently good wide-angle potential along the forward mast and deck area, which are now overgrown with soft corals and swirling baitfish.

Truk Lagoon is a "must do" for any serious underwater photographer. The erroneous perception that Truk is just for "wreck" divers is disproved by the rich coral growth and ample marine life that has come to inhabit these artificial reefs. The other misconception is that all the wrecks are deep. While it is true that some, like the *Seiko Maru*, rest in 160 feet of water, others come to within a few feet of the surface. In any case, these are big ships, and if they happen to sit upright they will lie within sport dive limits. In the case of the *Seiko Maru*, it is 30 feet to the top of the forward mast, 95 feet to the top of the bridge, and 120 feet to the deck. The hazard lies in planning a 120-foot dive to the deck and then getting seduced to going just a little deeper and staying just a little longer to photograph the propellers or some fascinating artifact strewn along the ocean floor. Logically, any deep exploration will be done as the first dive of the day, with repetitive dives being restricted to the more shallow shipwrecks or sunken airplanes. Still, diving Truk requires a conservative dive computer, the willpower to resist the temptation of staying too long at depth, and a fair dose of common sense.

Truk Lagoon is but one of many dive destinations within Micronesia, a marine wilderness of 2,203 islands and 3 million square miles of ocean. There are actually five national entities within Micronesia: the Marshall Islands, the Federated States of Micronesia, the Northern Mariana Islands, the Republic of Belau (Palau), and the U.S. Territory of Guam. After the American victory in World War II the re-

gion was declared a U.S. Trust Territory, and an infrastructure of roads, electrical service, and, perhaps most important for traveling divers, airports was created. Most of these island nations have since become independent, and one of their most precious assets is their legacy of air access via Honolulu, Guam, and Tokyo. This has become a major element of their marketability to visiting divers.

PALAU. The shallow reefs and drop-offs of Palau are included on the top-ten list of most experienced divers. I first "discovered" Palau vicariously through the early photographs of Douglas Faulkner. One of the most proficient practitioners of the Rolleimarin system, Faulkner saw the reefs of Palau as 2¼-by-2¼-inch visions of life and color. *Tridacna* clams, clownfish, soft corals, and even the rare deep-dwelling chambered nautilus became tiny vignettes of the Palau story as told through Faulkner's lens—a story I decided I must experience myself.

When I visited Palau for the first time in 1981 I was leading another photo tour. We made our base at a hotel on the main island and took daily two-tank dives along the majestic mushroom-shaped Rock Islands to the remarkable dive sites along the barrier reef that encircles this 93-mile-long lagoon.

Some of the dive operations were primitive even in those days, and customer service was not necessarily the top priority. On one dive, our group was dropped at one end of Ulong Channel to drift dive along the brisk tidal current. This was the

In order to photograph the stalactites in Palau's famed Chandelier Cave, I used a zoom lens at the wide-angle setting in my underwater housing to compose the shot and then used the TTL setting on my submersible strobe for the lighting. An assistant helped aim the strobe and directed a flashlight, which served to facilitate the autofocus. *Nikon N90, Seacam housing, 28–85mm zoom lens*

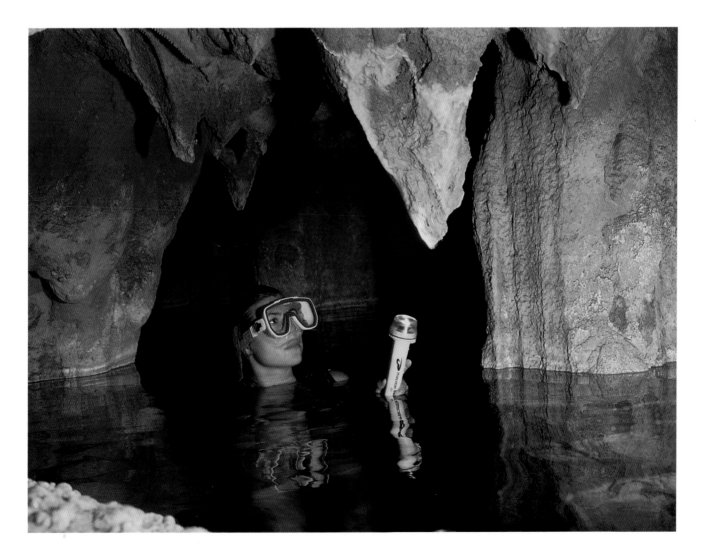

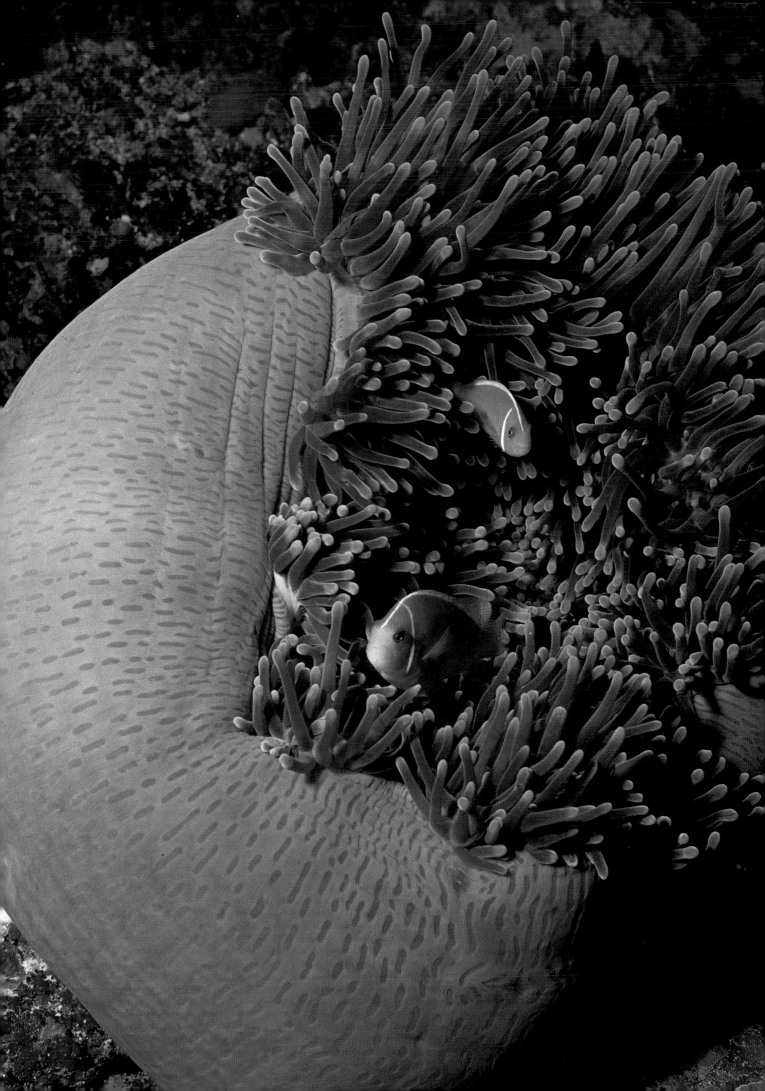

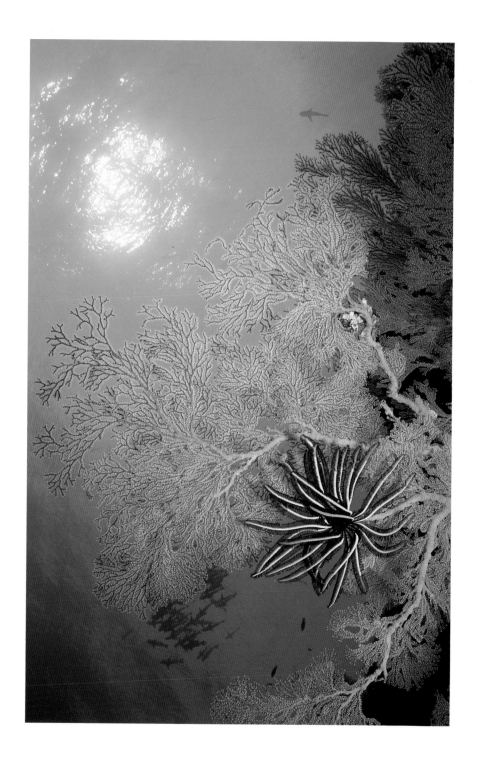

first time many of us had been in strong current, and the channel proved a high-velocity kaleidoscope of color and texture as we were swept from coral head to coral head. As the current abated, we all popped to the surface at the far end, trading stories of wonder at what we had seen. The dive master burst our collective bubble by shouting, "Hey you motherf—— tourists, get back on this boat now!"

Fortunately, the dive operations in Palau, and in fact throughout the Pacific, have become much more sophisticated and responsive to the needs of the visiting diver over the past decade. In addition to six land-based operations in Palau, there are also three live-aboards. My last trips have been aboard the *Palau Aggressor* and most recently aboard Peter Hughes's luxurious *Sun Dancer*, both of which have provided superior access to the outer reefs as well as exceptionally beautiful and

Left:
Palau is famed for its occasional swift currents and exhilarating drift dives. These are ideal conditions for the profusion of filter feeders along the wall like soft coral, gorgonians, and crinoids. *Nikonos V, 15mm lens*

Opposite:
The clownfish of Palau are endlessly fascinating. I especially like to catch them in the afternoon light as the anemone begins to roll up its colorful mantle for the night. *Nikonos RS, 28mm lens*

57

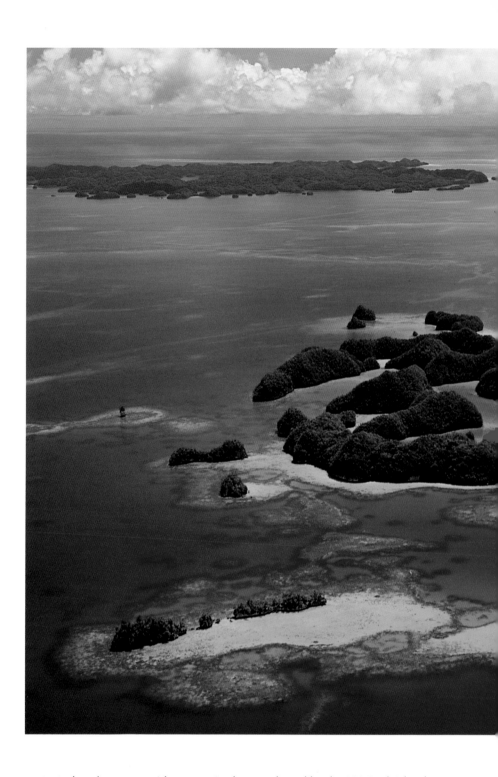

This photograph of the Rock Islands, taken from an airplane, demonstrates Palau's terrestrial beauty. *Nikon F4, 28–85mm zoom lens*

protected anchorages amid a turquoise lagoon dotted by the 328 Rock Islands.

Palau is noted for unusual dive sites like Chandelier Cave, a cave system of six distinct chambers of crystalline fresh water and dramatic stalactites, and Jellyfish Lake, where within a small, landlocked lake, more than one hundred thousand *Mastigias* jellyfish travel in a tightly clustered school following the sun's rays. Oddly, these jellyfish have lost the ability to sting, presumably because this defense mechanism was not needed and atrophied. This is a big plus for snorkelers, who can swim amid their pulsating mass without injury or irritation. Yet the biggest lure to Palau is world-class wall diving, the grandeur of which was impossible to capture behind the flat port and normal lens of Faulkner's Rolleimarin.

Much of underwater Palau is best snapped from a wide-angle perspective.

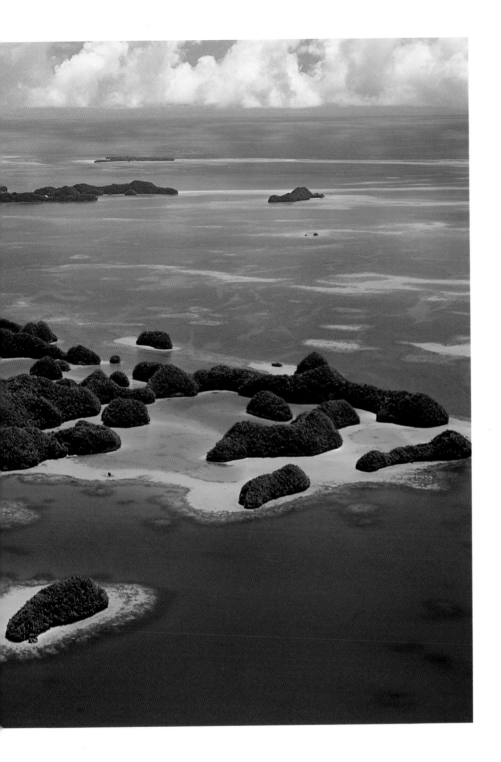

The most exciting site is along Blue Corner, where dozens of gray reef sharks swim very near the vertical precipice and large schools of barracuda are normally in residence. At Big Dropoff, the vertical wall begins in five feet of water and offers massive crimson gorgonians as a colorful complement to the deep blue of the open sea.

For more distant sites like Peleliu Wall, the extended range of a live-aboard dive boat is an advantage over a day boat. With the run time back and forth to the hotel eliminated, more dives per day are possible as well. It should be noted, however, that most of the day-boat ride is through the slick, calm lagoon in fast boats, and the excitement of running full steam ahead through the gorgeous scenery of the Rock Islands is worth the trip in itself.

Above:
We had been alerted that a saltwater crocodile was sometimes seen on one particular dive in the Solomon Islands, but no one had yet come close enough to photograph it—deliberately. Crocodiles have a ferocious reputation, and numerous deaths are attributed to them each year in Australia. There isn't a great deal of anecdotal dive lore about how crocs act when approached on scuba, but when I saw this one it didn't seem particularly aggressive. So I carefully moved in as close as I dared—about 3 feet—and the 28mm lens provided a nice perspective of the head. *Nikonos RS, 28mm lens*

Right:
The leaf fish is an expert in camouflage, making the primary photographic challenge simply finding it on the reef. Local dive masters, having acquired a great deal of knowledge about the behavior and habitats of such reclusive and invisible reef residents, often manage to spot them. *Nikonos RS, 28mm lens*

60

THE SOLOMON ISLANDS. There are plenty of other dive and photo opportunities in the tropical Pacific, places like Papua New Guinea, which I visited only recently for the first time, as well as old favorites like Fiji and the Solomon Islands, where I have dived several times in the past. Photographically, the Solomon Islands remains one of my favorites. My memories of the Solomons include my first (and only) chance to photograph a crocodile underwater, the huge resident school of barracuda and jack at Mary Island, and more species of clownfish than I have ever found in a single destination.

While many Pacific destinations are wide-angle wonderlands, the Solomons are particularly well suited to the single-lens-reflex camera equipped with a macro lens. This is not to say that there are not ample subjects for the 15mm lens and Nikonos; the water clarity at some reefs can be outstanding, although 50 to 80 feet is a more reasonable expectation. In addition, the reef color and texture offer appeal for broad reef scenics. But these cannot top the sheer abundance and diversity of the small reef dwellers.

For the smaller creatures like pipefish, blennies, gobies, *Anthias*, and long-nose hawkfish, the 105mm macro lens is the perfect optic. This lens takes more time and patience than I can sometimes devote on a brief assignment, but a place like the Solomons, with its fabulous diversity of tiny, elusive life, merits the time necessary to stalk images with the macro telephoto. Only thus can the comprehensive story of life on the reef be told.

The topside appeal of the Solomon Islands includes broad sand beaches, palm trees, and, often, slick calm water, ideal components of the over-under shot. *Nikon F3, 18mm lens, split +3 diopter with neutral density filter*

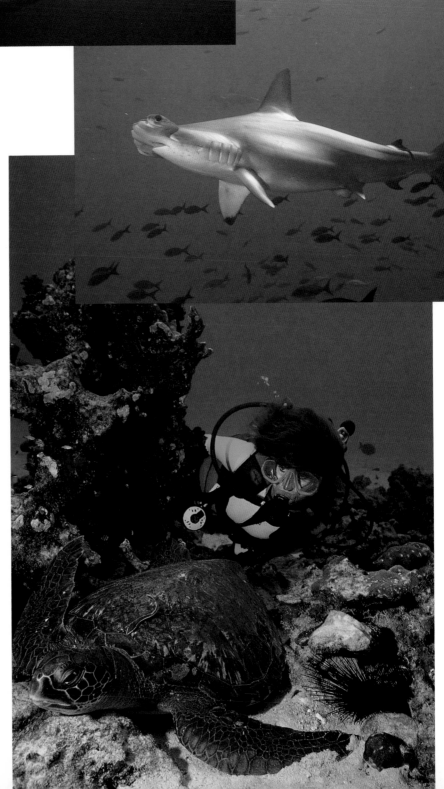

Above:
The whale shark was an underwater subject I had long hoped to capture on film, but it eluded me until my first trip to Cocos Island. I still remember the astonishment that gripped me as I rolled off the inflatable chase boat, cleared my mask, and found myself staring straight into the eyes of this twenty-five-foot-long fish. *Nikonos V, 20mm lens*

Center:
It is very difficult to get close enough to a hammerhead shark to fill the frame with a 15mm wide-angle while on normal scuba gear, because the bubbles scare the fish away. So I used the 20mm lens instead, and although the distance was still 5 feet or so, by using Kodak underwater film with the color correction filter, I was able to render this scalloped hammerhead shark, photographed in Cocos Island, in tones of gray rather than cyan, as a conventional film might. *Nikonos V, 20mm lens*

Below:
By carefully controlling our buoyancy and slowly approaching this sleeping sea turtle, we were able to shoot a series of photos without scaring off the subject. *Nikonos V, 20mm lens*

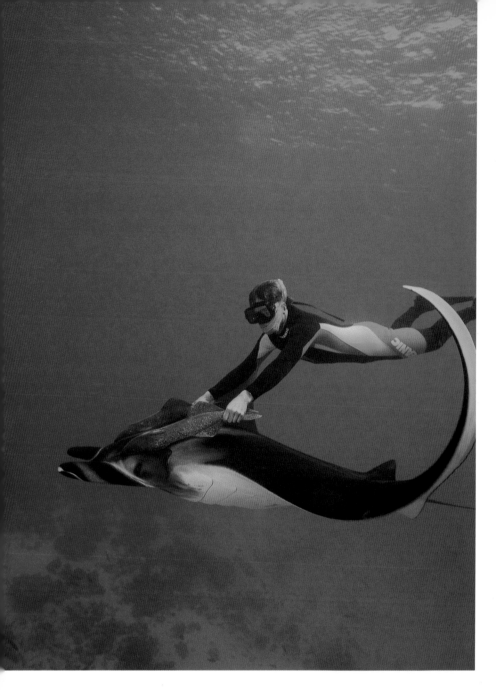

Left:
While enlightened divers prefer never to touch marine life, this manta ray in Cocos Island continually swam up to our group and hovered just below the snorkelers. The message seemed to be to hang on for a ride, and once someone gave it a try, the ray came back repeatedly to play with the next snorkeler. *Nikonos V, 15mm lens*

Below:
Sometimes the sheer density of marine life along the reefs of Cocos Island is astounding, as seen here, with schooling Moorish idols in the foreground and white-tipped reef sharks in the distance. *Nikonos V, 15mm lens*

COCOS ISLAND. There are many facets to the Pacific dive experience. Some, like the kelp forests of northern California and British Columbia, remain on my wish list. The waters are cold and the currents sometimes challenging, but I've seen stunning images from these waters by other marine-life photographers that tell me that these are locations that must not be ignored. Other areas, like the Poor Knights of New Zealand, I have visited briefly and someday would like to revisit to expand my portfolio. So many islands and so little time! But the two areas of the Pacific that I seem compelled to visit repeatedly lie off the coasts of Costa Rica and Ecuador — Cocos Island and the Galápagos. A few excerpts from my trip logs to these destinations tell why:

"Cocos Island, dive #1 at Manuelita Island. Dropped in the water at the northwest tip of the island and saw white-tipped reef sharks scattered along the bottom the minute I put my head in the water. My wide-angle camera jammed after about eighteen shots, so I began shooting with my housed F3 and macro lens. This directed my attention to the small creatures along the rocks and away from the whale shark swimming alongside a manta ray that everyone else saw. I was reminded of my last trip to Cocos when everyone who looked off to sea when they hit the water saw the whale shark, and everyone who looked toward the island saw only the normal reef life. That time I was lucky, but that's how it goes in Cocos. The big stuff is there, and if you're observant and fortunate, you'll see it."

"Dirty Rock. Immediately upon hitting the water we found huge schools of hammerheads. Creole wrasse were schooling, marble rays were cruising, and a green sea turtle was sitting on the bottom being cleaned of parasites by king angels. I hardly knew which direction to aim the strobe. To have been there alone for just twenty minutes and a rebreather so my exhaust bubbles wouldn't scare the fish would have been my special photo fantasy."

"Manuelita. Toward the end of the dive we found the most cooperative manta ray I have ever photographed. I saw it in the distance, and even though I was down to 500 pounds of air, I raced after it. It was shallow water and I was clean on my computer, but my air was quickly diminishing with the exertion. Then I discovered I did not have to chase it at all. Instead, it began to make wide, gentle loops, scooping up plankton. I went back to the dinghy, got another short tank of air, and finished the roll with our snorkelers swimming alongside this amazing animal."

"Dos Amigos. We moved down a wall face rich with schools of grunts and Moorish idols before finding a cleaning station manned by king angelfish. Here, the scalloped hammerheads would swim into the reef to be groomed. They were at first skittish at our arrival, but as the group settled into rock crevices and quit moving, the hammerheads returned, giving us great opportunities to get close. A later dive at the smaller island at Dos Amigos gave us more shots of hammerheads being cleaned, this time by a species of butterfly fish (*Heniochus nigrirostris*) that has come to be known as the barberfish."

The only disadvantage to diving Cocos is its location three hundred miles from the Costa Rican mainland, and its craggy coast can never support an airstrip. This necessitates a thirty-eight- to forty-hour cruise in a live-aboard dive boat before even getting to the dive site. It is also the world's largest uninhabited island (a testament to its impenetrable interior) and a tropical rain forest. Some parts of the year will be drier than others, but it is almost certain to rain a fair share during any visit to Cocos. However, this is one of the best places on the planet for pelagic encounters, and that is more than reason enough to go.

THE GALÁPAGOS ISLANDS. The Galápagos Islands offer much of the same pelagic appeal of Cocos, but instead of a thirty-eight-hour boat ride it is only one and a half hours by jet to San Cristóbal Island from the Ecuador mainland, and it is generally sunny. However, the big appeal of the Galápagos (in addition to the dive thrills) is topside. Here among the islands made famous by Charles Darwin during his 1835 voyage aboard the *Beagle* is a world of terrestrial and underwater wonder. Excerpts from my trip diary tell why:

Roca Redonda. We awoke to another fine, sunny morning with calm seas. The circular monolith known as Roca Redonda loomed in the distance, and visions of ever more shark encounters heightened our anticipation. Hammerheads reputedly school in profusion here, and our group of underwater photographers hoped to document the phenomenon.

As the *Lammer Law* crew set anchor in the lee of the island, we saw the surface of the sea rent by dozens of shark fins. For most prudent divers, this would be sufficient motivation to read a book on the sun deck, but for us it

Highly reflective fish like the steel pompano (photographed in the Galápagos) present an exposure problem much affected by the posture of the fish relative to the film plane. A slight angle with the head toward the camera seems to be ideal. *Nikonos RS, 28mm lens*

65

Above:
The Galápagos Islands are so rich in underwater life that few habitats remain deserted for long. When this barnacle was vacated by its original owner, a blenny soon called it home. *Nikonos RS, 50mm lens*

Right:
The scalloped hammerhead shark rarely responds well to a direct approach. The photographer who swims in pursuit will inevitably be left behind. However, the photographer who waits quietly in the coral recesses, carefully controlling his or her exhaust bubbles, will often be rewarded with at least passing proximity, as happened here in the Galápagos Islands. *Nikonos V, 20mm lens*

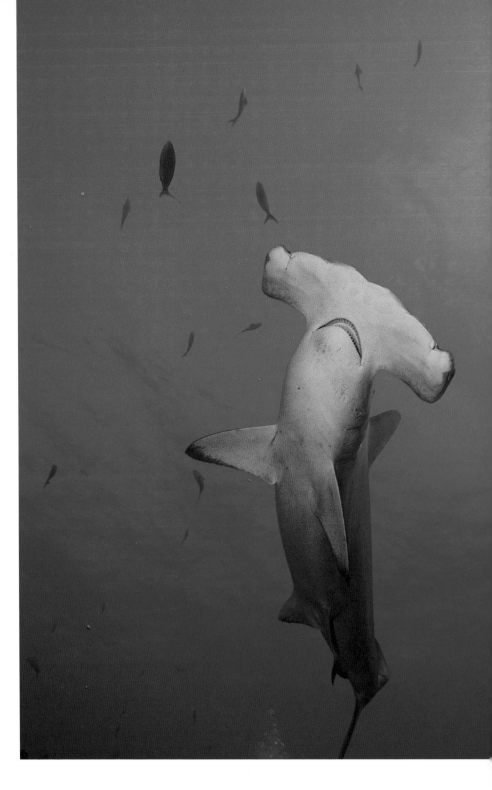

meant a world-class photo opportunity. And so we clambered aboard the inflatables for the short run to the dive site.

At the count of three we did a backroll entry from the panga. Upon clearing my mask I was startled to find myself among a school of steel pompano at the surface. As I exited their silvery mass, another shiny congregate awaited, this time at least a thousand barracuda packed tightly together. Although the formation was circular, given the sheer quantity of fish it was too massive to shoot in silhouette in the shallow forty-foot depth. Occasionally, the curtain of fish would part long enough to get a glimpse of a

I. PHOTO OPPORTUNITIES FOR THE DIVE TRAVELER

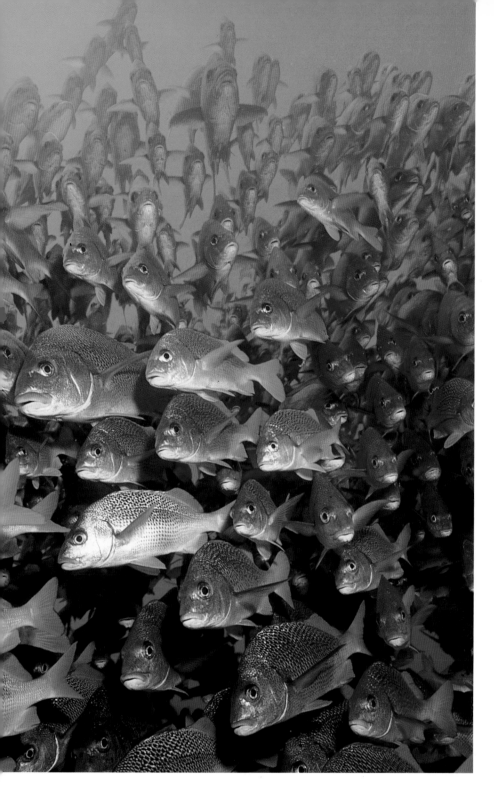

Above:
Protective coloration and poisonous
dorsal spines are the prime predatory and
defensive mechanisms of the scorpion
fish. Amid a field of barnacles this
scorpion fish in the Galápagos is well
camouflaged. *Nikonos RS, 28mm lens*

Left:
The yellowtail grunt is indigenous to coral
reefs from Peru north to the Baja, but in
the Galápagos they seem to school in
especially prodigious numbers. *Nikonos V,
15mm lens*

hammerhead or Galápagos shark swimming through the school, seemingly
unconcerned with any predatory behavior.

Only with great restraint did I limit the number of frames exposed on the
barracuda. The hammerheads still beckoned, and I swam off in pursuit. Just
seaward of the schooling barracuda were the hammerheads, scores of them
swimming in a sort of synchronized submarine ballet. I know from experience
to be careful with my approach, since a careless exhaust bubble will scare
them beyond effective camera range. So I found a barnacle-encrusted boul-
der surrounded by Creolefish and settled in to wait.

67

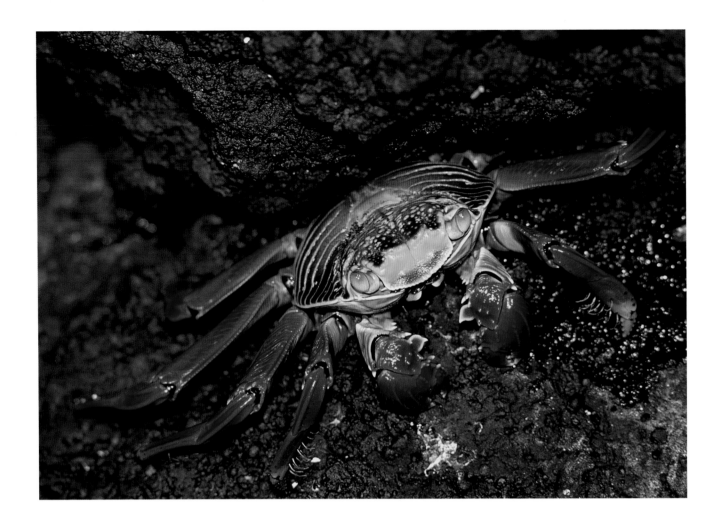

Top and above:
The Sally Lightfoot crab and the marine iguana are but two of the fascinating terrestrial species indigenous to the Galápagos Islands. *Nikon F4, 105mm macro lens*

Before long, the school moved inexorably closer. I found I could hold my breath until the leading edge of the school got within five or six feet and get off a few shots before my screaming lungs required replenishment. The bubbles would frighten them temporarily, but their numbers were so staggering that new sharks would soon swim into view. Still, the day that closed-circuit rebreathers are available to sport divers, I'll be the first to buy one so I don't have to contend with exhaust bubbles scaring the marine life.

Here the scalloped hammerheads seem less skittish than in Cocos, or even other places in the Galápagos. My film was unfortunately quickly spent, and typical of such predicaments, I then swam into a school of thirty Galápagos sharks without a single frame to show for it. Between the steel pompano, barracuda, hammerheads, king angels, moray eels, and turtles on this dive, I hardly knew where to point the camera next. This first dive at Roca Redonda revealed as much concentrated marine life as I had ever seen in any ocean, which is of course why I came back to the Galápagos.

Aside from the appeal of photographing sharks, rays, turtles, and a wide variety of smaller marine life off these islands, the Galápagos sea lions are a special treat. They are totally unafraid topside and permit a very close approach, but underwater they are curious and very quick. They may dart about inspecting the divers invading their playground, but they prove to be difficult subjects. Unlike the Australian sea lions or harbor seals off Northern California, which are light in

68

color, the Galápagos sea lion has dark brown fur, which requires a lot of light to record properly on film. This, combined with their erratic motion and the typically turbid water of their habitat, makes them a challenge. Available-light silhouettes work well, and often a snorkeler in shallow water can arouse their innate curiosity and bring them near where high ambient light can assist the exposure. In some areas like Cousins Rock, the sea lions hide in ambush among the chartreuse endemic corals, and the color contrast of the background makes them stand out better as a result.

Above water, the attractions of the Galápagos are equally inviting. The possibility of photographing marine iguanas, flamingos, boobies, cormorants, sea lions, crimson Sally Lightfoot crabs, waved albatross, Galápagos penguins, and, of course, the famed giant tortoises make this a destination with interest.

As good as the diving is in the Galápagos, it may not be so forever. Until recently the Ecuadoran government has taken a strong stand against commercial fishing in these islands. Sometimes long-liners would sneak into the northernmost islands of Wolf and Darwin to ply their nefarious trade, knowing there was little enforcement and they could likely get away with catching the sharks, cutting off their fins, and then dumping them back in the ocean to die a slow and ignominious death.

In fact, the last time I was in the Galápagos we caught a long-liner from Costa Rica working off Darwin Island. The crew members got very nervous when they saw our dive boat, and since what they were doing was against the law, we were able to persuade them to cut their lines. Then we went into the water to free any sharks that had already been caught. We saved six Galápagos sharks that day, and then sent the video footage to the government, thinking it would be outraged at the illegal poaching. Instead, we discovered it was actually in the process of issuing licenses for shark fishing in Galápagos waters. That stance has since been reversed, and the president of Ecuador has reasserted a conservationist zeal. Only time will tell whether the big bucks of the fishing industry or the ecological concerns traditional to the Galápagos will prevail.

While the Galápagos Islands offer a rich and wondrous marine environment, they are being threatened constantly by overfishing. During a 1994 visit to remote Darwin Island, our group found a long-lining shark fishing boat working waters supposedly protected from such activity. The carnage aboard is testament to the need for enforcement against illegal fishing practices in the Galápagos. *Nikon F4, 28–85mm lens*

Photo Ecology

I know I have bumped into my share of coral over the years, at first because I didn't know that I was hurting anything alive, then because I was once conceited enough to think the good my pictures would do in communicating the beauty of the coral reef would compensate for a little accidentally broken coral. I now know this was a dangerous and irresponsible attitude, and I try as hard as I possibly can to never touch the coral and leave the reef intact.

The coral reef is not an inexhaustible resource, and the ever increasing popularity of scuba diving makes it imperative that all divers protect the fragile resource. No photograph merits turning a living coral reef to rubble. Being constantly aware of buoyancy control, keeping gauges clipped to our bodies so they don't drag through the reef, and learning how to coexist with reef residents without harming them give underwater photographers the means to be at the vanguard of reef conservation. After all, if we do not revere and appreciate the reef, why would we bother taking pictures?

Significant as diver impact is to the coral reefs worldwide, water quality poses a far greater threat. I found a story told by Bob Halstead, a talented underwater photographer who runs a popular live-aboard dive boat in Papua New Guinea called the *Telita*, to be a good example of this diver-impact issue.

Outraged at seeing a brain coral callously vandalized by a diver who inscribed his name and date on the surface of the coral, Halstead went to the man's employer to vent his ire. However, his feeling of self-righteousness at having defended the coral reef turned to chagrin when he discovered the diver was so angry at being reprimanded that he went on to disfigure every brain coral he came across, usually by carving Halstead's name across the head.

This is a sad story but not without a moral of sorts. In Bob's words, "Brain corals are fascinating living sculptures. I love to look at them and play maze games or just marvel at their art. So when I returned to the same reef a couple of years later, I remembered the mutilated brain coral and tried to find it. Sure enough, it was gone. . . . I thought my worst fears had come true, the coral must have died of its injuries and turned into a rotting algae-infested rock. But I could not find one of those, either. Then I realized that the perfect specimen right in front of my eyes was the very same. It had healed! There were no scars — it was the exquisite, outrageous, wonderful brain coral it had been before the vandal struck."

Bob goes on to observe, "Coral reefs may be fragile in that they depend on unpolluted water and are easily broken, but in other ways they are incredibly dynamic and resilient. And corals grow *fast* if the conditions are right. I have seen reefs recover from being barren to having healthy coral cover in as little as five years."

Of course, those insights derive from twenty-two years of diving in some of the world's most pristine waters. Papua New Guinea has less than four million people, and most of those live in the highlands away from the sea. The point I see from this is that given a chance, the reef will recover. But once water pollution reaches a certain point, the reef can no longer replenish itself.

Halstead offers the ultimate in reef ecology from his vantage in Papua New Guinea: "We are watching the lives of coral reefs, seeing how they form, how they live, and how they die. It is wondrous. . . . If the reefs near you are dying without renewal, the fish disappearing, and the ocean filthy and stinking, then you had better do something about it. But do not talk to me about not touching corals or

70

peeing in the ocean. If you are serious about preserving all this natural wonder you have to talk about only one thing. Too many people. We have a plague on this planet and it is time we did something about it. It's not too late, you know." With the world population increasing geometrically at a rate of 250,000 per day, it's no wonder that the ocean is threatened. The planet is threatened. We had better preserve it, protect it, and enjoy it while we can!

Travel Considerations for the Underwater Photographer

While the beauty of the destinations visited is one of the joys of underwater photography, travel is also the biggest hassle for an underwater photographer. Traveling light is no longer a possibility, for not only must bulky cameras be packed, but bulky backups for bulky cameras should also be included. Clothes, dive gear, and camera bags typically add up to at least four checked bags and two carryon pieces no matter where I go, and often even more must be packed. Overweight baggage and porters are simply necessary elements of life on the road. The following are some considerations that might make life a little easier.

PHOTO EQUIPMENT. Some parts of the diving world offer camera rentals, film processing, and camera repair facilities for visiting photographers. In the Florida Keys, the more developed dive destinations of the Caribbean, and many of the better live-aboards worldwide it is recognized that much of their clientele consists of underwater photographers, and services are made available accordingly. Still, it is risky to assume that every kind of backup gear will be obtainable in case of a flooded camera or electronic malfunction. It is prudent to bring along more than one camera body and strobe head, and certainly extra synch cords, connectors, batteries, and tools.

Tools should include things like jeweler's screwdrivers (both slotted and Phillips-head), pliers, a crescent wrench, regular screwdrivers, an allan wrench set, WD-40, silicone sealer, electrical contact cleaner, cotton swabs, and, of course, plenty of O-ring lubricant. If the electrical current of the destinations differs from that at home, bring an adapter/converter kit. Even if the boat advertises a 110-volt charging station on board, I always bring a 220-volt converter, as it is unlikely that there will be enough 110-volt outlets to accommodate all the gear that needs charging.

FILM. Film will almost always be more expensive and less available on location than at home. I figure how many rolls of film I am likely to shoot per day, multiply by the number of shoot days, and bring at least 30 percent more. In destinations offering exciting topside potential, like some of our photo safaris to Africa and the Galápagos, film can be spent incredibly quickly, and there is nothing more frustrating than missing a valuable "photo op" because of being forced to conserve film. Compared to the cost of travel, film and processing are relatively cheap.

A word on airport X rays is appropriate here. According to a recent study by the National Association of Photographic Manufacturers (NAPM) as reported by the American Society of Media Photographers (ASMP), films under ISO 400 are unlikely to be affected by even repeated passes through security X-ray machines. Tests were made to simulate typical and worst-case travel scenarios, and inspectors found it impossible to detect effects of sixteen inspections upon 200-speed color negative films. Even with one hundred passes the effect was hard to see in

unexposed areas and even more difficult to perceive when there was a latent image. There was a slight increase in grain and minor color balance shift discerned, but overall the effect was very minimal. With color transparency films of ISO 50 to 1600, no effect was visible with sixteen passes, but at one hundred passes some decrease in D-max (the density of the dark areas and blacks) was visible in the higher-speed films only.

NAPM continues to recommend that travelers avoid airport X rays for films faster than ISO 400 but suggests that slower films pose no problem. The evidence is clear that the ISO 50 and 100 films I normally travel with can withstand a few passes. Yet I remain superstitious and carry my film in large, clear Ziploc bags and present it for hand inspection.

The main reason I do so is that I do not feel secure leaving my exposed film in checked bags for fear the bag might be lost and a week's worth of shooting along with it. Since I have the film with my hand luggage anyway, it is a simple matter to present it for hand inspection. If I carry Fuji film, which is packed in clear plastic cylinders, the inspectors can see the contents at a glance. Since I usually take a couple of hundred rolls, they seem to realize that photography is not a casual effort and may award the film only a cursory hand inspection. However, I have been at airports where grumpy security agents carrying automatic weapons told me to put it through the X-ray machine—in which case I quickly comply.

THEFT. Camera equipment is expensive and easy to fence, making it a prime target for thieves. They know the kinds of cases camera gear is packed in, and few padlocks pose a threat for a creative crook. I know this fact intimately, for on a return trip recently from the Solomon Islands I found my carrying case had been broken into somewhere between the Los Angeles and Denver airports and a Nikonos RS system plus two Nikonos V cameras with 15mm lenses had been stolen — an eight-thousand-dollar hit. I had off-premises business insurance, but it still cost me about a thousand dollars in deductibles and depreciation. Fortunately, it happened when I was on my way home rather than on my way to location. But it taught me a lesson: Never check anything you can't afford to lose or that is not adequately insured. As the television program "60 Minutes" revealed, some baggage handlers on American carriers are making a second career of pilfering bags, and the airlines offer *zero* compensation (read the fine print on your ticket jacket) for stolen camera gear.

It is important to carry at least one complete underwater camera system on board the plane. My airplane travel kit contains a Nikonos RS with 13mm, 28mm, and 50mm macro lens, SB 104 strobe, charger, and one Nikonos V body with 15mm lens and viewfinder. This allows me to shoot most subjects on location, even if my checked bags are lost or pilfered.

DIVE ACCIDENT INSURANCE. There are obvious accouterments that every traveler should have on hand, like tickets, passport, visa (if necessary), and plenty of cash, credit cards, and traveler's checks. But one further item I consider indispensable is insurance in the unlikely event a dive accident occurs.

Since many of our trips are to remote spots in the world, should an accident involving decompression sickness or some other form of dive-related malady befall, it is often a far distance to a recompression chamber or hospital. Usually treatment calls for some sort of air evacuation in a special aircraft pressurized for surface conditions so as not to aggravate the symptoms. Such evacuation and

subsequent chamber treatment can cost thousands of dollars, and to resist treatment because of the expense can be life-threatening or, at the least, threaten the future quality of life.

The insurance I use is issued by the Divers Alert Network (919-684-2948 or 800-446-2671). Available only to DAN members (a twenty-five-dollar annual membership fee), the insurance costs twenty-five dollars each year and includes the Assist America option, which will aid medical evacuation even in nondiving-related emergencies. For example, if I were in a car accident in a foreign country where I did not trust the quality of medical service, Assist America would arrange for and pay the expenses of my medical evacuation back home. The Professional Association of Dive Instructors (PADI) offers similar dive accident insurance (800-223-9998), and I carry that, too. Each policy is a modest cost, but these policies afford the security of knowing that help is economically available.

I know the value of such insurance firsthand. A few years ago, while I was leading a photo tour to Vanuatu, I was diving heavily but within the limits of my dive computer. At the end of the day I had the unmistakable symptoms of a central nervous system bends hit. Maybe I was a little tired, or maybe not properly hydrated, but whatever the reason, something pushed me over the edge from saturated to bent.

I followed the recommended course of action—I took oxygen, drank fluids, and quit diving for the week—but the symptoms persisted. I should have gone to a recompression chamber immediately, but denial is a big factor in most diving accidents, and I thought it might either get better soon or I could wait until I was back in the Miami area and go to hyperbaric medical experts I knew. Instead, the symptoms got much worse in the airplane between Vanuatu and Fiji. The altitude exacerbated my decompression sickness, and by the time I reached Fiji I knew I should go to a recompression chamber as soon as possible. Unfortunately, at the time there was no operational chamber in Fiji (one has since been donated by the Cousteau Society). I talked to a DAN representative and they arranged treatment in Honolulu. It was a frightening time for me, since I make my living as an underwater photographer and I did not know if this accident might make diving a problem in the future. But the treatment was effective and, aside from making me a far more cautious diver, rendered no permanent damage. Still, I would not consider scuba diving anywhere without proper first-aid equipment (including oxygen) on the boat and good dive accident insurance. I strongly recommend that any traveling diver be similarly concerned and insured.

II. *The Science of Underwater Photography*

CHAPTER 1 LIGHT BENEATH THE SEA

Aside from the fact that underwater photography introduces certain life-sustaining considerations to imaging — such as breathing; finding one's way back to the dive boat; and avoiding the bends, hypothermia, air embolisms, shark bites, and nitrogen narcosis — other physical attributes of sea-water must be considered each time the shutter release is pressed.

The Nature of Seawater and Light

DENSITY. Water is 600 times denser than air, and consequently, it absorbs substantially more light than air. This affects the amount of available light that reaches any given depth (vertical light), as well as the amount of strobe light that can strike a subject (lateral light). This single physical property of water makes the rules for underwater photography substantially different from those that apply topside.

Even under the best of conditions for light transmission, a bright sunny day at high noon with 200-foot visibility, there can be as much as a full f-stop lost for every ten feet of depth. This rule of thumb seems to hold true up to about forty feet, beyond which the level of light loss is less predictable. This points to the need for constant attention to available light levels, either by means of a light meter or intuition and experience.

Artificial light in the form of an electronic flash is usually used to replace or complement the lost natural light. If the density of the water can have such a drastic effect on a light source as strong as the sun, even the most powerful underwater strobe will likewise be affected as the strobe-to-subject (STS) distance increases (lateral light). In many cases, this loss of light is along the order of a full f-stop per foot for STS distances to about four feet. For example, a Nikonos SB 105 at full power with ISO 64 film will render approximate working apertures of f/22 for close-up and macro work, f/16 at 1 foot, f/11 at 2 feet, f/8 at 3 feet, and f/5.6 at 4 feet.

After about six to eight feet, most strobes have relatively little influence on exposure, so available light becomes the most important consideration. Since the light has to travel double the STS distance (to the subject and then back to the film plane after being reflected off the subject) through water, a dense medium that introduces a heavy color bias (usually blue, cyan, or even green, depending on the water), a requirement of effective strobe photography underwater is getting close to the subject.

REFLECTION. Light rays tend to bounce off the surface of the sea to a greater or lesser extent, depending on the time of day and surface conditions. A flat, calm sea will not scatter the rays of the sun as much as a rough, confused sea. Time of

Opposite:
The diver silhouetted against the entrance to a cave in the Solomon Islands was photographed with available light only in order to capture the strong graphic picture created by the sunburst through the cleft in the face of the reef. *Nikonos V, 15mm lens*

Overleaf:
Underwater photographs typically entail a blend of strobe and ambient light, as seen here in this Red Sea reef scenic, featuring emperor angelfish and soft coral. *Nikonos V, 15mm lens*

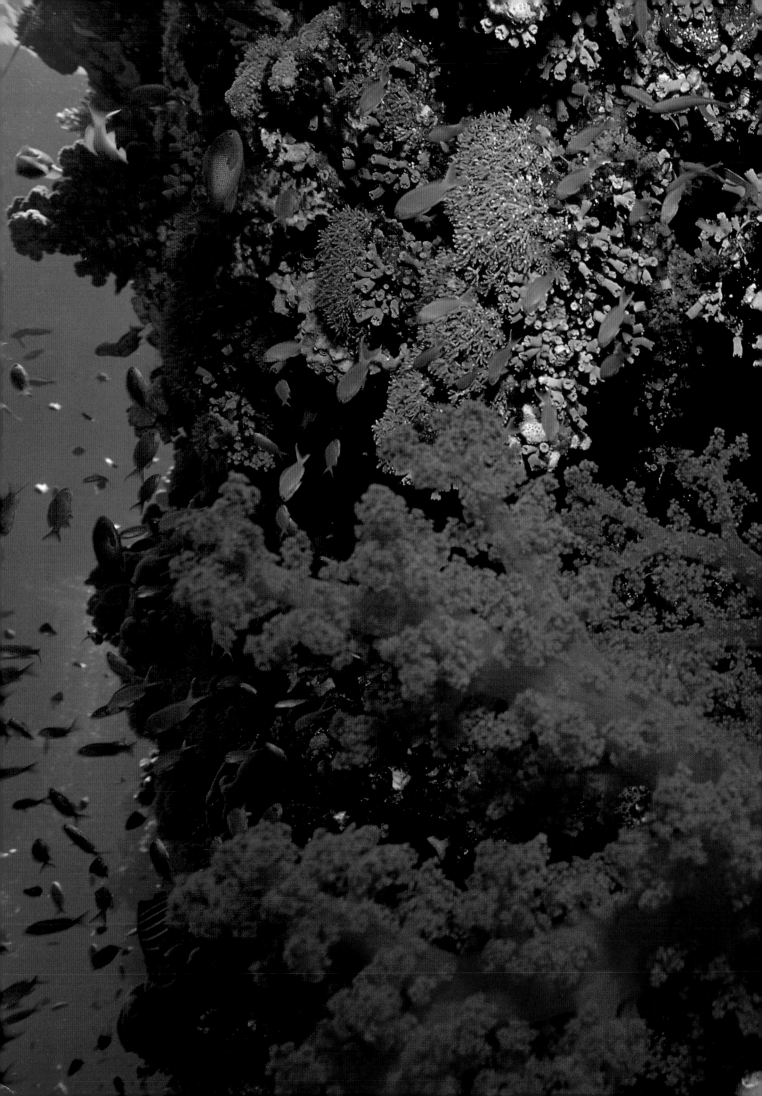

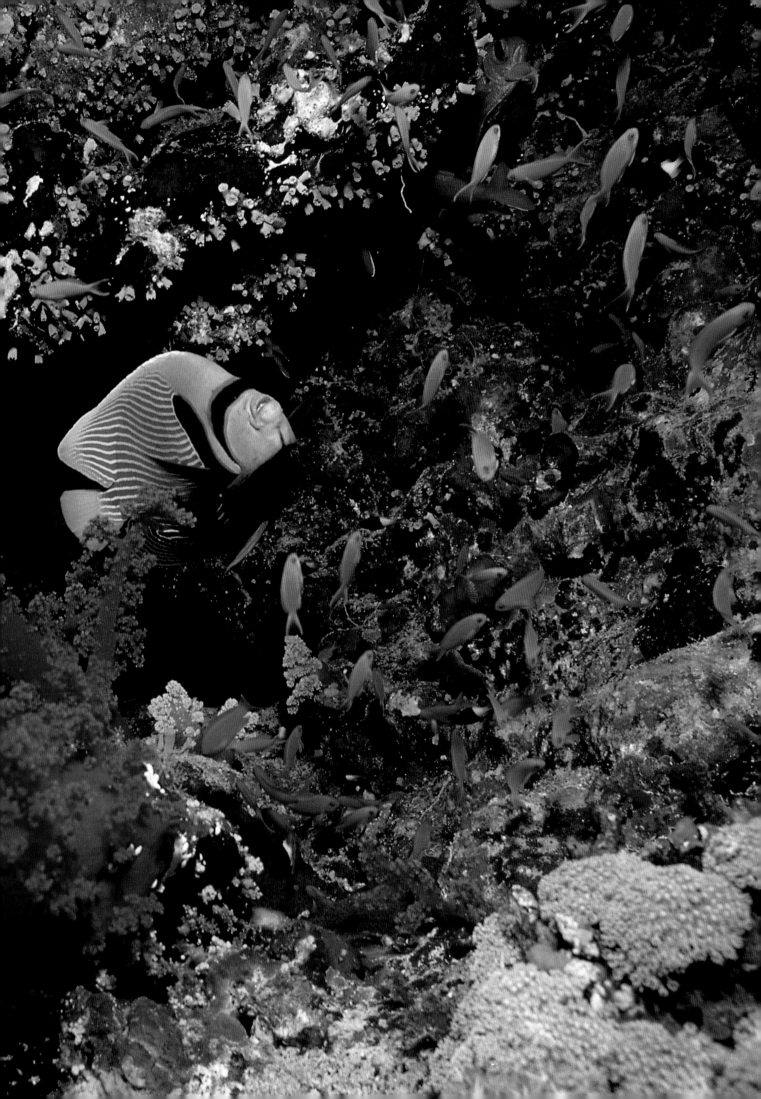

day is crucial as well, since the sun penetrates better when it is high overhead than when it strikes the surface at an oblique angle. The hours of 10:00 A.M. to 2:00 P.M. offer the greatest ambient light at any given depth, and as the sun sits lower in the horizon, more rays are reflected from the surface than are transmitted underwater.

This simply means that at midday, more light will be transmitted, not that it is preferable to early morning or late afternoon for underwater photography. These periods render warmer light, setting a special mood. It is also easier to get the ball of the sun to enter the frame as an element of composition during morning and late afternoon dives. The creative underwater photographer considers not just the quantity but, equally important, the quality of light.

DIFFUSION. The light rays that manage to pass through the surface of the water are dispersed underwater by particles in suspension and the density of the medium. No matter how clear the water, microbiological organisms and suspended silt will soften and diffuse the light. In turbid water this effect becomes problematic.

Particles absorb and reflect portions of the light both vertically and horizontally. The greater the number of particles that the light encounters on the way down, the less the amount of available light on the scene, and as the strobe light travels from the source and is reflected back to the subject, it, too, will be absorbed and scattered. As particulate matter increases, the photographer needs to open the aperture to account for light diffused or move closer to regain the light lost in travel.

Different lighting techniques and subject selection are required to minimize backscatter (the white suspended particles that are illuminated by the strobe either accidentally or unavoidably, depending on the skill of the photographer and the degree of turbidity).

REFRACTION. Waves of light travel in a straight line so long as they are passing though a single medium. As they encounter another medium with a different refractive index, the light rays are bent or diverted. Each medium has a specific refractive index based on the standard of air, which becomes the null point with a value of 1. Water has a refractive index of 1.33, which means it has the effect of magnifying by a third.

To estimate distances underwater accurately, the photographer must be aware of this magnification. For example, a subject that appears 3 feet away is really 3 x 1.33, or nearly 4 feet away. This doesn't matter with the through-the-lens (TTL) viewing of an SLR, because what you see is what you get, but does this mean that for critically sharp focus with a viewfinder camera like a Nikonos the lens should be set at 4 feet? Fortunately not, for the Nikonos lens and most other accessory optics for the Nikonos calibrate "apparent distance." For a subject that looks 3 feet away as viewed through the flat port of a face mask, set the lens for 3 feet.

This magnification effect enters into the photographer's calculations when aiming the strobe. If a strobe is aimed at the apparent distance of a subject 3 feet away, it will strike one foot shy of the subject's actual location 4 feet away. Such an error will often be masked since the strobe covers a wider angle than the lens, but in some cases an aiming problem is apparent at a glance.

I have seen published photos of a moray eel along a white sand bottom, with the brighter light in front of the subject and along the highly reflectant sand fore-

Opposite:
The sunburst is often a useful element of composition, as demonstrated by this portrait of a Caribbean reef shark in Grand Bahama, rendered with strobe fill.
Nikonos V, 20mm lens

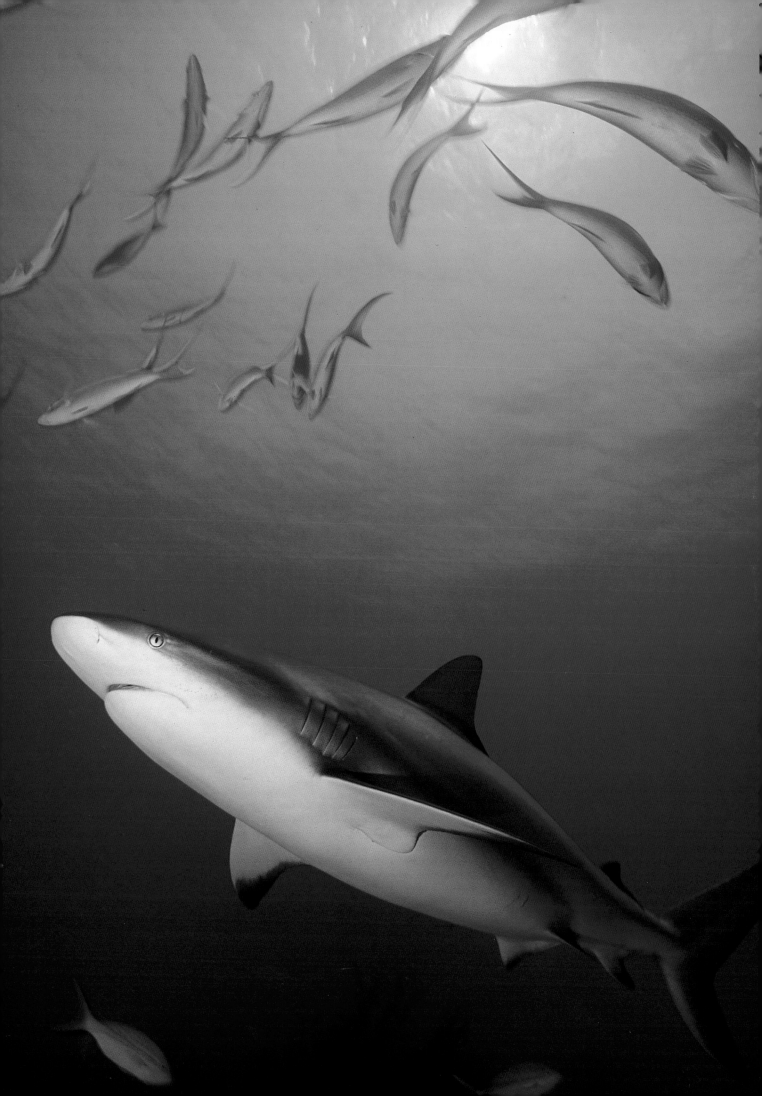

ground than on the subject itself. A better lighting effect would be achieved by consciously aiming behind the spot where the eye perceives the eel to be, thereby targeting the light to what is actually the main subject, the moray eel, and minimizing the foreground, which becomes distracting when unnecessarily illuminated.

CONTRAST. All of the forenamed conditions also conspire to decrease the contrast of the underwater scene. The black-and-white photographer can enhance contrast by underexposing and overdeveloping the negative or by using a higher contrast printing paper, but the color photographer can only enhance contrast by working in shallow water (minimize vertical distance), getting close to the subject (minimize lateral distance), or choosing a more saturated "contrasty" film, like Fuji Velvia or Provia or Kodak Lumiere. Adding artificial light will make a scene appear as if it has more contrast by adding color, thereby contributing full-spectrum light to a world otherwise primarily blue and black.

SELECTIVE COLOR FILTRATION. The spectral composition of light is affected as a function of depth, so that it is not only absorbed but altered. Even the clearest tropical seawater acts as a cyan (blue-green) filter, the complement of which is red. Therefore, red is absorbed first, and other colors at the warm end of the spectrum like orange and yellow are also soon to disappear at even shallow depths. Available-light photos generally do not record red at 15 feet; by 30 feet the orange will be gone; and by 50 feet the yellow will not be visible. Only various shades of blue and black remain in available-light photos at depth, but artificial light will restore the colors, at least at close strobe-to-subject distances.

The same cyan filtration affects the strobe light so the most authentic colors occur with minimal water separating the subject and the lens. Macro and close-up photos are often almost surreal in their vibrant colors, but as the water column increases in marine life portraits and wide-angle scenics, the colors become more

Macro and close-up photos allow the underwater photographer to move in close, minimize the blue filtration from the water, and maximize color, as in this shot of a yellow-axil chromis amid a red gorgonian in Papua New Guinea. *Nikonos RS, 50mm macro lens*

II. THE SCIENCE OF UNDERWATER PHOTOGRAPHY

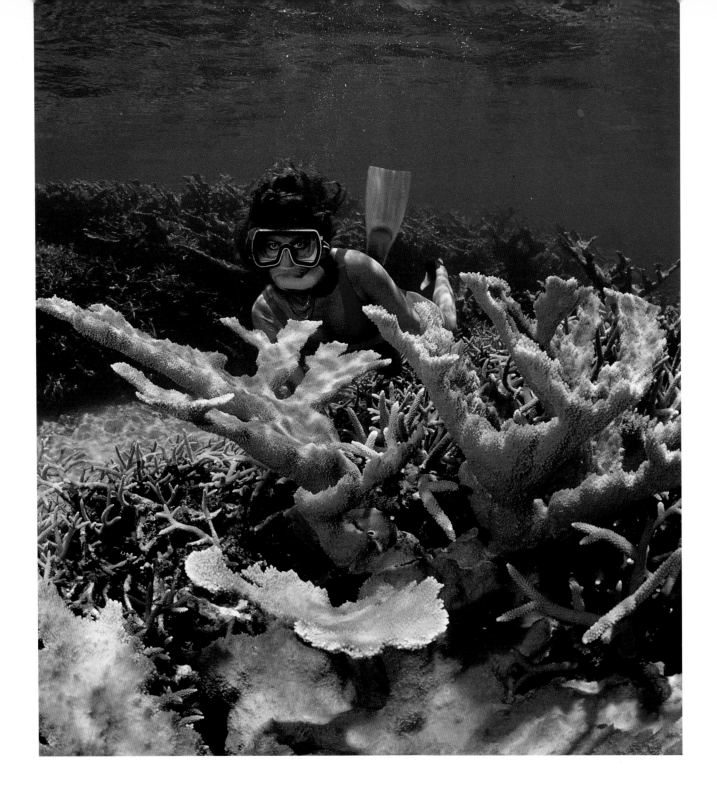

muted and influenced by the color bias of the sea. For this reason, underwater photographers are generally forced to forgo the efficiencies of a telephoto lens as in topside photography and always strive to get close—the closer the better.

For a large subject this means getting near with a wide angle as opposed to working from a distance with a normal lens. For a small subject it means getting tight with a macro lens rather than working from a comfortable distance with a long telephoto. Even with predators such as sharks it is necessary to get close to minimize the water column (the distance between the subject and the lens), thereby enhancing resolution and color. This affects the entire discipline of underwater photography, as cultivating a surreptitious, nonthreatening approach to marine life becomes an important element.

Even in very shallow water, selective absorption of color occurs, with the reds and oranges disappearing first in available-light photos. Strobe fill is useful to restore colors and light the face mask, as in this photo of a snorkeler in elkhorn coral, Key Largo. *Nikonos V, 15mm lens*

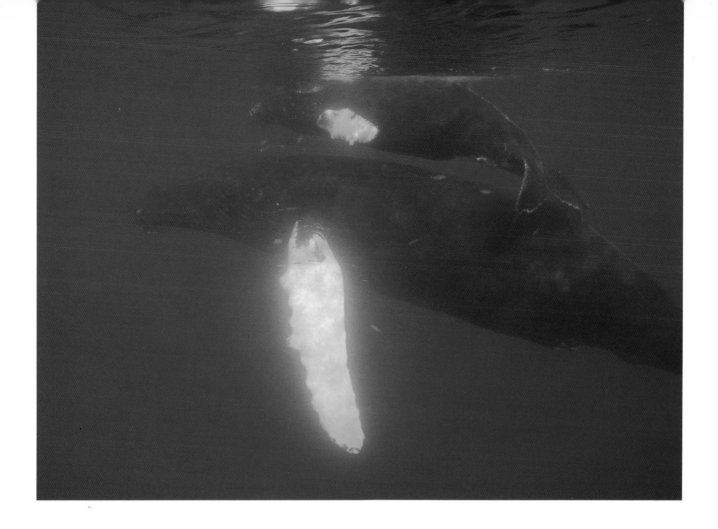

O *artificial light*. Some underwater subjects are either so large or so reclusive that it is impossible to get close enough for effective strobe illumination. For example, this mother humpback whale in Silver Bank, Dominican Republic, seemed to prefer to keep me at least 15 feet away from her calf, and such a distance made available light the only way to get the shot. *Nikonos V, 15mm lens*

Lighting for Underwater Conditions

Anytime we venture beneath the surface to take photos, we must take into account two forms of light, available light from the sun and artificial light from a flash. Each makes a contribution, and each requires a specific aperture for proper exposure. Stated simply, if the aperture is always set for the stronger of the two values, a proper exposure can be achieved. Yet creative underwater lighting is achieved by placing the two elements under control and predicting the effect that the combination of each will render. The photographs on this page and the next illustrate some of the considerations involved in deciding how much emphasis should be placed on ambient light values and how much artificial light will contribute.

AVAILABLE LIGHT. Accurate exposures for available-light subjects are communicated via a light meter, either an external unit, like the popular Sekonic L164 Marine Meter II, or an internal meter, like the TTL sensing unit on the Nikonos V, Nikonos RS, or housed camera. For available light only, the basic procedure is to find a shutter speed fast enough to freeze the subject, choosing the aperture dictated by the film ISO and ambient light level. With a little practice, this level of available light can also be estimated by transposing the "Sunny 16" rule to underwater use.

THE SUNNY 16 RULE. The Sunny 16 rule, so named for f/16 and sunshine, allows that in bright sun topside at midday (that is, between 10:00 A.M. and 2:00 P.M.), the shutter speed that will give a correct exposure at f/16 is the reciprocal of

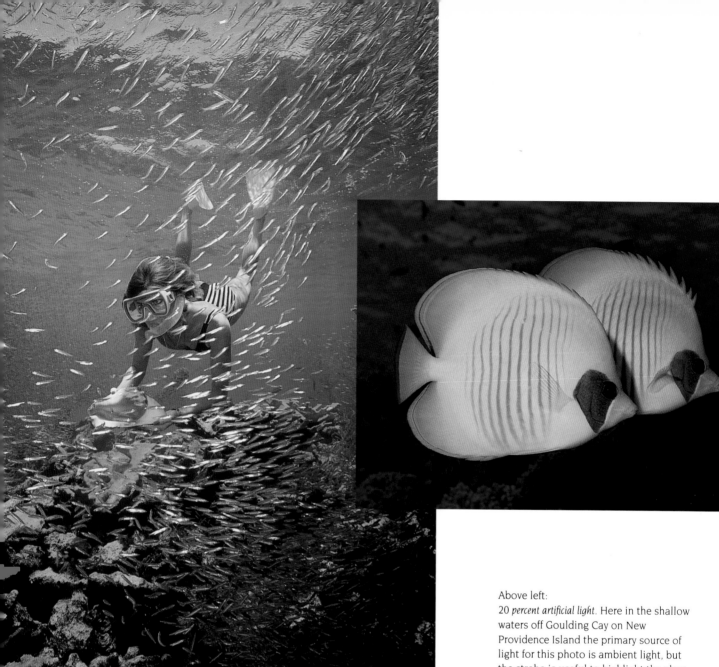

Above left:
20 percent artificial light. Here in the shallow waters off Goulding Cay on New Providence Island the primary source of light for this photo is ambient light, but the strobe is useful to highlight the glass minnows in the foreground and add color and detail to the model's flesh tones. *Nikonos V, 15mm lens*

Above right:
50 percent artificial light. This is nearly an equal blend of strobe and ambient, with the artificial light adding color to the blue-cheeked butterfly fish in the foreground and the ambient determining the density of the blue water background in the Red Sea. *Nikonos RS, 28mm lens*

Left:
100 percent artificial light. In the low ambient light of late afternoon, the strobe exposure for this Spanish dancer in Pemba Island, Africa, was at least three stops more than required by the ambient light of the background, hence the black appearance of the water. *Nikon F3, 55mm macro lens*

the film's ISO value. For an ISO 100 film, f/16 requires $\frac{1}{100}$ second, or whatever shutter speed is closest, in this case $\frac{1}{90}$. An ISO 400 film at f/16 requires $\frac{1}{500}$ second for a shutter speed, and an ISO 25 uses $\frac{1}{30}$.

But once that light goes underwater, it is absorbed as a function of depth, turbidity, and surface conditions. The average light loss is about one stop for every 10 feet in the first 40 feet of water. There are variables, of course; the light penetrates far less as the sun sits lower on the horizon, and the level of reflection off the surface is increased, and turbid water increases absorption. Still, the Sunny 16 rule provides a ballpark estimation of light values even without a meter. For example, at 30 feet with ISO 100 at midday, a photographer may assume the aperture value for $\frac{1}{90}$ second should be about three stops wider than the f/16 surface value, or f/5.6.

Just as in topside photography, underwater available-light exposures derive from a combination of film ISO (a measure of sensitivity to light), shutter speed, and aperture. But in underwater work the range of viable shutter speeds is far more limited. Rarely do subjects move so quickly that $\frac{1}{500}$ or faster are required to freeze them in available light, and seldom do shutter speeds slower than $\frac{1}{15}$ second render sharp photos with hand-held cameras. In fact, in twenty years of underwater photography, at least 95 percent of my exposures have been at $\frac{1}{30}$, $\frac{1}{60}$, or $\frac{1}{90}$ second.

This makes the wild card in underwater photography the f-stop, and even this is limited. Apertures wider than f/5.6 are usually avoided because the depth of field is so shallow, and most lenses have a minimum aperture of f/22. Thus, a combination of one of five apertures with one of three shutter speeds will work for almost all the underwater subjects a sport diver is likely to encounter, regardless of whether the primary light source is available light or flash.

ARTIFICIAL LIGHT. While available-light images may set the mood of a scene or may be used to record subjects too large or too far away to be lit with artificial light, they are necessarily low in contrast and monochromatic at depths greater than 15 feet. To record the wealth of color so typical of the coral reef, a submersible flash is an indispensable tool. If the available-light scene is the canvas, the strobe is the brush that brings to life the bizarre palette of the underwater world.

Since the artful use of a submersible strobe is so fundamental an element in successful underwater photography, when I teach sessions of the Nikon School of Underwater Photography, this becomes our first and most constantly repeated lesson. On our initial dive, a staff member will hold an exposure board and we'll set the student in the sand 3 feet away. Then we will take one set of photos with the strobe set at full power and the camera at manual at $\frac{1}{90}$ second. For ISO 100 film the set of brackets will be at f/5.6, 8, 11, and 16. We then set the strobe on TTL and the camera on automatic to repeat the same series of brackets.

The processed film will then show us three things:

1. The proper aperture setting for full power for a subject of average reflectance 3 feet away.

2. The ideal aperture setting for TTL strobe use for a subject 3 feet away.

3. The exposure latitude resulting from TTL reliance, that is, the range of acceptable exposures derived from the TTL technology.

We will see that the range of acceptable exposures on TTL is limited. If the aperture is set much wider than about f/8, the picture is usually overexposed, and smaller than f/16 turns out underexposed. The underexposure at smaller apertures

is easy to understand because it will be seen to correlate with the full-power test. Once the strobe discharges full power, it doesn't matter whether the setting is full or TTL—there is no more light to give. Also, at the wider apertures it is always possible to overexpose due to ambient light, particularly at shallow depths.

From these tests and experience we see TTL exposure is not a totally automatic point-and-shoot technique but a tool to refine exposure. The photographer has to be in the relative ballpark first. TTL will correct for modest errors in exposure due to incorrect distance estimation, and it will probably render a much higher percentage of good shots for most photographers, but a photographer should be aware of its limitations.

Once the ideal TTL exposure for 3 feet is established, it is a simple matter to interpolate for different STS distances. When working more closely, a smaller aperture will be chosen, and for greater distances a wider aperture is selected, moderated, of course, by the ambient light level. With TTL, the photographer need not be so precise in calibrating distance to exposure, but it is important to realize the effective range of automation.

The full manual test is crucial even for a photographer who never intends to shoot on manual because it determines what I call the upper limit of TTL. If we accept that TTL can never pump more light than full power, we know that no aperture smaller than is required by the full-power setting can couple with TTL. In addition, if the primary subject is not sufficiently large to reflect adequate light back to the TTL sensor, the system will assume it needs to keep discharging light up to the point equal to full power.

The classic example of failure of TTL is a small fish surrounded by a field of blue water. The open water background cannot reflect light back to the sensor, and the tiny fish reflects only a small percentage. Therefore, the sensor gets little light back and consequently "thinks" more is necessary. The strobe discharges full power, and the common result is an overexposed small fish. Typically, with a primary subject that occupies 65 percent or more of the frame, or with a coral background along the same plane as the primary subject, TTL will do quite well. However, when shooting a subject of less than 65 percent reflectance, it is safe to

In shallow water it is possible that the ambient light might overexpose what would be required of the strobe-to-subject (STS) distance for artificial light, as happened with this barracuda in Key Largo. The Sunny 16 rule helps to evaluate quickly whether strobe or ambient light is the primary contributor to exposure. *Nikonos RS, 50mm lens*

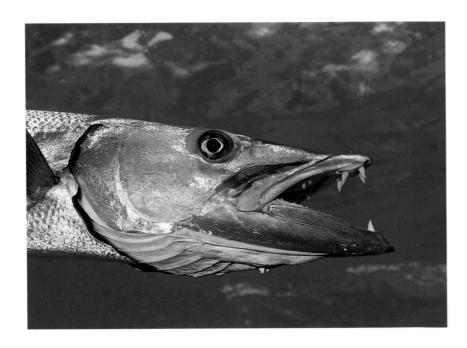

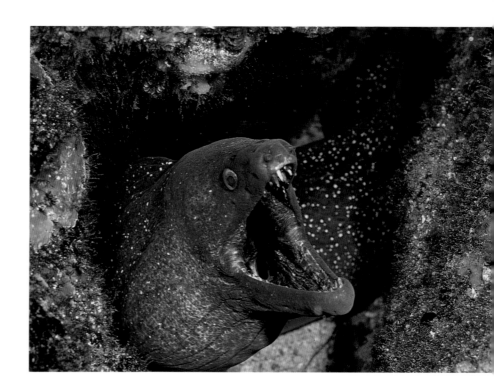

Above:
The color and detail of this fine-spot moray in the Galápagos are revealed through the use of a submersible strobe. *Nikonos RS, 50mm lens*

Opposite above left:
Fish like the midnight parrot fish in Key Largo require a Zone 1 exposure compensation, usually about one stop more light than an average subject. *Nikonos RS, 50mm lens*

Opposite above right:
Most coneys and grouper fall in Zone 2, subjects of average reflectance. However, the yellow coney (photographed in Grand Cayman) is slightly more reflective and benefits from an underexposure compensation of a half stop. *Nikon F3, 55mm macro lens*

Opposite below:
Light fish against light backgrounds, like this crocodile fish in the Solomon Islands, constitute Zone 3 subjects and usually call for a one-half to a full stop of underexposure. *Nikonos RS, 50mm lens*

assume the TTL system will dump full power, so choose the f-stop accordingly.

Manual strobe values have other determining factors, the most important being strobe-to-subject distance. Other considerations include capacity of re-cycle, power setting, whether or not a diffuser is in place, and reflectance of the subject.

The recycle time of a strobe is determined by how long it takes the capacitor to accumulate enough energy from the battery to power the flash. A neon light in-dicates the electrical charge of the capacitor, but it is often wired to illuminate be-fore the capacitor is at full charge, usually at about 85 percent. Nicads will typically give a faster recycle than disposable batteries, but no matter what power source is used, it is best to allow a few seconds beyond the ready light to assure consistent power output. If the recycle is beyond six to eight seconds, it is too slow to record efficiently the quickly moving underwater action. I prefer a recycle time of no more than four seconds.

The reflectance of a subject is something that should be considered whether TTL or manual exposures are employed. Just as Ansel Adams saw the need to assign tonal values to terrestrial topside subjects in his famed Zone System, the underwater photographer should consider zones of reflectivity. For Adams, the world ranged from Zone 0 (total black) through Zone V (middle gray of 18 per-cent reflectance as determined by a meter reading off a gray card) to Zone IX (approaching pure white). The underwater photographer need not be quite so discriminating, but at least three zones should be considered:

Zone 1. These are the dark fish like the midnight parrot fish, black grouper, black sea urchin, black durgon, blue tang, dusky damselfish, and tiger grouper that will require opening the aperture from one-half to one stop over normal.

Zone 2. These are the subjects of average reflectance that commonly populate the Caribbean reef, like the gray angelfish, green moray, rock hind, most coneys, gray snapper, queen angelfish, schoolmaster, Nassau grouper, trumpetfish, Atlantic spadefish, and so on. Most diver portraits fall in this zone as well, the ex-

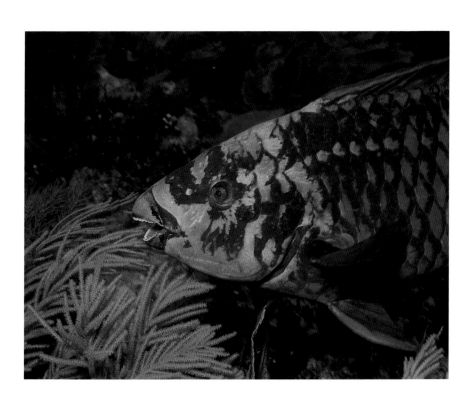
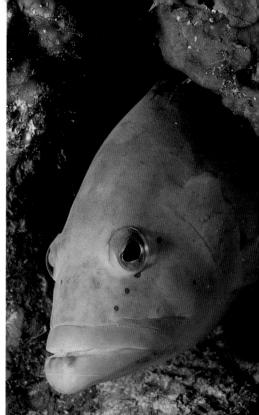
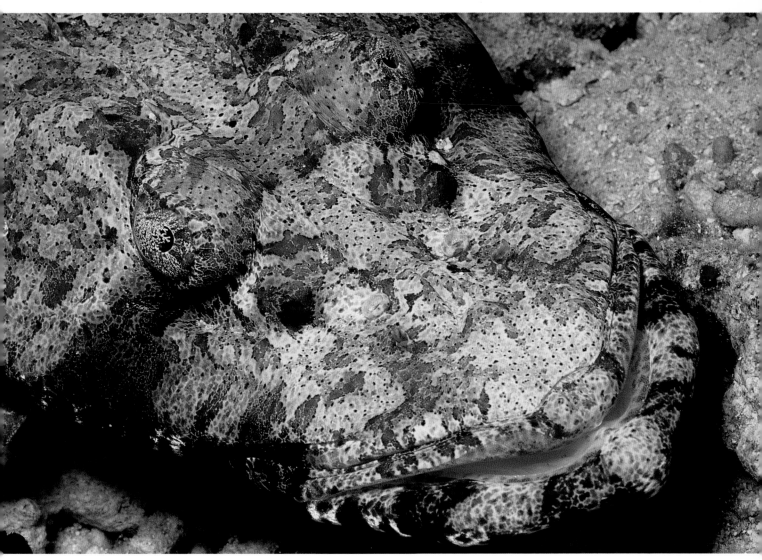

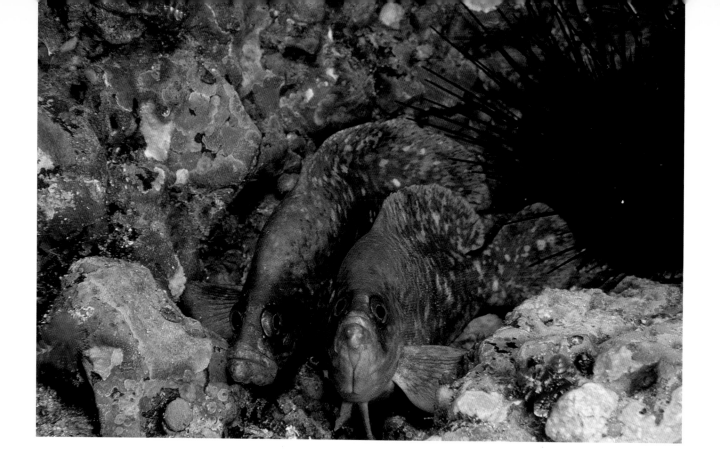

The use of a second strobe softened the shadows on this portrait of a pair of soapfish against the rocky seabed of Cocos Island. *Nikon F3, 55mm macro lens*

ception being tight close-ups of fair-skinned divers, which might require stopping down to a zone 3, or dark-skinned divers, who might need a zone 1 correction. This is the normal exposure, or what Adams refers to as the "pivot" density. Probably 80 percent of underwater subjects fall in Zone 2.

Zone 3. These are the high-key subjects of the reef, like the lizard fish on sand, flounder, the white phase of a hogfish, and highly reflectant fish like tarpon and barracuda. Zone 3 subjects often call for an aperture one-half to one stop smaller or a lower power setting on the strobe (for manual strobe settings).

MULTIPLE STROBES. A second strobe is often added to extend the coverage when using wide-angle lenses, to increase the light output so a smaller aperture can be used, and to fill the shadows left by a singular directional strobe. The second strobe can be triggered by a dual synch cord or it may be equipped with a slave sensor, so that the flash from the master strobe will trigger the slave. The dual synch cord method is far more reliable because the slave can be fooled by excessively high ambient light, minimal light being reflected back to the slave sensor, or the direction of the sensor relative to the master flash. Special double TTL cords are also available to take much of the guesswork out of determining multiple strobe exposures, but for manual exposures it is more complex, at least in theory.

A guide number may be used to calculate exposure information as follows: divide the rated guide number by the distance to yield the aperture. For example, with an SB 105 the manufacturer calls for an underwater guide number of 33 for ISO 100 film. At 3 feet this would yield an f/11 setting (33 divided by 3 = 11).

When using a second light source of equal power, aimed at precisely the same point, the new guide number is equal to the square root of the guide number of the first strobe squared plus that of the second strobe squared, admittedly a cumbersome calculation. More simply, multiply the original guide number by 1.4

to determine the new guide number. In the example of the SB 105, the new guide number for two strobes at full power with ISO 100 is 46.2; therefore, the suggested aperture for 3 feet is f/15.4 (near enough to f/16). Can we then assume that a second strobe adds one f-stop? Not necessarily.

It is uncommon that the first and second strobe will be aimed at precisely the same point. The second strobe is more often used to extend wide-angle coverage, and while there will be some convergence, total overlap is unlikely. In this case an exposure compensation of a half stop is more likely to be correct. In many cases the second strobe is used to fill shadows but retain textured light, so it might operate at only ¼ power, in which case the exposure compensation is negligible. Individual testing will determine the exact exposure for adding a second strobe, but it will probably be in the neighborhood of an aperture one-half stop smaller.

BLENDING STROBE LIGHT AND AMBIENT LIGHT. The manipulation of the ratio of strobe to ambient light is one of the most creative tools available to the wide-angle photographer. It is also important in photographing fish with a standard lens and, to a lesser extent, when working with macro or close-up.

We know that both available light and strobe light can contribute to an underwater exposure value, but they are not necessarily cumulative. The ratio of the aperture required for the strobe-lit foreground versus the available light falling on the background is the basis for evaluating the blend of strobe and ambient.

At first glance, the process of effecting this blend might seem a little complicated. Take, for example, a strobe distance that requires an f/8 foreground and a light meter reading of 5.6 for the ambient light at $\frac{1}{90}$ second. Now, consider the options, all shot at f/8. We can shoot at $\frac{1}{90}$ to have a properly strobe-lit foreground and a background that is a pleasing dark blue from being one stop underexposed. Or we could shoot at $\frac{1}{60}$ second to increase the ambient light striking the film by one-half stop due to the slower shutter speed. The new meter reading would be between f/5.6 and f/8 for the ambient light, and the background water would be one-half stop underexposed, also very acceptable. Or we could set the camera at $\frac{1}{30}$ second to yield a light meter reading falling between f/8 and f/11, but if we then set the aperture at f/8 for the strobe, we would be overexposed by one-half stop because of the excessive ambient light. So we would have to stop down one-half stop to account for the ambient and allow the strobe light to act as fill illumination and provide color. Other options to change the ratio include reducing the strobe power for manual exposure, let TTL reduce the strobe output automatically, or change the strobe-to-subject distance. All these would change the balance of the strobe-lit foreground and ambient light-influenced background.

To make it simpler, if the ambient-light background is intended as an element of the composition, it is possible to use the depth gauge as a crude sort of light meter to set shutter speeds. From the surface to a depth of 20 feet, use A or $\frac{1}{90}$, from 20 to 60 feet use $\frac{1}{60}$, and below 60 feet use a shutter speed of $\frac{1}{30}$ second. The slower shutter speeds will allow more ambient light for background but do not affect the strobe light in the foreground. I also use slower shutter speeds on overcast days, early in the morning or late in the afternoon, on shipwrecks, or any place I want to introduce more ambient light to the composition. I even use $\frac{1}{30}$ second or slower occasionally in macro photographs and close-focus wide-angle shots. In both cases a small aperture is called for in the foreground, due to the proximity of the flash, and by using a slow shutter speed the ambient light in the background records brighter.

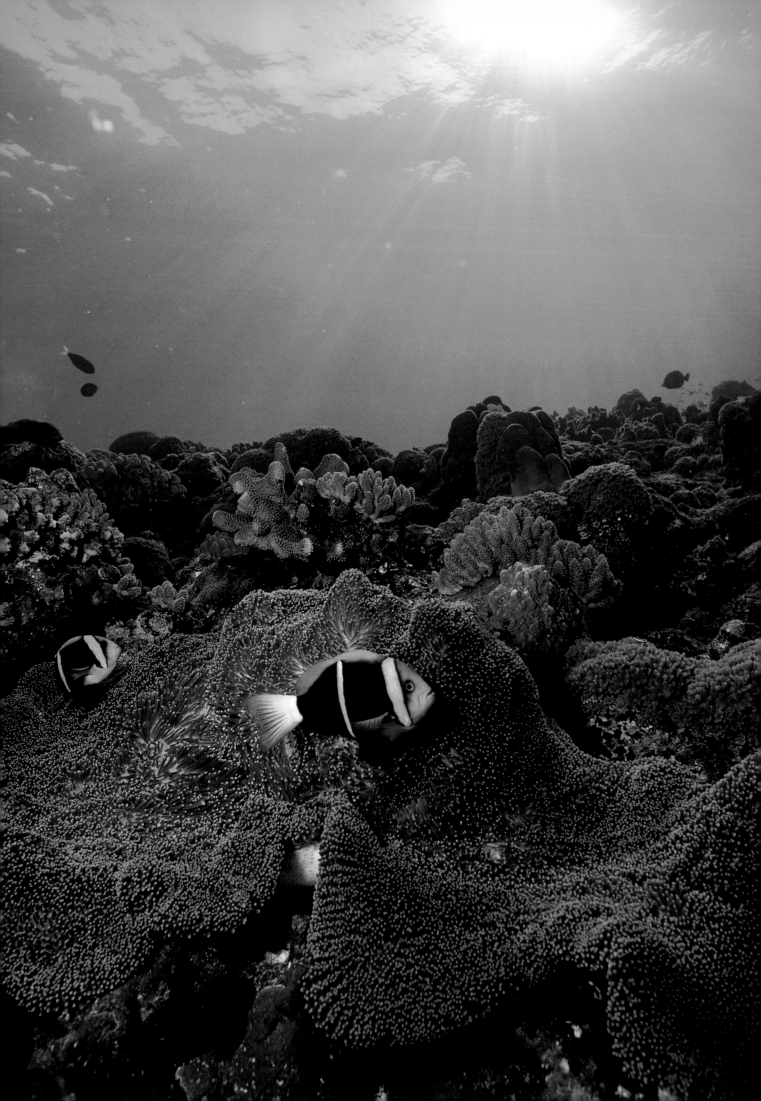

CHAPTER 2 THE TECHNIQUES OF UNDERWATER PHOTOGRAPHY

E ven a casual study of the living coral reef will reveal an abundance of photographic potential, but since the underwater photographer cannot change film and lenses underwater to suit the subject, some decision usually has to be made as to the type of subject likely to be photographed before entering the water.

Ways around this fact of underwater photography exist. With a budget big enough for assistants and a plethora of available camera gear, numerous cameras can be taken underwater so the right tool for the subject can be used as needed. David Doubilet has employed this technique to great advantage in many of his *National Geographic* assignments. Underwater photographer Jerry Greenberg has been known to leave a half-dozen camera systems clustered on the ocean floor while working in the Florida Keys, often with a sign that reads, "Do not disturb. Underwater Photographer at Work." I tried that method a few times, minus the sign, and I found it somewhat risky in a place where divers from other boats might converge on the same site. I once had to chase a diver all the way back to the boat on a Grand Cayman night dive after he found my Nikonos camera sitting by itself on the bottom.

Today's cameras make more choices possible. There are zoom lenses available for the Nikonos RS and housed cameras that can handle both wide-angle and standard-lens subjects on a single dive. A lens like a 60mm macro on a housed camera or either the 28mm or 50mm macro on the Nikonos RS will bridge the gap

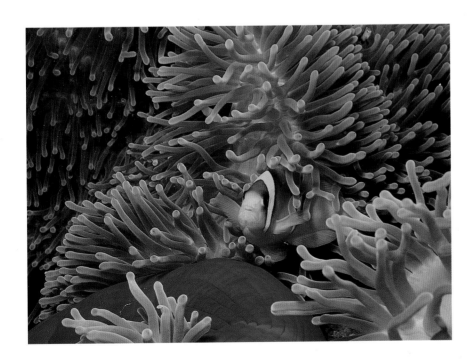

Opposite and left:
Since it is not normally possible to change lenses underwater (except with supplementary optics), the choice of lens being used to a large extent determines the type of subject matter. For example, using the 15mm wide-angle with the Nikonos allows a shot of the clownfish as well as detail of the surrounding coral reef (opposite), whereas the 28mm lens renders more of a fish portrait (left).

between standard-lens photography and close-up/macro work. However, for the most part once a system is set up underwater, it works best with only a relatively narrow range of subjects.

Reef Dwellers

These are subjects best photographed with a 35mm or 28mm lens on a Nikonos; a 50mm macro, 28mm, or 20–35mm zoom on a Nikonos RS; or a housed camera incorporating anything from a zoom lens or fixed focal-length lenses ranging from 35mm to 105mm macro.

Photographing the denizens of the tropical coral reef is probably the most compelling of underwater photographic endeavors. Diverse and colorful in themselves, these creatures inhabit environments lush and beautiful, and being as often as not elusive, they present a constant challenge. The giant port of a housed camera must look like the cavernous maw of some aggressive predator, and the diver a clumsy giant belching noisy exhaust bubbles. It is no wonder our mere presence often startles the photo subject into a hasty retreat.

Since effective underwater photography must be accomplished from a distance of four feet or less, the first consideration is the approach, a discipline I call "Zen and the art of fish photography." Successfully sneaking up on a fish is difficult, and outswimming it is out of the question. The fish must believe the photographer means no harm, and the photographer must communicate this with body language. It also helps to be calm and think good thoughts.

A word about the ethics of photographing marine life might be appropriate here. It is hard to know how much stress our photographic efforts might place on a marine organism. We know with certainty that bumping into fragile hard corals can damage the colony by breaking off chunks. But more subtle and insidious damage can also be caused by merely touching it, crushing polyps and abrading protective coatings, which allow algae and disease to take root. Silt is another problem created as an overweighted or careless diver fins off the sand bottom. The cloud of detritus can smother the coral polyps if repeated with enough frequency.

It is also a fact that handling a fish is harmful. Fish have a protective mucous coating, and grasping a fish to keep it from swimming away at the very least will scrape away some of this coating and facilitate the intrusion of disease. It will also panic the fish, which brings it to an entirely different stress level than being stalked by a benign strobe-flashing biped.

Sometimes the flash will seem to disorient the fish. I see this most often at night, and once I finish photographing the fish, I'll make sure it has enough time to get back to a coral recess safe from predation. I have seen many photographs of animals that do not swim in the open water, like arrow crabs, lettuce slugs, and banded coral shrimp, that have been tossed into the midwater so that macro-frame shooters can capture them against a water background. The problem here, aside from presenting a behavior that does not exist in nature, is that a yellowtail snapper or some other predator might swoop in to gobble the same hapless critter before it reaches the protection of the reef. Causing your subject to be eaten falls within the realm of unethical behavior. Marine life should be photographed where it normally lives and returned to a protective habitat before the photographer abandons the scene.

Even worse are mindless divers who grab on to a passing sea turtle. This animal breathes air and must get to the surface to survive. As it fights desperately to

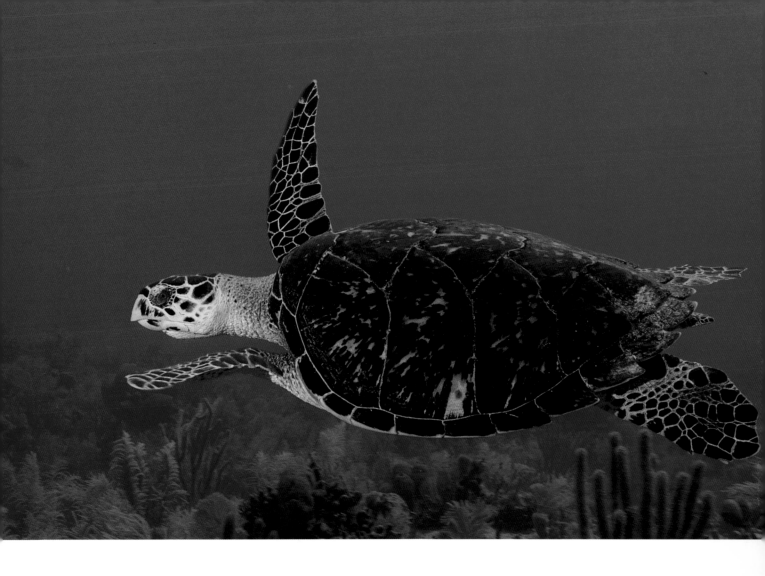

escape, it will burn more oxygen than normal and conceivably might drown. That's a pretty ugly fate for a marine creature that was minding its own business swimming along the coral reef but had the misfortune to come in contact with people. There is really little or no reason ever to touch marine life. The injunction found on T-shirts and bumper stickers, "Take only photos, leave only bubbles," bears consideration.

Any fish on the coral reef will be more likely to accept a photographer who swims to the scene slowly, cautiously, and in proper control of underwater buoyancy. A diver moving forward displaces a wall of water, and a fish is sensitive to such pressure sensations. Flailing arms and fins stirring a cloud of silt will do little to reassure the fish, and since mistakes made in discerning the intentions of animals the size of a diver mean certain death for a reef fish, they tend not to be trusting.

Breath control is crucial when approaching marine life, as a single burst of exhaust bubbles will often spook the fish. Even though our scuba instructors told us never to hold our breath underwater, doing so helps photographically. This means, however, moving only in a lateral or downward direction, since upward movement while holding compressed air in the lungs can cause the gas to expand in a dangerous air embollism. I try to time my final approach to the fish so that I take a deep breath just before entering the "field of flight," and then I try to wait to let my breath out until I have the shot.

The field of flight is different for different species, and for different specimens

Divers fortunate enough to encounter a turtle in the wild, such as this hawksbill turtle in the Florida Keys, should observe at a distance, and under no circumstance grab on for a ride. Turtles breathe air, and it would be possible to drown them by so doing. *Nikonos RS, 28mm lens*

93

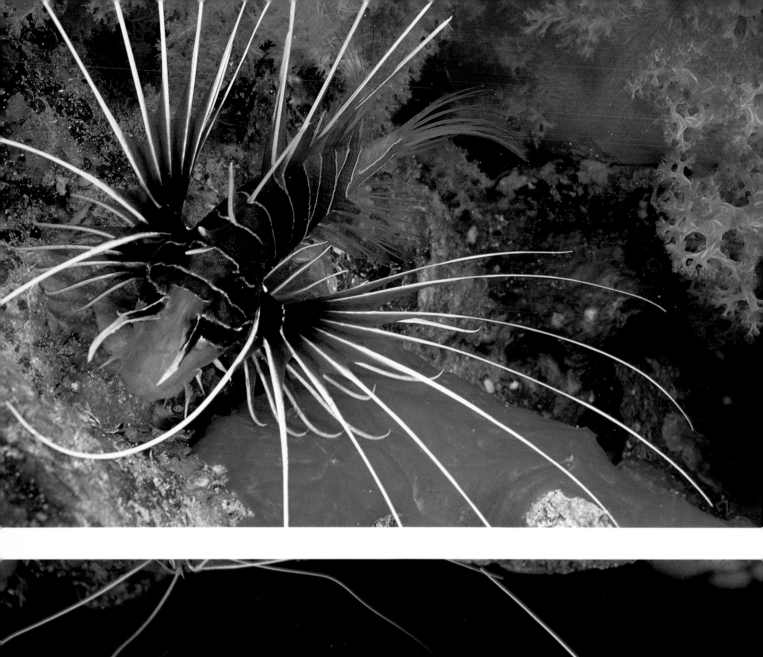

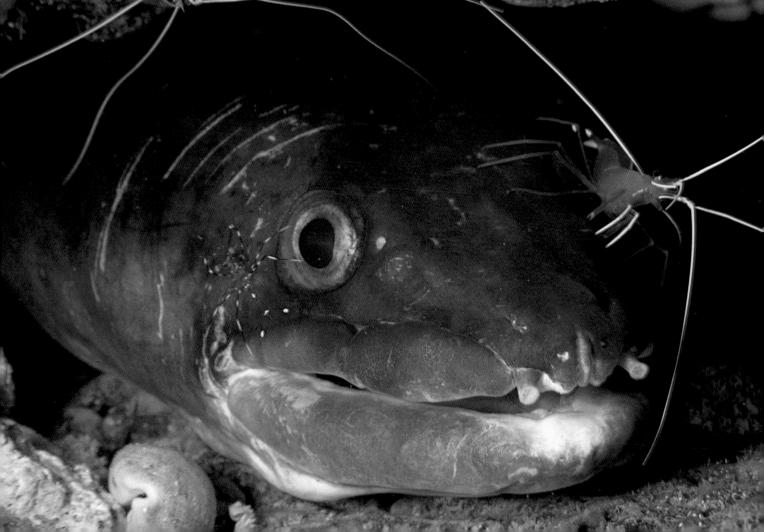

within the same species. This is a hypothetical zone outside of which the fish, while wary of the diver's presence, behaves normally, feeding, resting, or being cleaned. Once inside the zone the fish will realign its priorities and flee. The photographer's task is to get close enough for good color and resolution, yet always just outside the field of flight.

It helps to determine an approach where the field of flight is restricted by a natural barrier, like a bit of coral. If the fish has to swim in the direction of the photographer to get away, it is less likely to try to escape. Of course, trying to prevent the escape of a motivated fish can be problematic. I remember a night dive in Australia where I had a fire lionfish corralled in a small crevice. My camera port blocked the front escape, and the only other route was through a tiny tunnel I blocked with my left hand. I got one shot, advanced the film, got the second shot, and then through the ground glass I watched in dull-witted amazement as the lionfish postured its body to turn its poisonous dorsal spines toward my unprotected hand and rammed into me. As I felt the venom course through my veins while swimming back to the boat, I decided I had learned another lesson: fish usually run, but if they turn and fight, the diver will typically lose.

With some animals the best way to get close is by not approaching at all. Movement toward them signifies aggression, and they will flee. Fish such as scalloped hammerhead sharks are best photographed by finding a crevice in the reef near where the animals are likely to be and simply waiting for a shark to come close enough to shoot.

Tropical reef fish have preferred habitats, and a knowledge of their behaviors will assist in getting close. An example is found at the cleaning station. In a curious symbiotic relationship, small shrimp or fish will stake out an area of the reef where they "open for business." Their business is ridding fish of parasites, from which the cleaner derives a meal and the reef fish derives relief from the parasite. The much larger host does not eat the cleaner. In fact, it will hold its mouth open so that the cleaner has free access to the interior of the mouth and gills.

The posture of the host fish with its mouth open is interesting photographically, and when being cleaned, the fish is reluctant to leave the cleaning station prematurely. Several fish may be lined up waiting for the service, and they hate to leave before they are properly groomed. They will thus be more tolerant of the approach of the underwater photographer, who can not only get close but can take several photos in order to bracket exposures and vary the composition.

Once the target fish is identified and the ideal composition conceived in the mind's eye, it is time to creep ever closer. I try to have all the exposure controls set for the proposed strobe-to-subject distance and the strobe properly angled before entering the field of flight, for extraneous hand motions can spook the fish as well. I'll hope to get a first shot to record the scene, for once the shutter clicks and the strobe goes off I may never get a second.

Assuming the fish remains, the process of refinement begins. I may try to get a little closer, change the lighting, or bracket the exposures. With a good subject in an aesthetic background, I may shoot a dozen or more shots before abandoning the scene.

Schooling fish are inherently easier to approach than single fish because of their acceptance of the safety in numbers concept. The mind-set of the schooling behavior seems to be to present the appearance of one massive animal (or if that doesn't work, hope that the fish next door will be the one eaten instead). There is a beautiful symmetry to the way fish school in nature, usually all facing the same

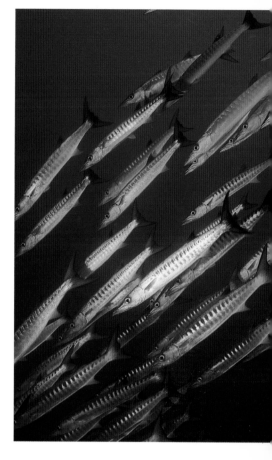

Above:
The natural symmetry of schooling fish will not be disturbed by photographers who approach slowly, carefully, and in a nonthreatening manner. These barracuda were photographed in the Solomon Islands. *Nikonos V, 15mm lens*

Opposite above:
Even a fish normally as docile as this Australian lionfish can react to being hassled by underwater photographers. Their venomous dorsal spines can inflict a nasty sting. *Nikon F2, 55mm macro lens*

Opposite below:
Even reclusive fish can be easily approached while occupied at a cleaning station. This conger eel in Kona, Hawaii, did not want to cut short its session with a cleaner shrimp. *Nikon F3, 55mm macro lens*

95

direction and turning in perfect synchronization. This is the kind of posture that should be captured by the photographer, not the random disarray the school breaks into when a predator gets too near. Again, a slow approach and careful breath control should keep the school intact.

Food is used by some underwater photographers to attract the fish close enough to photograph. With many sharks, this is almost obligatory, for rarely do divers even see a shark in the water, let alone get one close enough for a quality photo. Few shots of great white sharks would exist if they hadn't been chummed to the scene, enticed with chunks of horsemeat and dead tuna. Yet this whole concept of baiting marine life is controversial. Some people believe that offering such rewards changes the natural order of things, turning once proud wild creatures into Pavlovian robots.

That concept is a little too abstract for me, but it is valid to worry that when foods other than what would be part of a natural diet are used, the fish can get sick. Divers have traditionally used foods such as processed cheese, dog food, bread, sausage, and green peas to feed fish, and since many of these foods aren't even good for people, I'd accept that they aren't particularly good for fish. I have seen fish eat the plastic bags that the baits are carried in, which presents a potentially deadly health hazard to the fish.

The most valid concern with fish feeding is that by desensitizing marine animals to divers and bait, we make them more susceptible to hazards like spearfish-

Bait is sometimes used to attract marine life close enough for effective underwater photography. Here, Captain Spencer Slate in Key Largo holds a ballyhoo in his clenched teeth while his "pet" barracuda named Psycho races in for a snack. *Nikonos RS, 13mm lens*

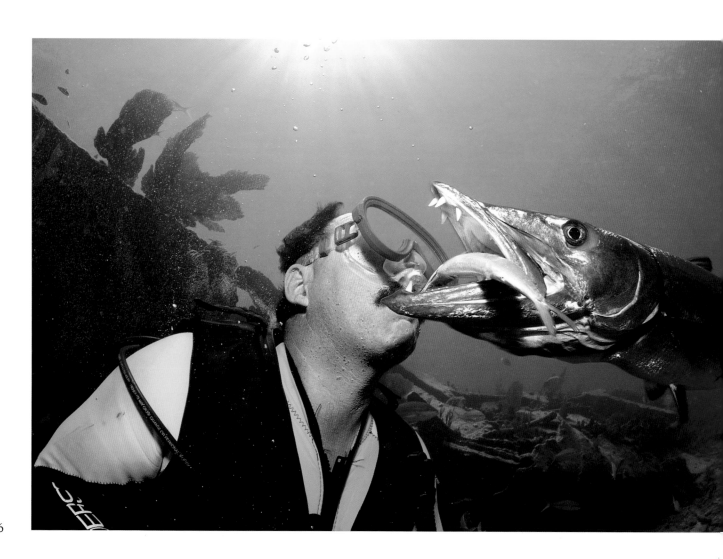

II. THE SCIENCE OF UNDERWATER PHOTOGRAPHY

ing, hook and line fishing, and even ruthless commercial fishing techniques like longlines. I've seen too many hand-fed groupers end up on a dinner plate to doubt this. At the other end of the spectrum, consistently hand-fed fish can be greedy enough to become a hazard to divers. We found this out all too well one day when my wife, Barbara Doernbach, was bit by a barracuda.

We knew the barracuda on this particular reef were used to being fed bally-hoo, and in fact I had taken a widely published series of photos of my friend Spencer Slate feeding the barracuda with a ballyhoo clenched between his teeth. Barbara and I had shot the hand-feeding setup a few times, but I had always been directly in front of her, watching her back, while she watched forward. Collectively we had a 360-degree field of vision, and she knew when it was safe to pull the bait out of the bag.

One day I was teaching a photo seminar and shooting video as a teaching aid while my students took still photos of Barbara feeding the barracuda. At one point, the barracuda came to rest just behind Barb's head, ominously near but outside her peripheral vision. The moment she took the ballyhoo from the bag, the barracuda struck with blinding speed. Even on the video playback it was almost too quick to follow. What we did see was her look of surprise, followed by a cloud of blood turned green by the color absorption of depth. The barracuda had made a mistake while going for the ballyhoo and sort of shredded her finger with its rapier-sharp teeth. It was definitely our fault, and it was also the last time Barbara ever hand-fed a barracuda.

COMPOSITION. When it comes to compositional considerations, my first thought is usually in regard to the plane of focus. A topside photographer may use an out-of-focus foreground to lead the viewer's eye to the primary subject, but in underwater photography anything out of focus in the foreground will also likely be closer to the strobe, therefore becoming both out of focus and overexposed. Instead of leading the eye to the prime subject, the eye is drawn to the bright spot in the photo. To avoid this, I usually place my primary subject at the front of the depth-of-field range, creating a clearly defined subject with optimal focus and exposure and thereby causing the soft focus to fall in the background.

By using sharp focus on a foreground fish and shallow depth of field, the primary subject, here, an *Anthias* in the Red Sea, stands out clearly against the background. *Nikon N90, 105mm macro lens*

A fish portrait, as of this arc-eye hawkfish in Kona, Hawaii, oriented from 45 degrees to parallel to the film plane usually produces a pleasing perspective. *Nikon F3, 55mm lens*

The posture of the fish relative to the film plane is also important. An orientation from parallel to 45 degrees with the head angled toward the camera always works well, and nontraditional compositions with the fish at right angles to the camera can also be effective. What rarely works are shots with the fish angled away from the camera as if in flight. These are the classic "tail shots" that should be avoided.

As most fish portraits imply motion, the fish should have "room" to swim. The sight of the fish jammed against the edge of the frame is somehow visually discomfiting. It is preferable to create some space forward of the fish, so the viewer's eye will track in one direction through the frame. The placement of the subject's eyes is crucial, for this is normally where the viewer looks first. The photographer should aim to reduce the number of saccades (rapid, jerky movements of the eye) necessary as the viewer takes in all the information in the photograph. Ideally, the viewer will be drawn to the subject's eyes and then be led through the composition with a minimum of visual confusion.

Finally, I must decide whether this will be a fish identification shot or an environmental portrait. The fish identification is a tight shot of the animal, good for taxonomic use. The environmental portrait shows not only the fish but something about where it lives. Naturally, the lens being used relative to the size of the fish and the distance will to a great extent determine compositional variables, but I normally prefer to record some behavior or a sense of the marine habitat rather than another tightly cropped fish shot.

Macro and Close-up Life

The tiny creatures of the coral reef are best captured with extension tubes or a close-up kit on a Nikonos, the 50mm or 28mm lens on a Nikonos RS, or the 60mm or 105mm macro lenses on housed cameras.

The technical aspect of executing macro and close-up photography is probably the easiest form of underwater photography and for beginners the most quickly rewarding. Exposures are easily controlled, often by relying on TTL automation.

98

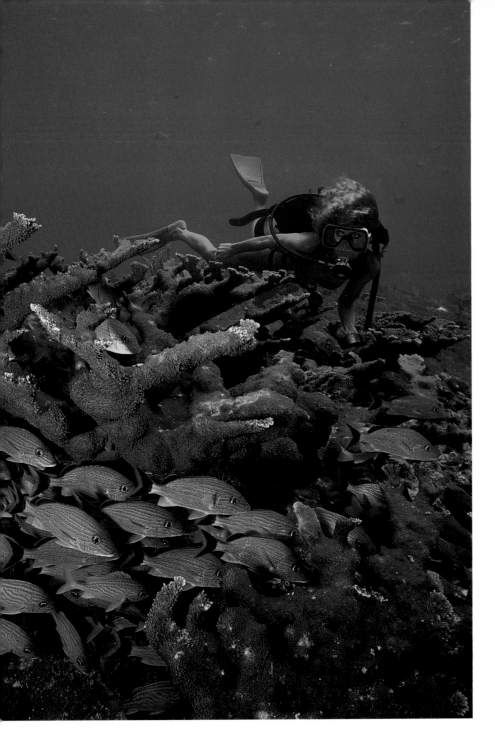

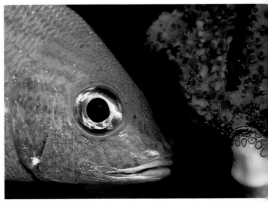

Left:
It is often preferable to show not only the marine life but also something of the world it inhabits, an image I call an "environmental" portrait. These schooling grunts populate a reef in the Florida Keys. *Nikonos V, 15mm lens*

Top:
The extreme close-up capability of the 1:1 macro tube presents ample opportunity to record the tiny details of marine life, such as the eye of this lizard fish in the Virgin Islands. *Nikonos V, 35mm lens with 1:1 extension tube*

Above:
The telephoto macro capability of the housed 105 macro lens allows tight head shots of medium-size fish or full-size portraits of smaller, more reclusive marine life. A grunt and flamingo-tongued cowrie were captured here. *Nikon F3, 105mm macro lens*

This works remarkably well for macro and close-up, probably because the average subject is either large enough (relative to the frame) or situated along a plane of focus near a background so it reflects greater than 70 percent of the light. Few subjects found in macro and close-up are the kinds that would fool the TTL sensor, such as a high percentage of open water, as is common with wide-angle.

Even with a totally manual system, a little testing will suggest the appropriate strobe-to-subject distance. The strobe can then be mounted on a tray to work consistently at this distance. In either automatic or manual, the mechanics of obtaining a proper exposure is a very simple point-and-shoot scenario. The hard part is finding subjects the right size for the magnification, getting close enough to photograph them before they flee, and when using a wire framer and focus wand, as with extension tubes and the close-up kits on the Nikonos, coaxing the animals inside the focus target.

99

MACRO AND CLOSE-UP WITH THE NIKONOS SYSTEM. With the wire framers of the Nikonos system, focus is very simple. The wands are calibrated so that close-up kits are in sharp focus at the framer with the lens set at infinity, and with most macro tubes, minimum focus is used to place the plane of focus at the framer. The Nikonos close-up kit has to work with three lenses, the 35mm, 28mm, and 80mm, so infinity is used as a convenient point where all three lenses will be equally in focus with a wand of a given size. While any focus setting could conceivably be used by an extension tube manufacturer simply by altering the length of framer support, minimum focus has been adopted as the industry standard.

Sometimes a subject may be inaccessible to the framer—for example, a flame scallop nestled within a coral recess. The macro photographer then has the option of shifting the focus to a point behind the framer by setting the lens at the infinity setting rather than minimum. However, it is difficult to determine exact focus. Depending on which extension tube is used, the focus shift may be in the range of ¼ to ½ inch—just possibly enough to make it work.

Set normally, any subject within the framer will be sharp, but the depth of field in front of and behind this point becomes progressively smaller as the level of magnification increases. Even though we are generally working at f/22 with macro and close-up, the range of focus is quite small, typically running from a third in front of the framer to two-thirds behind the framer. Sample focus ranges are shown in the accompanying chart.

Extension Tubes

1:6 close-up = depth of field approximately 3 inches
1:3 macro = depth of field approximately 1.5 inches
1:2 macro = depth of field approximately 1 inch
1:1 macro = depth of field approximately .5 inch
2:1 macro = virtually no depth of field, sharp only at plane of framer

Nikonos Close-up Kit

28mm lens = 1:6 magnification, focus range from 1.3 inches in front of the framer to 1.77 inches behind the framer
35mm lens = 1:4.5 magnification, focus from .86 inches in front of the framer to 1.1 inches behind the framer
80mm lens = 1:2.2 magnification, focus from .19 inches in front of the framer to .2 inches behind the framer

Given the narrow depth of field required by shooting macro, it is crucial to consider the plane of the subject relative to the film plane. Holding the framer parallel to the subject will assure maximum sharpness, and if the subject enters the framer at an angle, it is important to discern which elements need to be sharp and make sure they fall within the depth of field. When taking a close-up shot of a moray eel, for example, if the framer comes in from the front, the teeth might be sharp but the eyes are likely to fall off to soft focus. This may or may not be acceptable, but by shooting from the side, the mouth and the eyes are on the same plane of focus, which means both can be rendered sharply.

Extension tubes are simply O-ring-sealed aluminum cylinders machined at one end to mount on the Nikonos camera and at the other end to accept either the Nikonos 35mm or 28mm lens. This changes the optical properties of the lens to make it focus more closely, but also creates a watertight sealed unit that must not be removed underwater. With a Nikonos camera equipped for macro, the diver is

100

committed to this type of photography for the duration of the dive. On the other hand, the close-up kit, a supplementary lens that mounts on the front of the prime lens, can be taken on and off underwater for either close-up or standard-lens subjects.

Note that a tube made for a 35mm lens cannot be used for a 28mm lens, and vice versa. This is not to say it won't focus somewhere, but the framer will not show accurately where the point of focus is or what the composition might be. Care must also be taken to assure that the correct framer is used with both close-up kits and extension tubes. For instance, using a 1:1 framer with a 1:2 tube results in out-of-focus pictures, and the framer will likely show in each photo. Most tube/framer combinations are color-coded with an engraved dot or decal so that the yellow framer goes with the yellow tube and the red framer goes with the red tube. A special framer that will yield 2:1, or twice life-size, is marked by a red and yellow dot to indicate that two tubes must be stacked.

CLOSE-UP AND MACRO WITH THE SLR. While the extension tube or close-up-equipped Nikonos camera is a wonderful imaging tool for the reef's minutia, the mere presence of the framer, a strange and threatening, rectangular mouthlike object, can make some subjects incredibly skittish. Exceptions are subjects like a Christmas tree worm, coral polyp, scorpion fish, and a hermit crab, which don't move much. As long as the photographer approaches reasonably carefully and doesn't jostle the subject excessively with the framer, good, sharp photos will result. I've known extension tube shooters with sufficient patience to coax elusive critters like the longnose hawkfish into a framer, but they must have devoted a

Elusive, skittish creatures like the longnose hawkfish, in the Red Sea, are difficult to coax into a framer, but with a single-lens-reflex equipped with a macro lens, a careful approach can more easily capture the image. *Nikonos RS, 50mm lens*

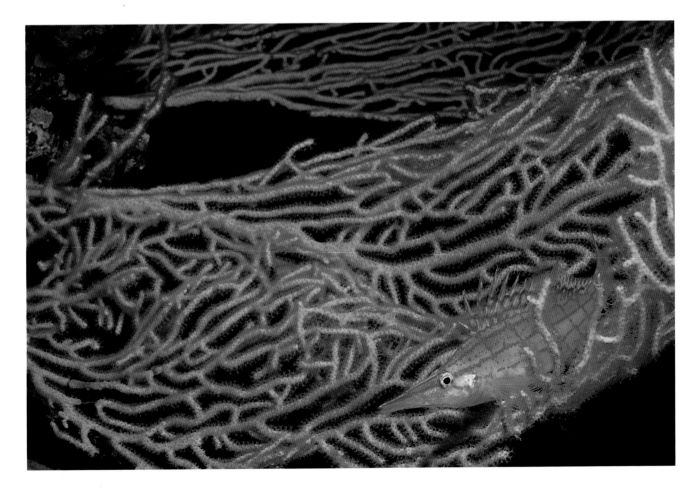

CHAPTER 2 THE TECHNIQUES OF UNDERWATER PHOTOGRAPHY

Invertebrates like starfish are easy to fit within a close-up framer, so they make popular subjects for Nikonos-equipped photographers. The brittle star comes from Bonaire. *Nikonos III, 28mm lens with a close-up kit*

whole dive to that single image. I prefer to find the tool that makes it easier—in this case, a housed SLR with a 105 macro.

Another problem with the framer is that it may not reliably reflect the view of the lens. Most of the time, subjects a quarter-inch inside the framer are shown on the film plane. However, I have used extension tubes with framers poorly calibrated that gave an inaccurate field of view. One of my lingering disappointments in underwater photography stems from the time I bought a brand-new 1:1 extension tube for an important assignment to photograph macro life in the kelp forest. I had to shoot Kodachrome and send it to the client for processing, so the assignment was actually over before I got to see any of the film. When I went in for film review, I saw that with every 1:1 shot (and I had shot dozens of rolls of film), subjects I had positioned in the center of the frame ended up at the extreme bottom of the film because the framer did not match the tube. The lesson: never go on location with an untested piece of equipment; at the very least, shoot some E-6 film and have it processed quickly to see that the equipment performs.

The Nikonos RS and housed SLR permit greater compositional accuracy in macro and close-up work, just as through-the-lens viewing does with fish photography. Submersible SLR systems work especially well at moderate distances from the subject. But once the composition requires the camera to be within a foot of the subject, even an SLR is intrusive. Especially with the 50mm on the RS or the 60mm in a housing, compositions at 1:1 are difficult because the front of the lens

II. The Science of Underwater Photography

must be placed just inches from the subject. Even an inanimate subject presents a problem, because the camera is so near the subject it blocks the light from the strobe. For these extreme magnifications, the 105mm macro lens allows the composition to be filled from a greater distance, which in turn makes it easier to illuminate with strobe and less likely to scare the fish.

While the focus with a framer is very straightforward, with an SLR the focus is achieved by either manually racking the focus or using autofocus. Both techniques are effective, but with macro and close-up subjects I often like to use a third method whereby I'll set the lens for a certain level of magnification, say, 1:2, and then carefully move into the subject until it pops into focus on the ground glass. This is good for subjects that might be scared by the sound of the servo motor operating the autofocus, subjects that might be better composed off center (away from the autofocus target), or subjects that dart about erratically.

Assuming the proper subject can be found and accurate focus achieved, the final element that delivers wonderful close-up and macro shots is the lighting. The color and resolution that result from working this close is remarkable since there is very little water column (and, subsequently, cyan filtration) to degrade the image, but it is all extremely strobe-dependent.

Some highly reflective macro/close-up subjects consistently present exposure problems. As with fish portraits, varying zones of exposure compensation are viable when working close, with dark subjects needing more light and a light subject needing less. With a manual system, exposure brackets are achieved by moving the strobe closer or farther away. Since the working aperture is best left at f/22 to assure maximum depth of field, the variable becomes the strobe-to-subject distance. With an automatic TTL exposure system, brackets are often best achieved by changing the film speed setting.

Assume the film speed is an ISO 100. By setting the film speed manually to ISO 200, the camera "thinks" the film is twice as sensitive to light as it truly is and will pump out half as much strobe light. Conversely, a setting of ISO 50 will tell the camera it is a slower film that needs twice as much light to expose properly. So long as the strobe is not already working at the upper limit of TTL (signified by a blinking ready light and slow recycle), it will pump out twice the quantity of light.

This method of auto-exposure bracketing is useful for any style of photography that integrates TTL, as well as for general calibration of a system. A photographer who finds exposures are always a half-stop too light with ISO 100 film and a particular combination of film, camera, and strobe may find the results improved by leaving the camera set at ISO 160. And the camera that consistently shoots too dark may benefit from an ISO 64 setting.

Beyond "proper" exposure—which can be very subjective—lighting can add creative elements to macro and close-up work. The standard lighting is 45 degrees from above, but holding the strobe by hand for backlight or sidelight can bring out new textures and details. Twin strobes of varying light ratios can create pleasing effects as well. But when using framers, it is important to make sure the angle of the strobe does not cause the shadow from the framer to fall across the subject. Some photographers will remove the frame entirely or cut off one of the frame arms to assure shadowless light, but with such a small strobe-to-subject distance as is typical of close-up and macro, it is pretty easy to predict where a shadow will fall and position the strobe head accordingly.

The artful execution of macro and close-up photography underwater is a wonderful way to record the bizarre, minute creatures found along the reef, and by

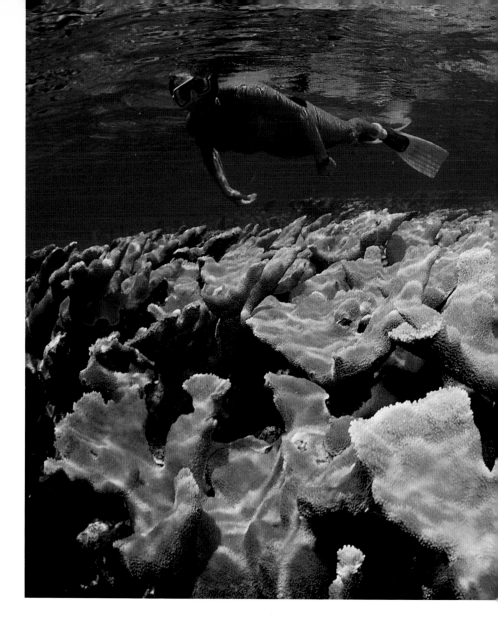

Above:
The wide-angle panorama conveys the story of "the reef at a glance," and the addition of divers to the scene (here in the Bahamas) adds a sense of scale.
Nikonos V, 15mm lens

Opposite:
Zoom lenses are excellent tools for recording both the wide-angle scene as well as more tightly composed fish portraits. These bigeyes were photographed in Pemba Island, Africa.
Nikonos RS, 20–35mm zoom at 35mm setting

training the eye to look for these sorts of creatures, greater understanding of how the symbiotic reef community is structured is achieved. The colors captured are almost surreal, and the resolution that results from working at such a minimal water column will render some of the most vibrant images in underwater photography. The addition of an extension tube is probably the least expensive option a photographer can bring to a system, and the success ratio is very high from the very beginning. All are compelling reasons to add macro and close-up techniques to any underwater photographer's bag of tricks.

Wide-Angle Work

Wide-angle is the format of commerce for an editorial and advertising photographer. This is the tool that tells the story of the wide panorama—the reef at a glance—and people in the marine environment. It also conveys the excitement of large marine life. To be considered wide-angle, the lens should have an angle of acceptance of at least 75 degrees or greater. For the Nikonos camera, this means the UW-Nikkor 15mm and 20mm lenses, the Sea and Sea 15mm or 12mm lenses, or the Aqua Lens from Aqua Vision Systems, which will house and adapt various topside Nikon wide-angle lenses to the Nikonos mount. For the Nikonos RS, the wide-angle tools are the 20–35mm zoom (used at the wide settings) and the 13mm

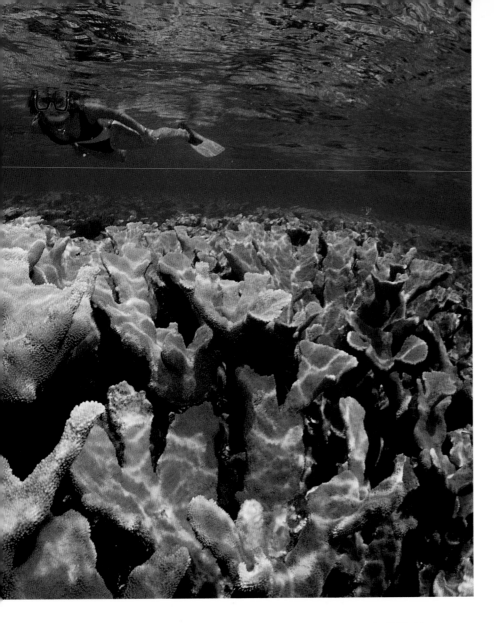

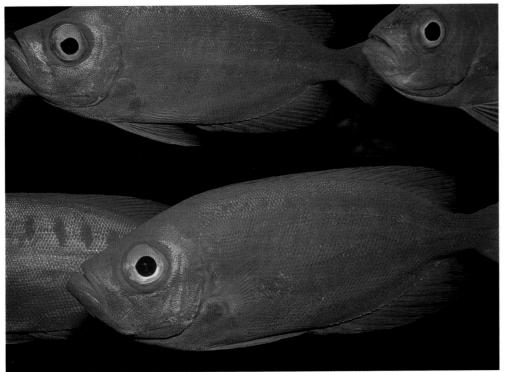

CHAPTER 2 THE TECHNIQUES OF UNDERWATER PHOTOGRAPHY

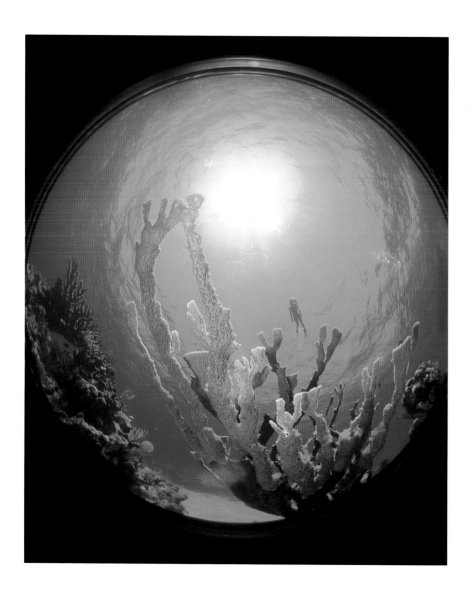

Right:
The 180-degree angle of coverage of the circular fish-eye creates interesting special effects, but it is difficult to light, since the coverage of the lens exceeds the angle of most strobe coverage. Pictured here is a snorkeler amid the elkhorn coral in San Salvador, Bahamas. *Nikonos V, 8mm circular fish-eye*

Opposite:
The 180-degree coverage of the 16mm lens adapted to the Nikonos camera via the Aqua Lens housing is excellent for recording foreground details, like these crimson whip gorgonians, while still providing sufficient depth of field for the diver and sunburst in the distance. *Nikonos V, 16mm lens in Aqua Lens housing*

fish-eye, and for housed cameras it may be lenses from a 16mm full-frame fish-eye to an 18, 20, or 24mm lens. Zoom lenses can also be used with the housed system for capturing wide-angle subjects, and on rare occasions I have even used the 8mm circular fish-eye for a special view of the marine habitat.

Strobes used for wide-angle photography typically utilize wide field reflectors or are equipped with diffusers to spread the beam evenly across the frame. Often dual strobe rigs are used with wide-angle as well, but it is rarely essential that the strobe cover the entire frame corner to corner. Most wide-angle compositions contain some element of open water that cannot reflect the strobe light anyway, so the concern becomes directing the strobe coverage to the portion of the reef that can be lit and allowing ambient light to take care of the rest. Good wide-strobe coverage is an important consideration, however.

WIDE-ANGLE WITH NIKONOS. The primary limitation of the Nikonos is that it does not see what the lens sees, either in terms of focus or composition, yet with wide-angle photography this weakness is far less relevant. Accurate optical viewfinders are available to approximate the angle of view of the lens, and at the normal subject distance of 2 feet and greater, parallax problems (such as cutting off part of a close subject) do not occur. Further, the extreme depth of field of the

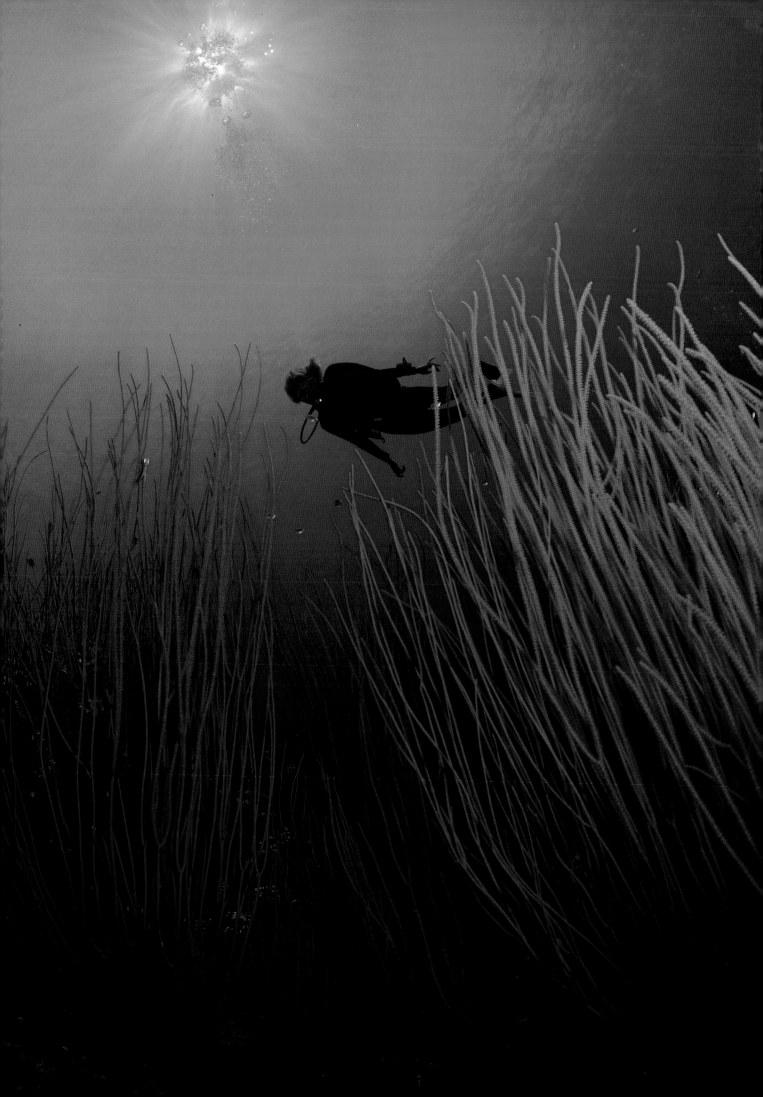

wide-angle makes focus very forgiving. This does not mean focus can be ignored with wide-angle lenses, but if you take the example of the Nikonos 15mm lens with an aperture set at f/8 and the distance set at 2.5 feet, the depth of field is from 1.25 feet to infinity. A photographer who cannot estimate within such a broad range has to be a pretty poor judge of distance. Given the accuracy of the available viewfinders and focus latitude, as well as the inherent speed and mobility of the Nikonos system, this is an exceptional choice for wide-angle work.

The wide-angle tools for the Nikonos RS, like those for the Nikonos V, are water contact lenses, corrected for use underwater and unable to function properly topside. Yet the tools for the RS are quite different from those available for the Nikonos V. The 20–35mm zoom lens used at its wide setting is reasonably good for diver portraits and excellent for reef scenics and portraits of big marine life, much like the 20mm lens of a Nikonos V. But it is a bulky and relatively expensive lens that creates greater water resistance than the Nikonos V/20mm lens package. On the other hand, the RS zoom will also deliver SLR compositions, autofocus, motor drive, and the ability to integrate other focal lengths at the twist of a knob.

There is no direct equivalent to the Nikonos 15mm lens and its 94-degree angle of view within the RS system. The Nikonos RS was created not to replace the Nikonos V but to supplement it, and as such there was little reason to duplicate the efficiency of the existing Nikonos 15mm. Instead, in the summer of 1994 Nikon introduced a 13mm lens for the Nikonos RS. With its 170-degree angle of view, it is substantially wider than the 15mm, and since it is a full-frame fish-eye, it is more likely to exhibit a barrel effect at the edges. However, the lens focuses very closely, to just an inch or so in front of the dome, and the depth of field is incredible. In one of my early tests with this lens I was shooting a diver through a portion of an old anchor. There was a gorgonian almost touching the dome on one side and coral heads at the far edge of visibility in the background. At f/8 and the lens focused for the diver 3 feet away, both the foreground and background were sharp, a range I'd estimate from 3 inches to infinity.

WIDE-ANGLE WITH SLR SYSTEMS. Housed cameras must use dome ports with wide-angle lenses to avoid excessive chromatic and spherical aberrations (see Chapter 3, "The Tools of Underwater Photography"), and the port must be sufficiently wide to avoid being "seen" by the wide-angle lens. While using a dome in water, the topside angle of view of the lens is restored, whereas with a flat port refraction occurs. Aberrations caused by the refraction of light rays at the water-dome surface (external) and dome-air surface (internal) are minimized when the entrance pupil of the camera lens is located at the center of the curvature of the dome. Failure to have the dome port specifically matched to the lens or mounted in a position that places the lens anywhere but at the center of the curvature of the dome will create optical problems such as chromatic and spherical aberrations. However, with the right dome and the lens properly mounted relative to the curvature of the dome, the housed camera provides a wonderful tool for wide-angle imaging, offering single-lens-reflex viewing and modern features like autofocus and motor drive. In addition, over-unders (photos taken half above the water and half below; see Chapter 3, "The Tools of Underwater Photography") can be done only with the housed system.

Regardless of whether the tool is a Nikonos, Nikonos RS, or housed camera, there are four basic types of wide-angle photos: ambient, reef scenics, close-focus, and those involving models.

AMBIENT WIDE-ANGLE. This is the available-light shot, appropriate for sub-
jects either too large or too far away to light effectively with a strobe, or in such
shallow water that strobe is not mandatory. There might even be a little strobe
light included to fill in shadows or add color accents, but by far the predominant
light is from the sun.

I often use this kind of shot to capture the scale and magnitude of an under-
water shipwreck or for large marine life near the surface. Ambient light is also the
primary source of light for over-under photos, but, again, a little strobe is some-
times used for the underwater portion of the frame. With wide-angle shots relying
entirely on ambient light, it is accepted that the tonal bias will be monochromatic
blue or green.

By using a 16mm lens behind a dome
port, I was able to capture the underwater
scene of the snorkelers with starfish as
well as the palm trees and clouds in the
distant background. In such shallow
water, ambient light is the primary
determinant of exposure. *Nikon F3, 16mm
full-frame fish-eye*

109

Most successful available-light shots use an upward-camera angle, with a primary subject in either full or partial silhouette against the sunlit shallows. Depending on the time of day and depth, the sunburst can be an interesting compositional element. The subject can be placed within the ball of sun or in some of the lighter-colored water around the sun. Divers and large marine life are particularly effective when silhouetted against the sun.

Exposure information for a wide-angle ambient-light image will depend to a great extent on where the light meter is aimed. With a sunburst as part of the image, aiming the meter at the most brilliant pool of light will cause underexposure elsewhere in the frame. To get an estimate of what setting would allow the sun to go light yet hold detail in the negative space, aim the meter off to the side about 30 degrees instead of directly at the sun. With an ISO 100 film and a depth of 50 feet in clear Caribbean water, this will give a reading of about f/8 at 1/125 second. As with any available-light underwater photograph, some judicious bracketing is advisable.

REEF SCENICS. The colorful reef scenic is one of our most requested type of stock photograph. The client desires an image that portrays the grandeur and diversity of the coral reef, while either consciously or unconsciously also looking for dramatic color and distinguishable detail. If the shot is taken from too great a distance, the color from the strobe will be diminished. If the perspective is too wide, the individual aspects of the coral reef may be lost, and the composition will have no clearly defined subject. Shooting effective reef scenics calls for a wide-angle optic used according to special considerations.

A 20mm to 24mm lens in a housing or a 15mm or 20mm on a Nikonos are good choices for most applications. This allows the camera to be positioned no more than 3 feet away but still retains the reef panorama. With a successful blend of strobe and ambient light, subjects in the foreground are brightly illuminated by the strobe and detail in the background is retained. Since the most prolific reefs are usually in fairly shallow water, blending strobe and ambient light is reasonably easy to accomplish with normal shutter speed/aperture combinations. For example, if I were shooting a luscious Red Sea reef scenic in 30 feet of water with a Nikonos 20mm, SB 104 strobe, and ISO 50 film, I would probably use 1/60 second, full-power strobe output, and set the aperture at f/8 for subjects 4 feet away.

Using wider lenses for reef scenics, like the Nikonos 15mm or even a full-frame fish-eye, entails getting close to a prime foreground subject and forcing the perspective slightly. Instead of working at 3 feet and recording everything along a single plane, isolate a subject of interest, get close, and use the perspective distortion that occurs when subjects are near the foreground in a wide-angle shot to advantage.

The classic example is the clownfish and anemone. A standard lens might be used to record the fish and its habitat, or a close-up lens might record only the clownfish, but working with close-focus wide-angle techniques and creative lighting, the clownfish and anemone will be the obvious subject of a reef panorama composition.

CLOSE-FOCUS WIDE-ANGLE. This is a technique long practiced by underwater photographers, but it was perhaps first and best explained by Howard Hall in his 1982 *Guide to Successful Underwater Photography*:

Opposite:
This Red Sea shipwreck is an example of the normal perspective of the 15mm lens. The divers are about 3 feet away, and the more distant bits of wreckage, about 12 feet distant, remain in sharp focus.
Nikonos V, 15mm lens

111

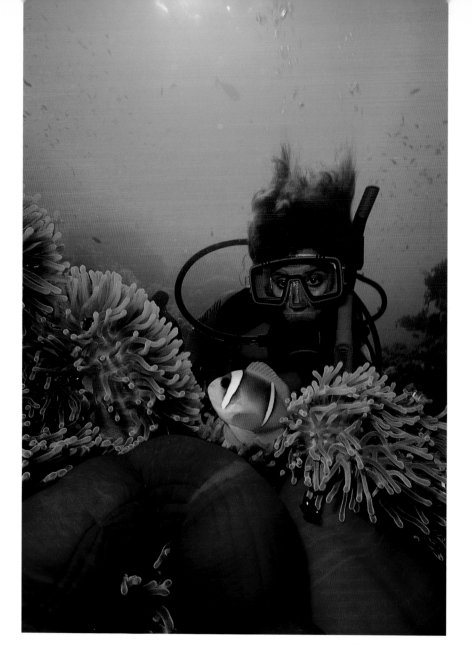

Close-focus wide-angle is a useful technique to force perspective and make small foreground subjects appear large—here, a diver and clownfish in the Red Sea. The difficulty is controlling for the parallax that occurs when the viewfinder does not see precisely the same view as the lens does. *Nikonos V, 15mm lens*

Close focus wide angle (CFWA) photographs are perhaps the most beautiful type of photograph that can be taken underwater. The result is the beautifully rich colors of macro, combined with the expansiveness of wide angle available light and silhouette photography. The first CFWA photographs I saw were taken by well known underwater photographer Jerry Greenberg. At first, I thought this technique was magic, and it took me a long time to figure out just how it was done.

Much of the secret is given away by the name I have arbitrarily given to this type of photograph. The idea is to take advantage of the extreme depth of field which wide angle lenses are capable of. For example, the 15mm Nikonos lens has a depth of field of from one foot to nearly infinity when set at f/16. It is therefore possible to get an average sized starfish nicely framed in the foreground with a diver swimming through a kelp forest in the background, all in focus at the same time. The trick is to balance exposures.

Actually, there are two tricks: balancing exposure, as Howard says, and accurately composing the picture. Because of the close distance and the desire for

good depth of field, small apertures like f/16 are often used for CFWA. In order to open up the background, that is, bring the foreground and background to a more "balanced" exposure, I usually use a slower shutter speed, at least 1/60 and often 1/30. CFWA is most often practiced on relatively stationary foreground subjects, in which case the slow shutter speed is not a problem, and the brief illumination of the strobe will freeze any slight motion that the subject or camera movement might create.

In terms of composition, with a single-lens-reflex camera, close-focus wide-angle setups are no more challenging than any other type because the photographer actually sees through the lens. But with a viewfinder-style camera like the Nikonos, parallax problems (created because the lens does not see the same subject as the viewfinder up close) occur at distances closer than about 1.5 feet.

When shooting close-focus wide-angle photos with the Nikonos, it is therefore necessary to work semi-independent of the viewfinder. I may use the viewfinder to previsualize the scene, but when it comes time to shoot, I'll remove the viewfinder from my eye, leave my head positioned the same, move the back of the camera to where the viewfinder had been, and shoot. This puts the lens where the viewfinder had been, presumably to see what the viewfinder had framed a moment before, thereby correcting parallax. With experience, the angle of view and close-focus capability of the lens can be predicted, making the viewfinder superfluous.

WORKING WITH MODELS. Divers can be a fascinating element of the composition in a wide-angle photograph, both to give a sense of scale and perspective and to create a sensation of "being there." The underwater environment is an exotic location for most viewers, and placing a diver within the frame renders the scene somehow more accessible. It "sells" the excitement and beauty of being underwater, making the ability to capture divers effectively in a wide-angle photo a crucial skill for both editorial and advertising illustration.

While I have used 28mm lenses for head and shoulder shots, and occasionally use a 20mm focal length, by far the majority of my wide-angle shots of divers have been with the Nikonos 15mm lens. The 94-degree angle of view makes it possible to frame a full diver from only about 3 feet away, and it does not excessively distort. Sometimes I will use a lens like the housed 16mm or 13mm on the Nikonos RS (both full-frame fish-eyes) for diver portraits, but care must be taken with these lenses to prevent unnatural perspective distortions, or what I call "the hands that ate Chicago" syndrome.

Some years ago I did an advertising photograph of a diver holding outstretched hands dripping with gold chains and coins, booty from some imagined undersea shipwreck. The art director was not used to looking at underwater photos and did not realize how much we rely on wide-angle lenses when photographing people. When I showed him the results of the first day's shoot he gasped, "My God . . . those are the hands that ate Chicago!" With the hands nearer the lens than the diver's face, the lens distorted the perspective, making the hands seem excessively large. We reshot with the model's hands closer to the body, thereby keeping everything along a single plane, and all was well. But I'll never forget the art director's shocked dismay at an optical property I had accepted as the natural order of things in underwater photography.

In some cases the inclusion of a diver in the frame is a fortuitous accident. While setting up a wide-angle scenic, off in the distance a diver will appear in sil-

houette, a perfect complement to the composition. With luck, you can get a few shots in before the diver meanders out of the frame. A far better technique is to gain the cooperation of a diver to work as an underwater model, someone who can be directed to complement the composition.

This collaboration should begin topside. Beyond the obvious responsibilities one dive buddy has for another in terms of life support, the photographer/model pair should have some means of underwater communication so the photographer can tell the model whether the shot will be a vertical or horizontal, where the model's eyes should be directed, and where in the frame relative to the foreground the model should be positioned. If the photographer intends for the model to swim through a school of brightly colored fish, for example, some hand signal should communicate this at a glance. If there is too much backscatter on the scene, a signal should so indicate. Since the photographer will have hands full of equipment, signals should be economical, perhaps involving only the fingers.

Once a diver/model team is able to predict the kinds of setups that might be encountered underwater and outline the appropriate signals for model position, the shooting will begin to flow smoothly. Instinct and experience play a big role here. The more a photographer works with a single model, the better their underwater communication will become. This communication is best enhanced by spending time at the light table after the shoot collectively analyzing what worked and what did not. It also helps if the model has a reasonable background in underwater photography. By knowing the angle of acceptance and perspective of a 15mm lens, for example, the model is better able to position within the frame. By knowing the effective range of a submersible strobe, a model will know whether he or she will be appearing as a primary subject or a silhouette element of composition.

Some of the collective considerations between the model and photographer include:

Ease underwater. The model should appear to be enjoying him/herself and in control of buoyancy. A stiff, rigid posture is unnatural, and flailing arms or any body language that implies agitation is inappropriate. The best photos occur when the model doesn't appear to be posing.

Gear. The ratty old T-shirts and blue jeans that divers wore in years past belong to another era. Today's dive fashions are colorful and functional, which gives an underwater photographer more to work with. Translucent silicone masks make it easier to light a model's eyes, and brightly colored buoyancy compensators and wet suits attractively complement the tropical scene. I've also found that having models comfortably warm and freed from abrasion by wearing a wet suit will assure more cooperation (and a longer dive) than having them shivering in the cold. If possible, some degree of color coordination is nice, but just having modern and obviously functional equipment is an aesthetic advantage.

Eye direction. The model should seem to "interact" with a primary underwater subject, whether it be a sponge or fish or shipwreck. There should be some purpose for the diver's placement in the frame, and the direction of the eyes should communicate that purpose, so a signal to direct the eyes is useful.

Note also that it is important to see the eyes, and a fogged mask will prevent this. Make sure when using new equipment that it has been scrubbed sufficiently so it will not fog (try mild scouring powder or abrasive toothpaste for this) and that an appropriate defog agent is used on the mask before diving.

Bubbles. Some photographers prefer to have no exhaust bubbles from the

diver in the frame. Since I consider breathing an important part of being under-
water, I have no problem with bubbles unless they obscure the face or cause the
model's hair to billow out in some bizarre fashion. The only time bubbles become
a nuisance is when they rise to dislodge particles (an effect known as percolation)
while the photographer and model are working under an overhang or inside a
wreck. The photographer needs to be aware that the exhaust bubbles from either
photographer or model will soon make the site too full of particulate matter to
shoot without backscatter. To obviate this potential problem, I'll work just inside
an overhang, grab a few shots, and then lean back out in the clear to breathe be-
fore continuing. This way my bubbles don't dislodge particles.

 Environmental concerns. Touching coral obviously damages the marine envi-
ronment, and photos that show divers touching the coral endorse a very harmful
practice. Models in underwater photos should not touch the coral at all and
should have all gauges and hoses attached to their bodies in such a way that they
will not touch, or even appear to touch, the coral. Likewise, handling marine life is
best avoided, particularly when wearing gloves, which may abrade the protective
mucous layer that coats most marine life.

Eye contact is very important when
working with models, as demonstrated in
this photo in the open ocean of a sea
turtle hatchling released in the Virgin
Islands. *Nikonos RS, 28mm lens*

115

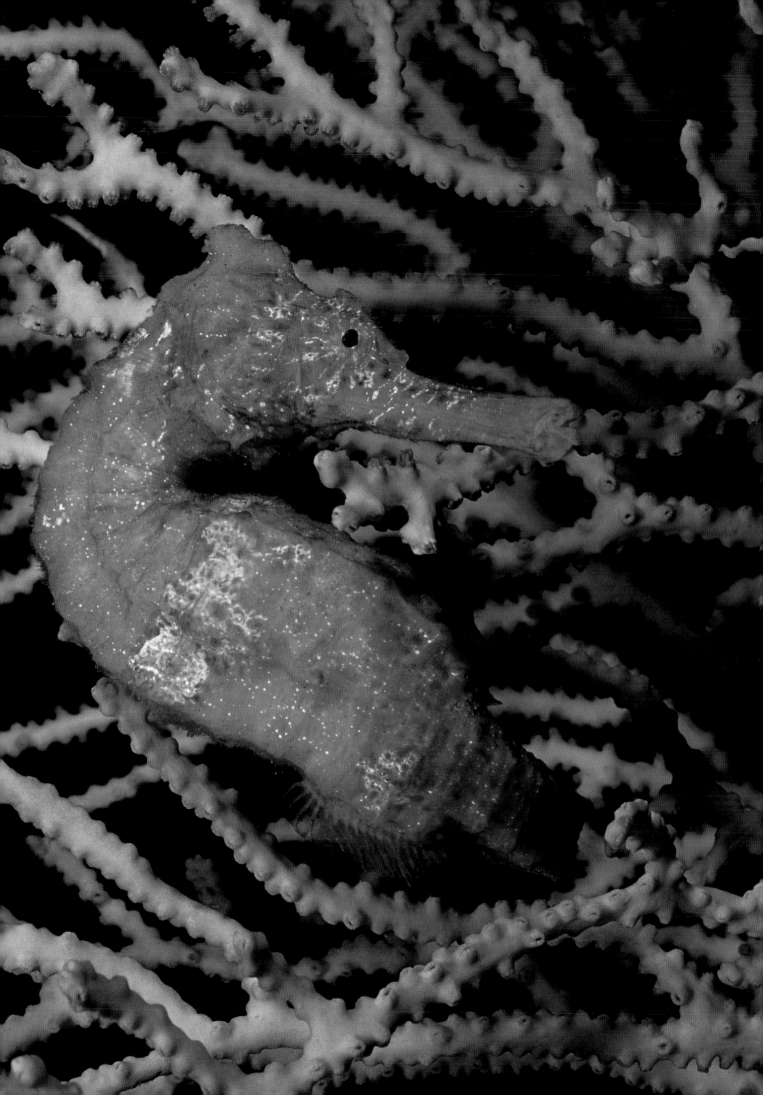

CHAPTER 3 THE TOOLS OF
UNDERWATER PHOTOGRAPHY

U nderwater photography is an equipment-intensive art. It calls for the means to take the film underwater, record the image, and come back with dry film. As simple as this formulation may seem, I've returned to the surface with enough soggy rolls of film and ruined cameras to realize that it must have presented a daunting challenge to the inventors and pioneers of underwater photography.

History of the Tools

The first to rise to the challenge, a Frenchman named Louis Boutan, devised a way to keep his camera dry long enough to take the first underwater photo just over a century ago, in 1893. He constructed a watertight box that weighed over four hundred pounds in the water to house a 5-by-7-inch wet-plate camera that took only a single frame per dive. Today's underwater cameras are much smaller, of course, except for specialty rigs like the IMAX 3-D camera and housing, which weighs in at 1,800 pounds and takes several divers to position it in place on the reef!

Other experimenters soon followed, most notably Etienne Peau, who studied the eyes of the Maya crab to pick up pointers on underwater optics around 1905, and H. Hartman, who developed a remote-controlled time-lapse camera that weighed 1,700 pounds and could shoot 6,000 frames without reloading. In the United States, John Williamson began taking pictures with a topside camera through a special submerged observation ball his father had fitted to a barge to assist marine salvage. Through this sphere, Williamson captured still images of Chesapeake Bay marine life that were so astounding, he was financed to do an underwater movie. Shot in the Bahamas, *The Williamson Submarine Expedition* featured a key scene where the diver was to use a knife to rip open the belly of a marauding shark. A bloody horse carcass was brought in to attract the shark, and when the first two divers failed to bring the desired action to the filming port, Williamson did it himself while an associate filmed the scene. Williamson's magnum opus was *Twenty Thousand Leagues Under the Sea*, produced forty years before the Walt Disney film of the same name and complete with a patented mechanical giant octopus.

On the still-photograph front, Dr. W. H. Longley began working in the Dry Tortugas with Autochrome color film underwater. He realized that in order to capture moving fish, he needed a powerful flashlight. He collaborated with Charles Martin, a photo technician at *National Geographic*, to contrive a way to ignite a full pound of magnesium flash powder on the surface with a tented reflector. This gave enough light for a $\frac{1}{20}$ second exposure, but the tremendous explosion was very dangerous. Once a detonator with only one ounce of powder exploded prematurely, and Longley was out of work for six days. A full one-pound charge would have killed him. His results were first published in the January 1927 issue of *National Geographic*.

Opposite:
Underwater photography captures the tiny details of the coral reef, such as this sea horse and gorgonian, as well as the wider panoramas. *Nikon F3, 55mm macro lens*

In the early 1940s underwater pioneer Jacques-Yves Cousteau was collaborating with his pals Frederic Dumas and Philippe Tailliez to build and film with underwater movie cameras. By 1942 they had produced *Sixty Feet Down* in black and white, and by 1948 were filming in color at depths of 130 feet. As Dumas played his powerful floodlamp along the deep wall, they were astounded to discover a brilliant montage of color assaulting the lens. They had no idea the underwater world was so vibrant. Cousteau wondered, "Why did nature put this color here, where it could never be seen, even by fish?" He later added bulb flash guns to his Rollei housings to add a similar level of color to his underwater still images.

The Austrian Hans Hass used an adaptation of the Draeger oxygen lung for underwater photography, and he learned the hazards of breathing pure oxygen at depth after his friend Commander Hodges convulsed on the surface and drowned after making an 80-foot dive with Hass. Hass went on to become one of the most influential of the still photographers, not only in terms of the quality of the images he captured but also in terms of equipment design. The venerable Rolleimarin housing for the twin-lens-reflex Rollei was a Hans Hass creation.

The Housed Camera

Modern underwater photography probably owes more to the invention of scuba (self-contained underwater breathing apparatus) in 1943 than to any optical or mechanical photographic invention. Scuba made the underwater world truly accessible to those with an air tank on their backs and a regulator in their mouths. Nearly as soon as divers began exploring their new universe, they wanted a way to bring home memories of what they saw. The logical way was to take an existing land camera and adapt it to underwater use via a "housing."

Many of the early pioneers in underwater photography were forced to design and fabricate their own underwater housings because the market was too small to justify mass production. Jerry Greenberg, in his book *Underwater Photography Simplified*, published in the mid-1950s, observed, "When underwater photography first made its splash in this country photographers found only a ripple of commercial housings available, all carrying a high price tag. This situation lasted only long enough for underwater photographers to assert their ingenuity. It wasn't unusual to see them shooting their first underwater pictures with such make-shift housings as plastic food containers, hot water bags, rubber gloves, and pressure cookers. Although these cumbersome housings served as an excellent stepping stone to underwater photography, serious underwater photographers required more exacting equipment for their work."

Two early housings that could still render top-quality images even today are the Rolleimarin for the Rollei twin-lens-reflex camera and the Ocean Eye for the Nikon F. The Rolleimarin was a clever housing with a built-in magnifying prism so that divers with face masks could have a clear, enlarged view of the ground glass. Shutter speed, aperture, film advance, and bulb flash synchronization ports were available as external controls, but probably the most inventive accessory was the lever that switched a pair of close-up lenses in front of or away from both the viewing and taking lens while underwater.

By the late 1960s the Ocean Eye, designed by *National Geographic* photographer Bates Littlehales and photogrammetric engineer Gomer McNeil, was considered the new state of the art, with its 8-inch cyclopean Plexiglas dome offering full optical correction for a variety of Nikkor lenses mounted on the Nikon F camera.

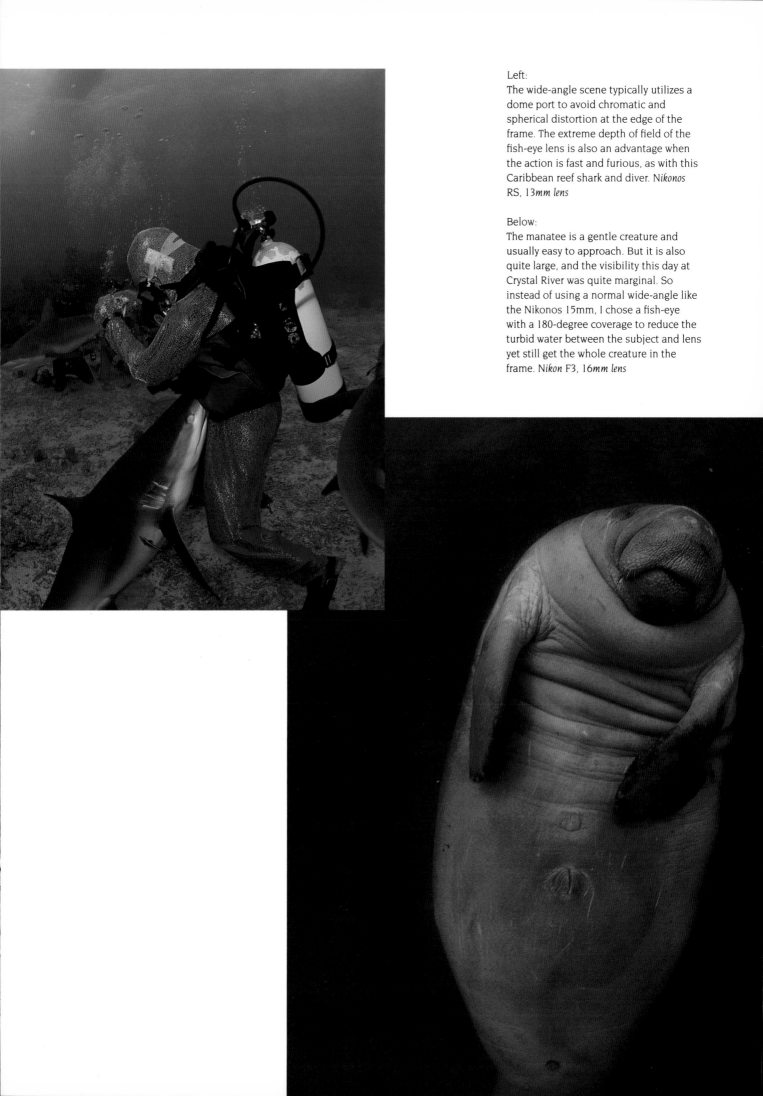

Left:
The wide-angle scene typically utilizes a dome port to avoid chromatic and spherical distortion at the edge of the frame. The extreme depth of field of the fish-eye lens is also an advantage when the action is fast and furious, as with this Caribbean reef shark and diver. *Nikonos RS, 13mm lens*

Below:
The manatee is a gentle creature and usually easy to approach. But it is also quite large, and the visibility this day at Crystal River was quite marginal. So instead of using a normal wide-angle like the Nikonos 15mm, I chose a fish-eye with a 180-degree coverage to reduce the turbid water between the subject and lens yet still get the whole creature in the frame. *Nikon F3, 16mm lens*

The Nikon F was chosen because it featured interchangeable viewfinders, specifically, an Action Finder, which allowed underwater photographers with face masks to see clearly the entire ground glass from a distance. Fish photographers could now use the 55mm Micro-Nikkor to capture images from infinity (or at least the limits of visibility) down to half life-size macro shots, or capture the wide-angle world with a 24mm, 20mm, or even a 16mm full-frame fish-eye lens for a 180-degree field of view. The optics were great on the Ocean Eye, but the buoyancy caused by the volume of the air inside the housing made it constantly want to float dome up. Photographers continually fought this buoyancy bias underwater, making powerful wrists a helpful attribute of Ocean Eye shooters.

It was Ikelite, with its wide variety of Lexan housing designs, that really brought affordable camera housings to the masses. This company made housings for the Nikon F and Canon F1, which were popular with serious underwater photographers. However, it went further, adapting the housings to virtually all of the popular single-lens-reflex cameras of the day. It even made inexpensive box housings for the 110, 126, and 35mm point-and-shoot cameras of the 1960s and 1970s. Today, the best of the modern housings are ergonomic enclosures for topside cameras that utilize such high-tech features as automatic focus and through-the-lens exposure control adapted to underwater use.

Ideally the housing should allow the photographer to choose between manual and autofocus, taking advantage of the technology when appropriate and falling back on tried and true focus methods as needed. Unfortunately, not all housings permit an easy shift from auto to manual focus.

The servo motor that drives the lens autofocus on a topside camera is usually not strong enough to power past the resistance caused by a manual focus gear, so even though a control could be installed to access the M/C/S switch (manual/continuous/single servo focus modes), switching from auto to manual focus underwater can still be a problem. Some housings ignore this problem altogether and allow for *only* autofocus, and others force the photographer to make a decision before going underwater whether to shoot in auto or manual focus modes. Some housings have the option of switching focus mode with a limited selection of lenses and ports. All of this is enough of an issue to make it a point of research in evaluating which underwater housing is best to buy.

Housed cameras allow a variety of lenses to be used with corresponding ports to enhance the optical quality and ease of handling, but for the best optical performance, the lens must be matched to the right port.

DOME PORT. The dome port eliminates refraction so that the lens's angle of view underwater corresponds to its angle above water. The light rays bend at the port interface on a flat port just as they do with a diver's face mask. This is an optical problem not relevant with the narrow angle of view of a standard lens. With a wide-angle lens, however, the light rays near the edge of the frame are severely refracted. The lens "sees" these distorted light rays as chromatic and spherical aberrations. The dome port allows the light rays to pass through undistorted—theoretically.

Not every dome matches every wide-angle, and distortions can still be found. When evaluating a housing's wide-angle performance, pay particular attention to the corners of the frame. If circular subjects that lie near the corners of the frame appear "stretched" or elliptical, or if the colors tend to separate as if through a prism in the extreme corners, the lens does not properly match the dome.

The dome port creates an image seen by the lens that is much nearer than the actual subject is in reality. This is known as a "virtual image," and it is a property that must be considered with any dome port. The effect of the virtual image is that the distance scale on the lens is no longer accurate, and that the lens must be capable of focusing at least as near as the virtual image, regardless of the true distance between the photographer and the subject.

The virtual image generally locates at a distance twice the diameter of the dome from the film plane. A six-inch dome creates a virtual image twelve inches away; in this case, if the lens cannot focus as near as a foot away, a supplementary close-up lens must be used.

I've had several customers bring their housings to my store convinced that either their eyes were bad or the camera defective because even though they could get a sharp picture topside, underwater everything was fuzzy. This usually happens when they are using zoom lenses behind domes. The zooms typically don't focus as closely as a prime wide-angle, and they rarely focus as near as a foot. However, the solution is simple. By adding a diopter (close-up lens) to the lens, the close-

The wide-angle lens behind the housing's dome port permits the view of the Red Sea reef environment with butterfly fish, as well as the diver in the background, and the slow 1/30 second shutter speed increases the ambient light in the background. *Nikon N90, 18mm lens*

121

focus capability is enhanced, bringing the virtual image into sharp detail. Most housing manufacturers will advise of this and suggest the strength of the diopter most appropriate for their dome.

FLAT PORT. That the flat port refracts is a given, but it is not necessarily a bad thing. Increased magnification results, which makes it is possible to fill the frame more easily with skittish creatures from a greater distance. For tight shots of the small creatures on the reef, the flat port is a valuable tool commonly used with 60mm or 105mm macro lenses.

I prefer to use my 60mm macro behind a dome port to get an environmental portrait of a medium-size fish (the fish and reef where it lives), because I might have to be too far back to light the composition effectively were I to use a flat port. With a dome I can get closer for the same basic composition, with consequent improvement in color saturation and resolution.

The older 105mm Micro-Nikkor lens will not work behind most domes. Even though the lens will focus to a 1:1 level of magnification, it is still more than a foot away from the subject at minimum focus, making it impossible to focus on the virtual image. However, the new autofocus 105mm Micro-Nikkor can focus as near as twelve inches, making dome applications possible. Note also that the "throw" of the 105mm macro—that is, the length the lens barrel extends from infinity to minimum focus—usually requires a port extension as well.

The most popular lenses used in housings include the 60mm and 105mm macro lenses for fish and macrophotography and the 16mm, 18mm, 20mm, and 24mm lenses for wide-angle shooting. More and more photographers are beginning to use zoom lenses as well, but these usually have to be operated in autofocus only, because the housing's focus control is used to operate the zoom.

The color and detail of macro photography is fascinating, but it is often difficult to coax fish into the wire framer. By photographing this clownfish in the Red Sea at night when its activity had significantly slowed, a macro composition was possible. *Nikonos III, 35mm lens with 1:1 extension tube*

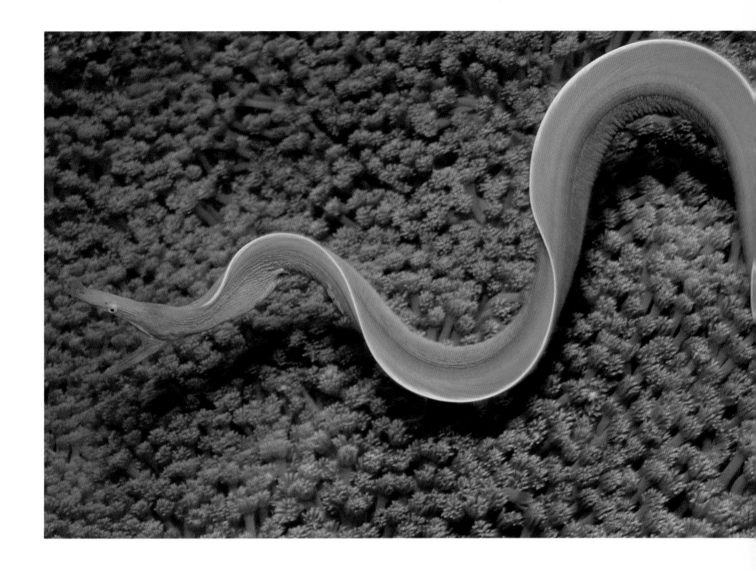

The integral motor drive of modern cameras is an advantage underwater as well, not so much for its speed (we usually still have to wait at least a few seconds for the strobe to recycle) as for the elimination of the distraction caused by removing the eye from the finder to manually wind the film. The subject might escape, or the photographer might be slowed down by having to focus all over again following each exposure.

Housing manufacturers have had to adjust to the fact that the normal viewfinder on a topside camera is too small to be used effectively underwater. The photographer's eye is displaced by a face mask, and even modern low-profile masks keep the eye at least two inches from the viewfinder. This makes it hard to confirm focus and impossible to see the whole frame at a glance. The traditional answer has been to utilize some sort of enlarged viewfinder, like the accessory sports finders available for the Canon F1 and Nikon F, F2, F3, and F4, or build a magnifying prism into the housing, as in the Rolleimarin housing and the Aqua Vision housing for the Mamiya RZ67.

More recently, housings are being delivered with accessory viewfinder magnifiers, like the Ikelite Supereye. This screws onto the camera viewfinder inside the housing and permits an enlarged full-field view. Another response is to build an external magnification system into the housing viewing port, as Aqua Vision Systems has done. Since the ability to see the subject properly in order to focus

The housed camera with manual focusing macro lens is sometimes difficult to focus for a quickly moving subject, such as this ribbon moray eel in Kenya, Africa. It usually works best to prefocus on a probable distance, swim parallel to the path of the subject, and make fine focus adjustments either with body position or focus control. *Nikon F3, 55mm macro lens*

123

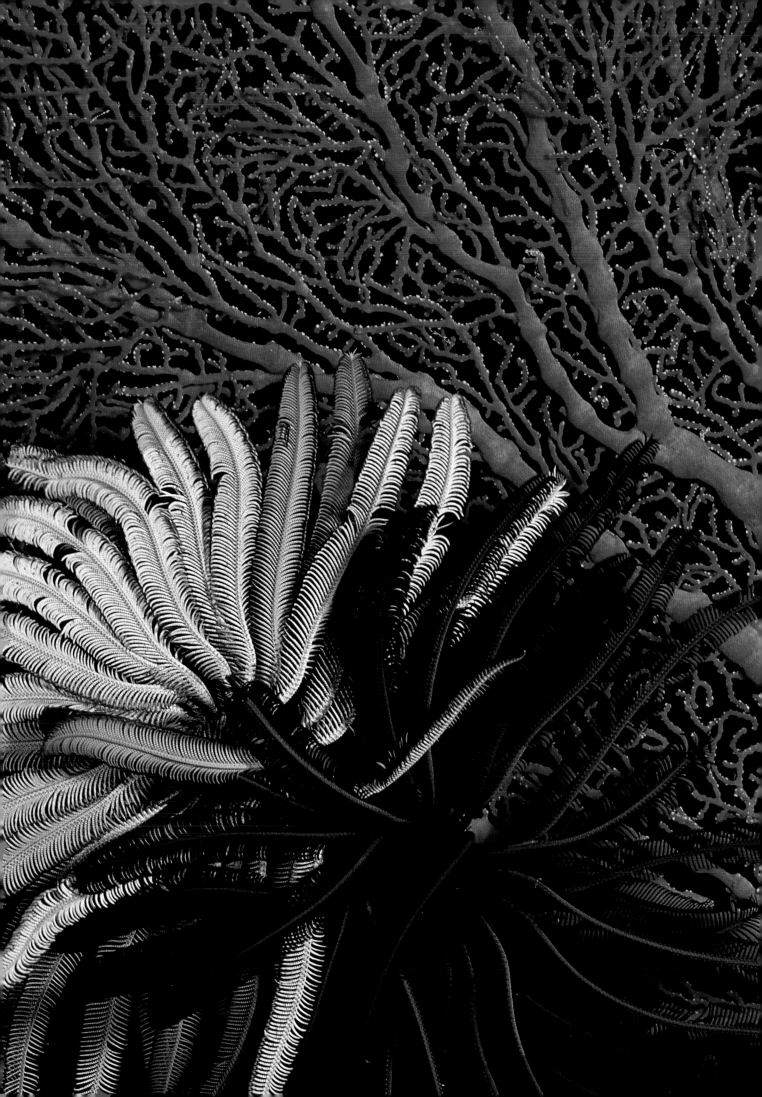

accurately and create the composition is critical to quality photography, the viewing system of any housing should be rigorously examined before purchase.

When evaluating housing viewing systems note that for the same reason that large-format photographers use a black focusing hood draped over their heads when shooting their view cameras, underwater photographers should use dark-skirted masks when shooting SLR systems underwater. The popular translucent silicone face masks that look so attractive on a model transmit too much light through the sides and onto the ground glass of the viewfinder. This diminishes contrast and makes fine focus more difficult. A black or gray silicone mask is an important accessory for any underwater photographer working with a housed or amphibious SLR.

The Nikonos

As scuba became more popular, demand grew for an amphibious 35mm underwater camera, and a soon-to-be famous Jacques Cousteau collaborated with a Belgian aeronautical engineer named Jean de Wouters from 1952 to 1958 to create a camera that could work both underwater and on land, which they named Calypsophot. By 1959 this amphibious camera was in production in France, but the manufacturing and production rights were soon acquired by Nikon. The Calypso gave way to the Calypso/Nikkor, and by 1963 the camera was in production as the Nikonos.

The concept of that first Nikonos camera was simple yet efficient in keeping water on the outside, where it belonged. The inner body contained the shutter, pressure plate, and film wind/rewind mechanism. The inner body fit snugly within an anodized aluminum outer shell that provided a surface for the O-ring to seat and an external strobe/flashgun synchronization port. The lens then fit through the shell via a bayonet mount that also served to lock the inner body in place. The seals were protected from water intrusion by several O-rings, rubber seals that fit around the control shafts, main body, lens, and synch port. Properly seated, the O-ring kept the water out of the Nikonos up to a depth of 164 feet (50 meters).

Over the years the Nikonos camera underwent some evolutionary, and later some very revolutionary changes. In 1975 the Nikonos III brought a larger, heavier body and a much improved film transport system. The film from a Nikonos I or II had wide, irregular spacing between the frames, requiring the film to be hand-mounted, since automatic slide mounters would misregister the images. The Nikonos III solved this problem. The Nikonos III also had a three-pin strobe synch, similar in design to that used in all subsequent Nikonos cameras (the TTL systems utilize the three pins, plus two shorter pins for the automatic strobe exposure system). Thus, a manual strobe used with a Nikonos III can also be used on the Nikonos IV, V, and RS, and, conversely, a modern TTL-compatible strobe can also be used on the Nikonos III, although in the manual mode only. (Since the Nikonos II was last in production in 1975, it is hard to find strobes adaptable to the old-style connector today, although some of the Nikonos repair facilities will convert them to the Nikonos three-pin system for a modest charge.)

The Nikonos III was my camera of choice for many years when I was starting out as a professional underwater photographer, and I still use it occasionally. I rarely use strobe synch speeds faster than 1/60 second underwater, so this limitation is not much of a problem for me, and since most of my strobe exposures are still manual, the lack of automation is not a significant factor. In addition, since

Opposite:
For stationary subjects like this pair of crinoids and gorgonian in Palau, either a housed camera or a Nikonos with close-up kit makes an excellent tool. *Nikonos V, 28mm lens with close-up kit*

125

the camera is of a rugged mechanical design, it holds up very well in the saltwater environment, and should a flood occur, there are no electronics to short out, simplifying field repairs. However, I've found that the rotary film-advance/shutter-release on the older Nikonos cameras imparts camera motion compared to the separate film-advance lever and shutter-release button on the Nikonos IV and V. I find I get sharper pictures with my Nikonos V, and that is more than enough reason to make the switch.

Back in 1980, when the Nikonos IV was introduced, it was thought that the new model would be the long-awaited amphibious single-lens-reflex. This expectation was not satisfied until a dozen years later, with the Nikonos RS, but the Nikonos IV offered an electronic shutter with aperture-priority automation for available-light exposures in stepless speeds from $\frac{1}{30}$ to $\frac{1}{1000}$ second. For topside and available-light underwater use this automatic setting was great, but when the strobe was plugged into the synch port and turned on, the shutter speed operated only at $\frac{1}{90}$ whether in the automatic (A) or mechanical (M) mode. To serious photographers this lack of shutter speeds other than $\frac{1}{90}$ for strobe synch was a huge problem.

On the positive side, the hinged back allowed more efficient film loading (the lens no longer had to be removed to slide out an inner body); the enlarged viewfinder located directly above the lens was easier to use and introduced less parallax; the anatomical grip made the camera more ergonomic, and, of course, the separate film-advance/shutter-release so common in topside cameras was a major improvement.

The Nikonos V was introduced in 1984 and remains the most popular tool for the underwater photographer today. The shutter-speed settings offer an automatic setting for aperture-priority automatic available-light exposures, as well as manual quartz-timed exposures at $\frac{1}{30}$ and $\frac{1}{60}$ in the strobe synch mode and $\frac{1}{125}$, $\frac{1}{250}$, $\frac{1}{500}$, and $\frac{1}{1000}$ for available-light images. There is also an M, or mechanical, setting that operates independently of the camera's electronics at $\frac{1}{90}$ second.

One of the real innovations with the Nikonos V was the introduction of through-the-lens (TTL) metering to underwater photography. This method of exposure determination is now found in most modern underwater cameras, including housings and the Nikonos RS but was revolutionary in 1984. It meant that most casual operators could get reasonable results with minimal effort and experience. Underwater photography was at last becoming demystified.

TTL features a pair of internal silicon photodiode (SPD) sensors that meter the light passing through the lens at the film plane. One of the sensors is for available light so that the camera, when set on A, would select the appropriate shutter speed (somewhere between $\frac{1}{30}$ and $\frac{1}{1000}$ second). In addition, the chosen shutter speed could be seen in the red LED display in the viewfinder (another improvement over the Nikonos IV). This was great when using the camera above water, and also a benefit when shooting available-light images in shallow water. But since most effective underwater photography utilizes electronic strobe, a second SPD sensor measures the amount of strobe light striking the film plane, making possible automatic strobe exposures. This gave confidence to a whole new generation of underwater photo enthusiasts.

LENSES. All Nikonos cameras feature interchangeable lenses, and any lens made to fit the Nikonos I, II, III, and IV will fit on the Nikonos V with the same spring-loaded, O-ring-sealed, bayonet mount. These lenses are as follows:

126

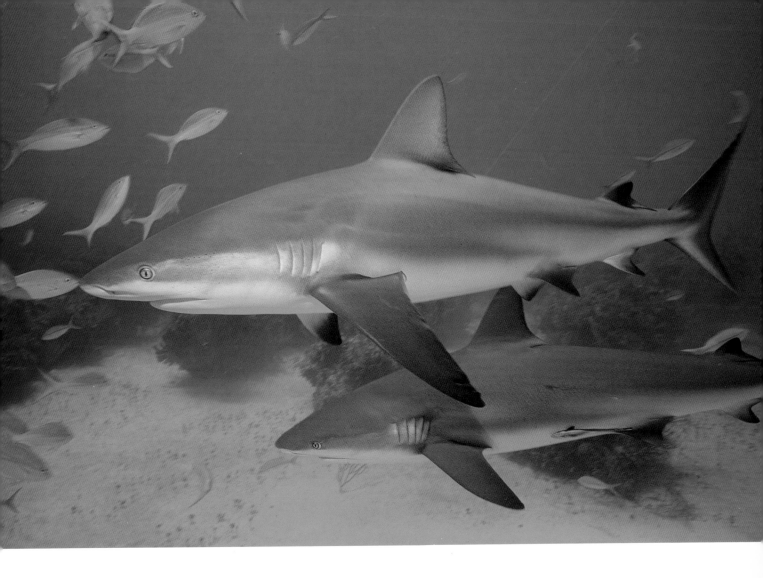

Nikkor Lenses for the Nikonos Camera

	15mm	20mm	28mm	35mm	80mm
maximum aperture	f/2.8	f/2.8	f/3.5	f/2.5	f/4
minimum aperture	f/22	f/22	f/22	f/22	f/22
minimum focus (feet)*	1	1.3	2.0	2.75	3.5
angle of coverage	94	78	59	46	22

*Note: Discussions of distance underwater normally refer to "apparent" feet.

The Nikonos 20mm lens is a good choice for these Caribbean reef sharks in Grand Bahama and other large fish that are difficult to approach closely. The wide-angle not only provides good depth of field, it also allows the frame to be filled more completely than it might be with a 15mm lens. *Nikonos V, 20mm lens*

When the Nikonos IV came out, it soon became apparent that at least one older Nikonos lens, as well as a few aftermarket lenses in production at the time, caused serious metering errors with the new camera. The first incarnation of the Nikonos 15mm lens featured a rear element that protruded inside the camera body. This created a compact wide-angle tool, but the long rear element blocked the light reflecting to the SPD, making automatic exposures impossible.

The 20mm lens, introduced subsequent to the Nikonos IV, was designed to circumvent this problem. The 15mm lens was then redesigned with the lens elements forward of the bayonet mount, allowing it to be used TTL with the newer electronic Nikonos IV and V bodies. The old 15mm lens can still be used on the new cameras, but it only works with manual exposures.

CHAPTER 3 THE TOOLS OF UNDERWATER PHOTOGRAPHY

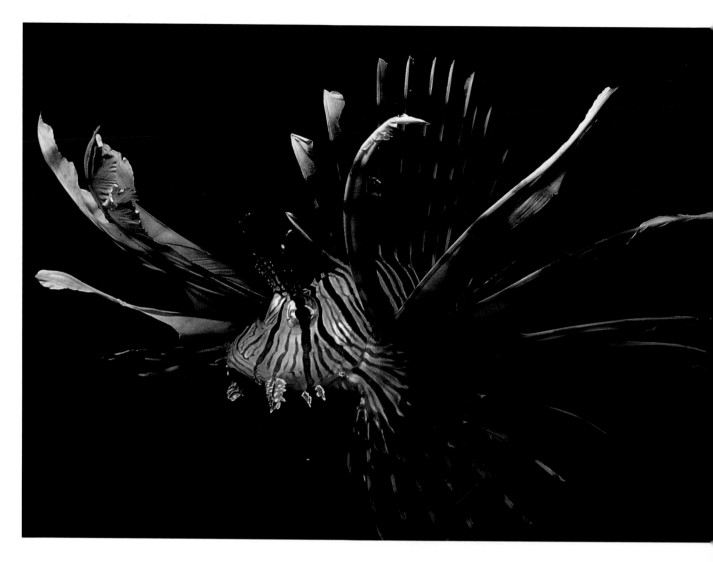

Above:
Night dives create wonderful photo opportunities for subjects that might be difficult to approach during the day. This particular lionfish in the Red Sea was wary of the wire framer of the close-up kit when I tried to photograph it during a late afternoon dive, yet on a night dive to the same site, it was totally cooperative. *Nikonos V, 28mm lens with close-up kit*

Right:
This largetooth cardinalfish in the Red Sea, was holding a mouthful of eggs, presumably to incubate them. Securing a tight composition of the mouth area for a fish this skittish required the use of a macro telephoto. *Nikon N90, 105mm macro lens*

The Nikonos 35mm lens is most often the first lens acquired and is considered the standard lens. It is truly amphibious, usable both above and underwater. Modestly priced, it offers a wide variety of accessories such as close-up kits and extension tubes. Many subjects on the average coral reef can be nicely composed within the field of view of the 35mm lens. At three apparent feet the lens sees a section of reef about two by three feet, allowing for tight head shots of medium and large marine life and environmental portraits of fish the size of an angelfish or large butterfly fish.

The downside to using this lens underwater is that it has a relatively narrow depth of field. Since a Nikonos is focused by means of distance estimation, shallow depth of field leaves little room for error. Effective use of the 35mm lens can be enhanced by using smaller apertures for better depth of field. More sensitive films, at least ISO 100 or faster, and a powerful strobe will help. With the lens set at 3.5 feet and a working aperture of f/11, the depth of field permitting a sharp photo ranges from minimum focus (2.75 feet) to 5 feet. With a little practice, most photographers can master this technique, but they will never achieve the precision that single-lens-reflex viewing offers.

Close-up kits and extension tubes significantly enhance the viability of the 35mm lens and make it more a part of a "system." An extension tube is merely an aluminum tube that mounts between the camera and lens, and a close-up lens is a diopter that mounts on the front of the lens. The extension tube may not be removed underwater because the camera will, obviously, flood, but a close-up kit

Subjects that are easily composed in the center of the composition are ideal for autofocus, but with stationary subjects like this frogfish in Cocos Island, it is also easy to use the single-servo mode to shift focus. *Nikonos RS, 50mm lens*

CHAPTER 3 THE TOOLS OF UNDERWATER PHOTOGRAPHY

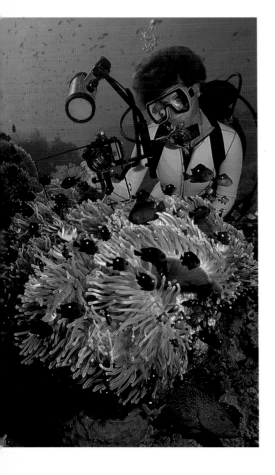

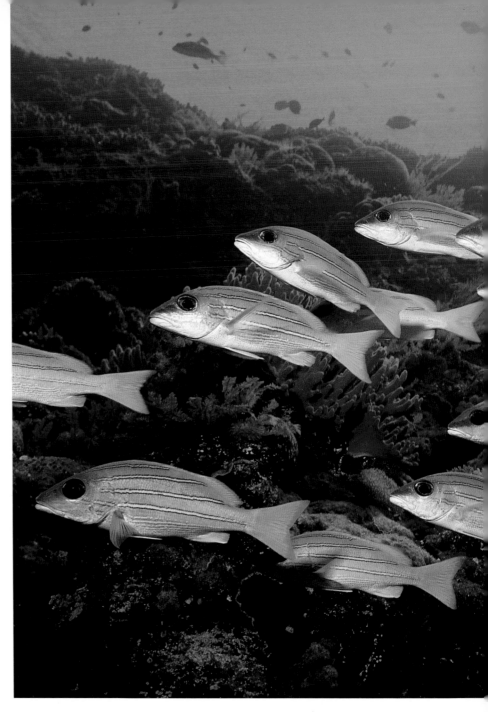

Above:
This image of "a photographer at work" in the Red Sea was enhanced by careful strobe placement in order to illuminate not only the clownfish and anemone in the foreground but the diver's face mask as well. *Nikonos V, 15mm lens*

Right:
Colorful schooling fish are a popular subject for advertising and editorial underwater photography, so whenever the opportunity presents, I will photograph them. The 20mm setting on the RS 20–35mm zoom lens captured the school of blue-striped grunts in Palau, and the slow 1/30 second shutter speed allowed the ambient light to illuminate the reef face in the background. *Nikonos RS, 20–35mm zoom*

130

can be installed or removed underwater. Framers and wands are typically used to assist crucial distance estimation and composition.

Most manufacturers build their extension tubes for the 35mm lens for the simple reason that there are far more 35mm lenses out there. In addition, the wider field of the 28mm lens means that at magnifications of 1:1 and greater, the front of the lens is very close to the subject, making it difficult to light effectively with strobe. The Nikonos close-up kit may be used with the 35mm, 28mm, and 80mm lenses, employing the same wand for focal distance but different framers according to the lens in use. With close-up and macro, the f-stop is typically set at 22 to enhance the depth of field, and since the strobe is so close to the subject, even slow 50 ISO films have plenty of light.

Close-up and macro accessories for the Nikonos camera significantly add to the variety of subjects that can be photographed. They allow the tiny subjects of the coral reef to be captured and, because of the minimal water column between

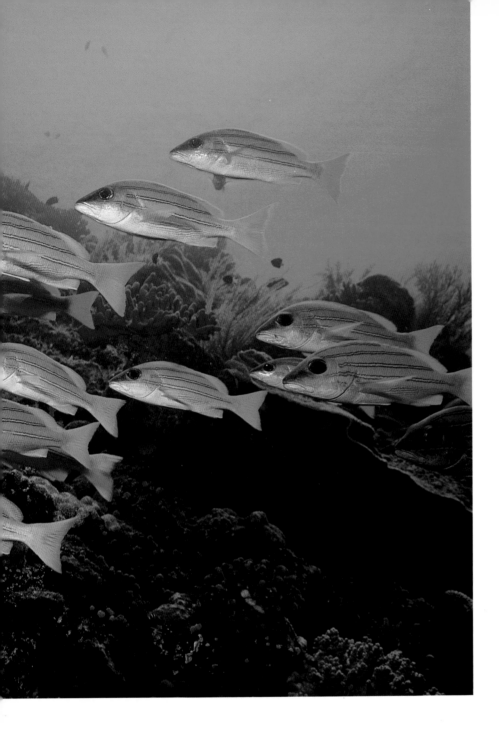

the subject and film plane, in riotous color. When the water is turbid, this system is a good choice because it minimizes the effects of particulate matter showing up on the film (backscatter). The negative side to close-up kits and extension tubes is the frustration that results from trying to coax elusive fish into a framer. Inanimate objects and slow-moving invertebrates serve well as subjects, while a fish probably takes a framer for the cavernous maw of some exotic predator. In order to get them inside, it helps if they are asleep (hence the effectiveness of night diving for close-up and macro work), hemmed into a corner where escape is difficult, enticed into the framer by food, or just plain stupid. Most fish aren't stupid.

The 28mm lens (as well as the 20mm and 15mm) is a "water contact" optic, meaning that the water interface with the glass functions as a lens element crucial to the optical formula. The prime advantage of this lens is that it is quite sharp when properly focused, and the depth of field is better than with the 35mm lens. In the hypothetical example we used with the 35mm lens, f/11 and a distance set-

131

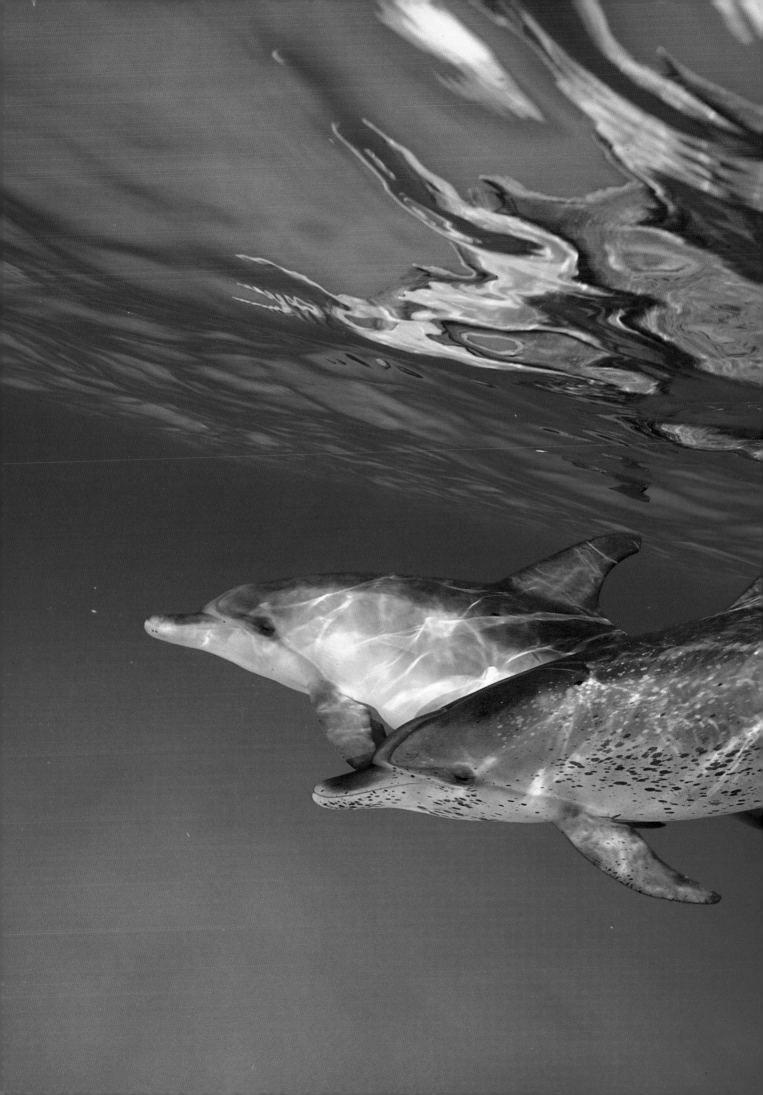

ting of 3.5 feet, the 28mm lens offers effective focus from 2.5 to 6.5 feet. This makes it easier to use, but it may be harder to find appropriately sized subjects—that is, at least the size of an angelfish or barracuda, or perhaps a school of smaller fish. A "head-and-shoulders" shot of a diver is also possible.

Because of its narrow underwater angle of view, the 80mm is exceedingly difficult to use as a primary lens. At f/11 the depth of field is about six inches when focused at four feet, and few photographers could estimate distance so unerringly. With the attachment of a close-up kit, it is an excellent tool for photographing tiny marine life, but the same angle of view can be approximated with the 35mm and extension tubes. Clearly, the best use of the 80mm lens is as a short telephoto for topside photography in inclement conditions.

The Nikonos 20mm lens is probably the best tool in the system for photographing reef scenics, schooling fish, or large marine life. This is a significantly different optic from the 15mm lens, and while I don't use it as often as the 15mm, with some subjects it is definitely preferable. For example, when shooting hammerhead sharks in the Galápagos or Cocos Island, their skittish nature makes it hard to get within three feet, as would be required to capture a single full-frame animal with the 15mm. However, with a little luck and more patience, the fish will frequently come to within five or six feet, and then the 20mm lens will fill the frame.

I also like the 20mm for reef scenics, especially those exotic locales rich with soft corals, crinoids, and myriad small fish. This lens will show a broad enough view to encompass a reef vignette while rendering individual elements large enough to identify at a glance. Depth of field is excellent with the 20mm lens; with a lens setting of 3.5 feet and the f-stop at 11, the effective focus is from about 2 feet to infinity.

The Nikonos 15mm lens is my favorite wide-angle tool. It is sharp, and its 94-degree angle of view (the same as a 20mm on a topside camera) is perfect for shooting wide-angle reef scenes, large marine life, and environmental portraits of divers and the coral reef. The extreme depth of field of this lens makes sharp pictures easy. For example, at f/8 and a distance setting of 3.5 feet, the lens is in focus from 2.5 feet to infinity. On top of that, since it was corrected for underwater use with a dedicated dome port, the resolution is quite good in the corners.

While the 35mm and 28mm are typically used with the camera's built-in viewfinder, the 20mm and 15mm call for an accessory optical viewfinder to gauge the angle of view. At minimum-focus distances, however, parallax does become a problem.

PARALLAX. The Nikonos is a viewfinder camera rather than a single-lens reflex, and by definition the lens does not see what the photographer sees when peering through the viewfinder. With a wide-angle lens like the 15mm or 20mm and subjects more than two feet away, it gives a pretty close approximation, but up close it will not be accurate. Hence, close-focus wide-angle photography requires some degree of composition estimation (see Chapter 2, "The Techniques of Underwater Photography").

The Nikonos RS

First introduced in January 1992, the Nikonos RS (for reflex system) is the world's first and only amphibious single-lens reflex. This means that the photographer

Opposite:
The extreme depth of field of the 15mm wide-angle lens makes it a suitable optic for capturing fast-moving subjects like these spotted dolphins in Grand Bahama. *Nikonos V, 15mm lens*

With the single-lens-reflex viewing system, the lens sees exactly what is recorded on the film plane. With this regal angelfish amid black coral in Vanuatu, it was therefore possible to predict all compositional variables. *Nikon F3, 60mm macro lens*

can compose and focus through the lens, assisted by an oversize viewfinder, and what the photographer sees is recorded on the film. Previously, this remained the exclusive province of housed cameras.

The autofocus allows the photographer to choose between the single servo mode (the shutter will not fire until the subject in the target is in sharp focus), continuous autofocus (the focus tracks the changing position of a moving subject), power manual focus (accomplished by pressing a lever rather than turning a ring, as is common topside), and a freeze focus.

The freeze focus mode is one I've rarely used underwater, but the idea is to prefocus on a point and keep the shutter depressed; when the subject swims through the plane of focus, the shutter will trip. However, I regularly use the other three focus modes, particularly the single servo and power manual. The ease of the focus control, selected by a switch conveniently located on the top of the camera, is a huge advantage over housed autofocus systems.

Autofocus was a technology I was slow to adopt topside, trusting my old Nikon F3 and traditional lenses even after the new Nikon 8008 and F4 with their dedicated autofocus lenses were introduced. Then, for a photo safari to Africa, I borrowed an F4 and an assortment of lenses from Nikon, and with the first roll of

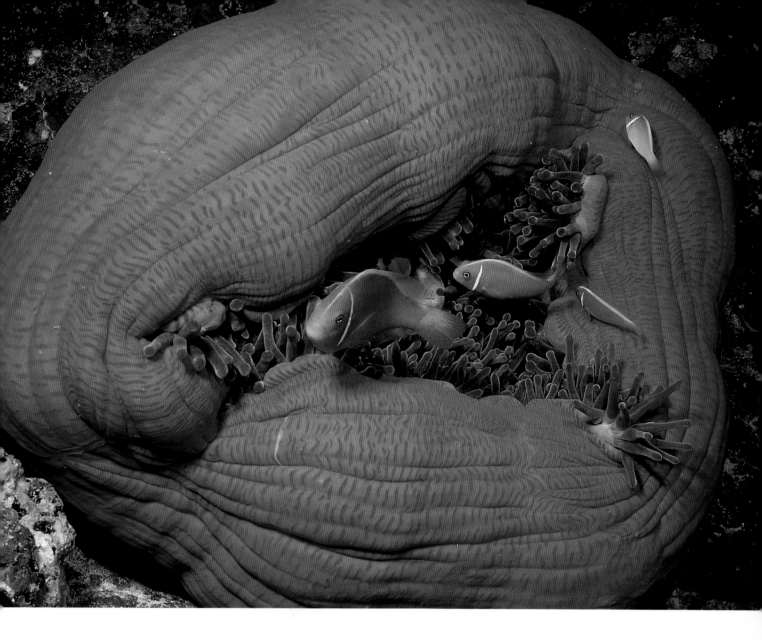

film I realized that this feature made focusing far quicker and more accurate than I could do it manually. So, when autofocus became available in underwater photography, I was anxious to give it a try.

I usually use my RS in the single servo (S) mode—that is, I press the shutter release halfway, and the camera locks focus onto the subject in the target. I can continue to press the shutter to take the picture, or shift the composition and then complete the shutter release so that the primary subject remains in focus but off center. The camera will not fire until accurate focus is achieved, but the photographer has to be careful that the subject that ends up in sharp focus is the primary subject intended. Single servo is great for stationary subjects, center-located subjects, or subjects moving approximately parallel to the film plane.

Continuous autofocus (C) is useful for quickly moving subjects. The camera will make fine focus adjustments as long as the shutter remains slightly depressed and the subject is still in the AF target. When proper composition is achieved, the photographer finishes the shutter release stroke and the picture is taken. However, note that if the subject strays outside the target, the camera will seek focus on whatever new subject occupies the target.

Despite the seductive appeal of autofocus, I still use the power manual focus

Even with autofocus, I often use the manual focus setting to prefocus and then move toward the subject until it pops into sharp focus on the groundglass, as for this clownfish and purple anemone in Palau. *Nikonos RS, 28mm lens*

Overleaf:
The continuous autofocus is often used for quickly moving fish, like these red-back butterfly fish in the Red Sea. Note that the uniform background provides a high level of strobe reflectivity, making this a perfect candidate for accurate TTL strobe exposure. *Nikonos RS, 28mm lens*

135

(P) on the RS with some regularity. For example, it works well with a shot as simple as a clownfish in an anemone. As the fish darts about continually, the S setting would easily lock into focus, but there is no way to keep it in the same plane of focus while I perform all the machinations for composition shift. The C setting, on the other hand, will follow the motion of the fish but still limit the primary subject to the target area. An alternative is to use S to achieve a preliminary focus for the composition (this can also be done with the power manual focus lever) and then switch to P and make slight focus adjustments by physically moving closer or farther from the subject. When the subject pops into focus on the ground glass, shoot.

The P setting is also useful when the subject requires a close focus or macro setting. By using the lens distance scale (inset into a window on the lens barrel), it is possible to choose an approximate focus distance or reproduction ratio, prefocus the lens, and once again move into the scene until sharp focus is achieved. With a little practice the combination of autofocus and manual focus is far more productive than using either option exclusively.

One warning: some marine life may respond to the sound of the servo motor operating the autofocus. A scorpion fish sitting on a sand bottom probably couldn't care less, but a longnose hawkfish on a gorgonian will probably spook. If I anticipate that a subject will bolt, I'll prefocus on a similar-size subject and then carefully swim toward the subject with the camera set on P. When the subject is sharp through the viewfinder I'll shoot. If the composition is slightly off, I'll make minor adjustments with the power manual lever and then shoot.

In addition to autofocus, the Nikonos RS has a sophisticated metering system. Integrating either a matrix of five zones or a traditional center-weighted pattern for TTL exposures, the RS is particularly compatible with the SB 104 speedlight, Nikon's companion submersible strobe. It also works with any of the earlier Nikon TTL strobes, like the SB 103 and SB 102, but I have noticed with some other manufacturers' TTL strobes that a simple press of the shutter release button will trigger the motor drive to run through numerous exposures—sometimes a whole roll of film—due to some sort of voltage incompatibility. It doesn't happen all the time, and it doesn't happen with every strobe, but it may be something to check out when picking a TTL compatible strobe for use with the Nikonos RS.

RS LENSES. When it comes to lens selection, the RS shooter has a variety of autofocus choices, including the 50mm macro (focusing from infinity to 1:1), the 28mm (focusing from infinity to 1:6 close-up magnification), a 20–35mm zoom, and a 13mm extreme wide-angle.

The 50mm macro is probably the workhorse for most RS users because it is so good for fish portraits. The fact that it can quickly rack into a macro mode is a tremendous advantage as well. The 28mm, the least expensive lens for the RS, is, I think, largely ignored by those who feel they have the 28mm focal length covered within their 20–35mm zoom. However, the 28mm is very fast to focus because of the short throw, and it focuses much more closely than the zoom. Speed, compact size, and compositional versatility make it one of my favorite lenses. The zoom, of course, allows underwater photographers the option of shooting from a moderate wide-angle for large marine life and diver portraits all the way to a 35mm for increasingly intimate fish portraits. You can't change lenses underwater, but with a zoom lens you can choose the appropriate focal length for the subject.

The newest lens for the system is the 13mm, not as a replacement for the

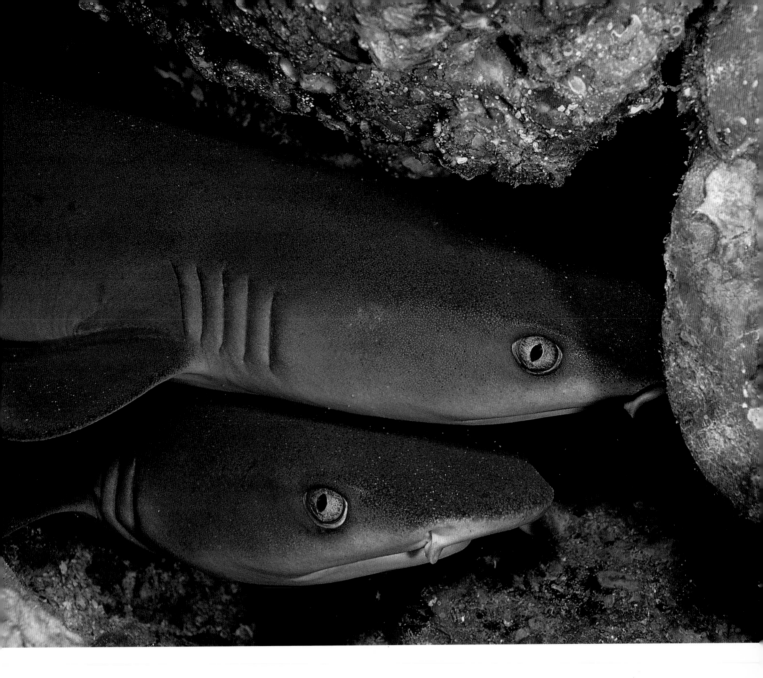

venerable 15mm lens on the Nikonos V but as an additional imaging tool. The 94-degree angle of view of the 15mm is totally different from the 170-degree full-frame fish-eye view of the 13mm. The 15mm remains my primary tool for shots of divers on the reef and wide-angle reef scenics, but the 13mm on the RS is great for shipwrecks, large marine life, and close-focus wide-angle, where the advantage of SLR viewing provides a compositional aid. The 13mm, like any fish-eye, will exhibit a substantial barrel effect on straight lines located near the edge of the frame, but, fortunately, few underwater subjects include the straight lines that would make the curvature obvious.

Medium-format Cameras and Housings

Soon after I committed to underwater photography as a career, I decided a housing was essential equipment. I was getting good results with my Nikonos, but I was frustrated by the approximate nature of the distance estimation and composition required for marine-life portraits with the 35mm and 28mm lenses. For fish pho-

Finding this pair of white-tipped reef sharks resting within the coral reef of Cocos Island was exciting, but to capture the image required a stealthy approach. It is usually advisable to move in slowly and carefully, control breathing to minimize the noise from exhaust bubbles, and pay attention to the fishes' probable field of flight. *Nikon F3, 60mm macro lens*

139

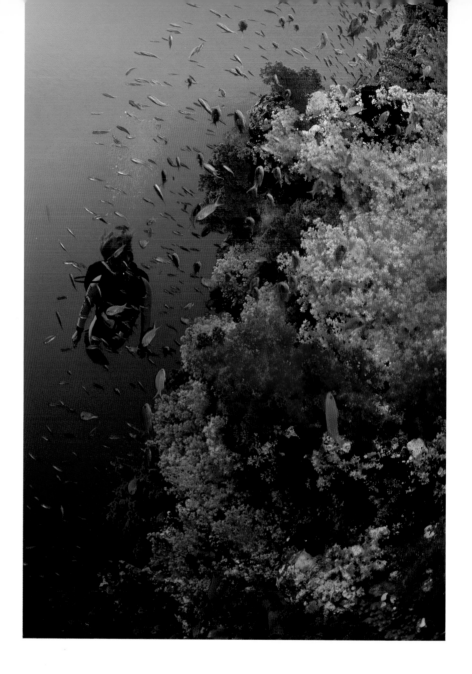

The extreme depth of field of the full-frame fish-eye on a 35mm camera gives sharp focus to this Red Sea reef scene, from the soft corals and *Anthias* in the foreground to the diver in the background (and beyond). *Nikonos RS, 13mm lens*

tography I felt I needed the precision of single-lens-reflex viewing, and because I wanted to use a film format larger than 35mm, I housed a medium-format single-lens-reflex camera I already owned, a Bronica.

This first housing was something of a revelation for me. I only got twelve exposures per roll of 120 film, and it was awkward to crank the film after each exposure, but my aluminum housing had an enlarged viewfinder with a bright ground glass that gave me a new intimacy with my photographic subjects.

When I put my eye to the finder I was shut out from the surrounding world; it was only the fish and me stalking the fish. Slowly I would creep forward, rocking the focus ever so slowly in and out, seeing the coral reef in perfect 2¼-by-2¼-square-inch vignettes. When all was aligned and right with the world, I'd trip the shutter. Of course, the resultant crash from the huge mirror and brilliant flash was usually enough to terrorize the fish into an instant retreat. I didn't harvest many acceptable images with this system, but those that were good were very good.

One problem with this housing was that it does not allow the photographer to add diopters while underwater—something the Rolleimarin did very well. The Rolleimarin also had the advantage of a quiet leaf shutter that would synchronize

at any shutter speed, since it was a twin-lens reflex with no clunky mirror to bang up and down.

The Rolleimarin was my favorite camera housing for several years, and I might still use it once in a while if my old housing didn't leak so much. Parts are hard to find for any piece of equipment that has been out of production for a few decades, and without new gaskets on the control shafts, water continuously trickles in. I tried a few dives with sanitary napkins taped to the inside bottom of the housing to absorb the water enough to keep the camera dry. Ultimately, I decided it was time to embrace the new and improved technologies out there for the underwater photographer.

I haven't given up altogether on medium-format photography, though. I still use it topside for scenics and advertising product shots, and for underwater I have a couple of systems I use occasionally. I used to own a Pentax 6-by-7 in the Pentax aluminum housing, but found I used it very rarely because the focal plane shutter synchronizes at only $\frac{1}{30}$ second (and slower), so for underwater work in reasonably high ambient light or with quickly moving subjects the synch speed is too slow. I also tried the Aqua Vision aluminum housing for the Mamiya RZ67, primarily to

Medium-format cameras like the Rollei twin-lens-reflex in the Rolleimarin housing were at one time the professional's underwater camera of choice, but advances in 35mm cameras and film have made the latter far more popular today. Still, when a medium-format image is exposed properly and sharply focused, it can be quite impressive, witness this Spanish dancer in the Red Sea. *Rollei twin-lens-reflex in Rolleimarin housing*

CHAPTER 3 THE TOOLS OF UNDERWATER PHOTOGRAPHY

use with a 37mm fish-eye for extreme wide-angle. This is a finely machined housing for a camera that synchronizes at all shutter speeds due to its leaf shutter, and the viewing system has a prism built into the housing, which makes it quite good.

I consider these cameras specialty tools to use when I have plenty of time on location and am shooting stock for myself rather than on assignment for a client. While on assignment, I feel the need to perform more efficiently in terms of the number of "keepers" (good photographs) generated, and underwater 35mm systems are far more efficient than any medium-format camera and lens.

Because film can't be changed underwater, the number of exposures per roll is another consideration in the choice of cameras. With 35mm film there can be thirty-six exposures to a roll, whereas 120 film allows only ten or twelve shots (or twenty or twenty-four if the film is 220), depending on whether the camera shoots 6-by-6- or 6-by-7-centimeter images. Some cameras offer 70mm backs for extended shooting capacity, but processing for these special loads is hard to find at most labs. In addition, the variety of macro-focusing, wide-angle, and zoom lenses available for 35mm cameras, combined with their motor drives, enlarged viewfinders, and new technologies like TTL strobe exposure and autofocus (which still is not available in medium-format) make 35mm cameras dominant in underwater photography.

However, the main reason I embrace 35mm over medium-format for most of my underwater photography has less to do with cameras or housings and more to do with circles of confusion and depth of field.

In photography, sharpness is rendered when a point source of light records on the film plane as a theoretical point with a diameter of zero. This is a hypothetical concept that is actually rendered as a circle on the film, but the smaller the diameter of the circle (the closer it gets to zero), the sharper the image. An image of any subject is composed of tiny overlapping circles known as circles of confusion, and the smaller the circles of confusion are, the sharper the photo.

Now, consider focal length. As explained by Ansel Adams in *Camera and Lens* (1970), "The focal length of a lens is the approximate distance from the rear nodal point of the lens to the film plane when the lens is focused on infinity." This is not the same as angle of coverage.

For a Nikonos camera with a 35mm lens, this focal length yields an angle of coverage of 62 degrees in air (46 degrees underwater, due to the refraction from the lens's flat port), while the same approximate focal-length lens on a medium-format such as the Hasselblad Superwide and 38mm Biogon lens gives about 90 degrees. From this we see that for the Nikonos camera underwater, the 35mm lens is considered "normal," yet on medium-format, the 35mm is wide-angle. Conversely, on a film smaller than 35mm, like the 110 format, a 35mm lens would be a telephoto.

Now, assuming the image is focused at maximum sharpness on the film plane (or on the ground glass), any part of the image that falls before or behind the image plane will be, to a greater or lesser degree, out of focus. As the lens is used at smaller apertures (stopped down), the angle of the light rays passing through the lens is narrowed and the diameter of the circles of confusion in front of and behind the film plane is reduced. This is depth of field.

Depth of field is therefore dependent on the focal length of the lens and the size of the aperture, not the angle of coverage. The larger film format captures more of the field of view, but at any given aperture, the depth of field remains the same regardless of the size film used to record the image.

Using a faster film to stop down to a smaller aperture will help with depth of field in medium-format, but at the cost of increased film grain. Also, since underwater photography relies on artificial light sources and the subjects are often moving, the range of useful apertures and shutter speeds is relatively limited compared to solutions available to the topside photographer wishing to extend depth of field. Unlike the landscape photographer, the underwater photographer cannot set up a tripod and shoot for thirty seconds at f/64 in order to cover the azure vase sponge in the foreground and the diver fifteen feet away in silhouette, but a Nikonos with a 15mm lens can accomplish this very easily, even at f/5.6 and 1/90 second.

The two underwater subjects that a housing can handle that a RS presently cannot are tight shots of small, skittish marine life and over-unders. The 105mm macro lens behind a flat port is ideal for capturing small blennies, fairy basslets, hawkfish, and the like. These small creatures are very cautious, and by the time a photographer gets near enough to frame such fish with a 50mm macro lens, usually they are long gone. The 105mm allows the frame to be filled from a sufficient distance without scaring off the fish.

OVER-UNDERS. The over-under, a shot where both the underwater and topside scene are recorded simultaneously, is typically accomplished with a housed cam-

Even with the extreme depth of field of the wide-angle lens it is important to previsualize the portion of the composition where sharp focus must appear. By focusing the 13mm full-frame fish-eye about 2 feet away from the film plane, the staghorn corals in the foreground of this Papua New Guinea reef and the diver in the background are both rendered in sharp focus with an f/8 aperture. *Nikonos RS, 13mm lens*

In order to capture a tightly composed head shot of this coney and the parasitic isopod, in the Turks and Caicos, the macro telephoto was my most useful tool. Even with a 50mm macro lens it was difficult to get close enough to illustrate the isopod, but the 105 macro allowed this composition from a distance of about 14 inches. *Nikon N90, 105mm macro lens*

era behind a dome port (an eight-inch dome is better than a six-inch dome because it spreads out ripples from the water surface over a larger area and makes it appear smoother). The lens and port are situated so that the bottom half incorporates the underwater view and the top half sees the topside image. Of course, refraction and light absorption must be taken into account when shooting an over-under.

Water magnifies, so an optic that is focusing on an object underwater cannot focus at the same distance for a subject in air. Additionally, light is absorbed when it strikes the water, the amount of absorption determined by the time of day (this varies the angle at which the light rays strike the water and affects how much light penetrates and how much reflects off the surface), surface chop, and the clarity of the water. So, to a greater or lesser degree, there will always be more light on the topside part of the frame than transmits to the underwater portion.

To account for both factors, many over-unders are shot with split diopters, that is, a special filter that uses a close-up lens on the bottom and a neutral density lens on top. This matches the light levels above and below the surface and assures similarity of the plane of focus.

I usually use a +2 or +3 diopter on the bottom and a one-stop neutral density filter for the top. The bottom half of the optic has to focus on the virtual image from the dome, which will usually be about a foot away, so the power of the diopter is determined by where the point of topside focus should be. If it is to be near the camera, a +1 or +2 diopter is used, and if it is to be more toward the infinity setting, the +3 is more appropriate. To find out for your own system, on dry land set up a target one foot away and prefocus your wide-angle lens on the distance you want the topside subject to be. Without moving the lens focus, try different diopters over the lens until the one-foot target falls into sharp focus. Then, using that power of magnification, have the split diopter cut by an optician. This allows the water half to focus on the virtual image and the topside half, unaffected by the diopter, to focus for the proposed topside subject.

A wide-angle lens like a 20mm or 18mm is good for a split diopter, but another way to shoot over-unders is with an extreme wide-angle lens like the 16mm full-frame fish-eye. This lens has no filter threads, so a split diopter cannot be at-

tached easily, and it would probably vignette anyway. But the depth of field is so great that the difference between topside and underwater focus can reasonably be overcome at apertures of f/8 and smaller. I typically focus on the underwater portion of the scene to make sure it is as sharp as possible. The topside portion is usually in the distance, and the eye accepts faraway subjects as being in softer focus. However, since we have no neutral density for the above-water portion, I expose for the highlights topside (for slide film): focus for underwater, expose for topside.

In shallow water at midday with a fair level of light reflecting off a sand bottom, the results can be spectacular. This method also offers the choice of shooting verticals, horizontals, or both. With a split diopter, the decision has to be made when the filter is installed, and the photographer is committed while the camera is in the water. Split diopters are successful with flat, calm conditions, but the 16mm is more forgiving of waves or light wind chop.

Submersible Strobes

The use of artificial light is crucial for restoring color in underwater photography. In the early days of underwater photography, artificial light came from flashbulbs. Later it became popular to encase topside strobes in underwater housings, but as

While on assignment in Virgin Gorda in the British Virgin Islands, to shoot a catalogue for a dive-equipment manufacturer, I was called on to illustrate both the use of the snorkel gear and something of the location. An over-under was the answer, and by using the full-frame fish-eye behind a dome port, I was free to shoot both verticals and horizontals (something the use of a split diopter prohibits) and choose an off-center water line. *Nikon F3, 16mm lens*

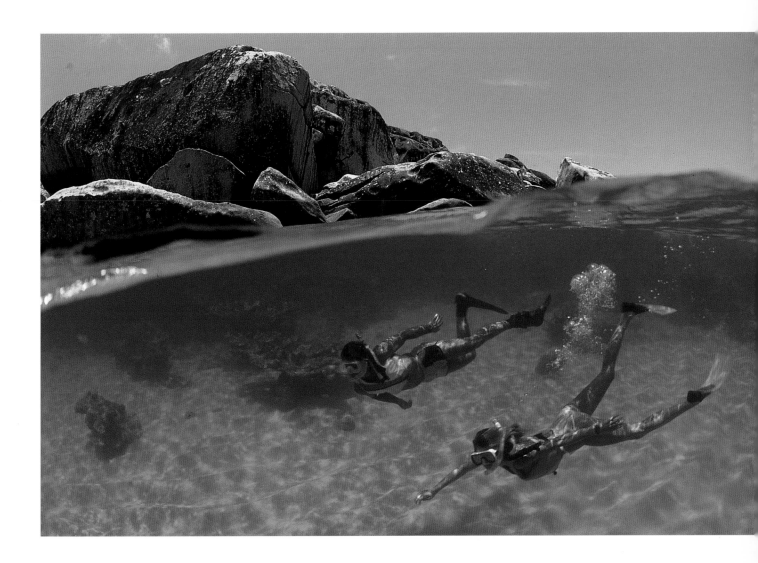

the science of underwater photography evolved and the universe of potential consumers grew larger, submersible strobes became the most popular form of artificial light.

In their 1976 text *Underwater Strobe Photography*, Jim and Cathy Church divide strobe function into five basic parts: a battery, storage capacitor, ready light, triggering circuit, and flashtube. Strobes for underwater use have become far more sophisticated in the past two decades, particularly in terms of automatic TTL exposure compensation, but the basic concept of the electronics remains the same. The battery brings available electrical current to the system, and once the strobe is turned on, energy flows to the capacitor, where it is stored. When the capacitor is electrically charged, a ready light is illuminated. When the trigger circuit is activated by the shutter release, the electrical energy that has been stored in the capacitor is transferred to the flashtube. The flashtube has two electrodes at opposite ends of a glass tube filled with xenon gas, and this tube briefly lights up while under the influence of a surge of high-voltage current. A sixth factor I consider crucial is the reflector. The reflector, which directs and concentrates the light on the subject, can turn out to be a tremendous variable in underwater strobe performance.

These strobe functions must be adapted to underwater use, and the degree to which any manufacturer's strobe succeeds should be judged by the following criteria:

POWER SOURCE. Given the portable nature of the submersible strobe, the power source will be batteries, typically disposables or rechargeable Nicads. The use of disposable batteries (usually AA, C, or D) reduce the initial cost of a strobe but substantially increase the cost of use. With some strobes it can cost three dollars per roll of film just in amortizing the cost of the batteries before they recycle too slowly to use. Nicads recycle faster, can be recharged repeatedly (although not infinitely, as they have an upper limit to the number of charge cycles they accept), and require less bulk for travel. Their disadvantage is that they may develop a memory for the number of flashes and underperform.

POWER OUTPUT. Given the density of water and its propensity to absorb light, a strong strobe is essential. This is not to say it would always be used at peak power, for the most effective strobe photography is that which blends strobe and ambient light, but the power should be there for distant subjects or the use of small apertures to extend depth of field.

RECYCLE TIME. Photo opportunities happen quickly underwater and the photographer has to be ready to react. Many modern strobes recycle as quickly as three seconds (or even faster at less than full power), but a strobe with disposable batteries in marginal condition may take more than twelve seconds between flash cycles. This is too long. It might be fifteen minutes between shots as the photographer swims along the reef searching for a subject, but when the right subject is located the photographer may have little time to react before it flees. A quick recycle makes the difference between a single grab shot and a controlled series of photographs.

COLOR TEMPERATURE. Measured in terms of degrees Kelvin, the color temperature of a strobe is crucial. Daylight is around 6,000 degrees Kelvin (6,000K),

and tungsten light is 3,200K. Tungsten light on daylight film records yellow; consequently, the lower the color temperature, the warmer the light. Underwater photography needs to fight the blue bias of seawater, so strobe light warmer than 6,000K is advisable. But if it is too warm, everything will look yellow in close-up photography; if too cool, the flesh tones will turn out unnatural in wide-angle shots of models. This is why underwater photographers used to use blue-coated bulbs up close and clear flashbulbs for distance shots in the days before strobes were popular. The strobe's color temperature is moderated by the color bias of the film used, but a good compromise between the needs of wide-angle imaging and close-up/macro is around 4,800 degrees Kelvin.

ANGLE OF COVERAGE. The strobe light should cover slightly more than the widest lens in use, although wider coverage gives less intensity in the center. Again, a compromise is usually determined by port and reflector design. A shiny reflector and flat port will give maximum intensity, but since a flat port compresses the beam angle, it can't cover a very wide lens. Conversely, a dome port on the strobe and a matte surface reflector will spread the light more evenly for softer, wider light.

AUTO-EXPOSURE CAPABILITY. Most modern strobes offer through-the-lens automation with either the Nikonos V, RS, or contemporary housed cameras. They also offer manual exposures, usually in ratios of full, half, and quarter power.

FEATURES. Submersible strobes may offer model lights to help aim the strobe, function as an autofocus assist, or even work as a night-dive light. Built-in slave capability (that is, the strobe is triggered by the flash of another strobe) is another popular feature.

BRACKETRY. There has to be some means of holding the strobe in place via trays and arms. The manufacturer will offer a system, and numerous aftermarket purveyors offer alternatives. I like a ball-joint system with various length arms to articulate the strobe head into position and a quick release so that the arm can easily be removed from the tray for hand-held lighting.

CONNECTORS. TTL connectors traditionally required the camera and strobe to be direct-wired via an O-ring-sealed cord, which meant each camera taken below had to be equipped with a dedicated strobe. To connect and disconnect strobes from cameras while underwater, systems utilizing either the E-O or Sealock connectors worked in manual but not in TTL. Nikon now offers an underwater TTL connector utilizing an infrared interface to connect and disconnect camera and strobe systems underwater. Since film and lenses cannot be changed underwater, the ability to shoot more than one roll of film or different optics for different subjects is a real advantage.

COST. Cost is, of course, a consideration for any consumer, but a proper submersible strobe is so essential to quality underwater photography that it has to be considered an integral component of the system, just like the camera and the lens.

Overleaf:
Off the north end of the Lighthouse Reef atoll in Belize there lives a friendly Atlantic bottle-nosed dolphin divers have named Honey. As she seems to crave the attention of humans, she is quite easy to approach. For this shot I used the zoom lens on the Nikonos RS so I could shoot full-length scenics as well as crop in tight, as with this 28mm portrait. *Nikonos RS, 20–35mm zoom lens*

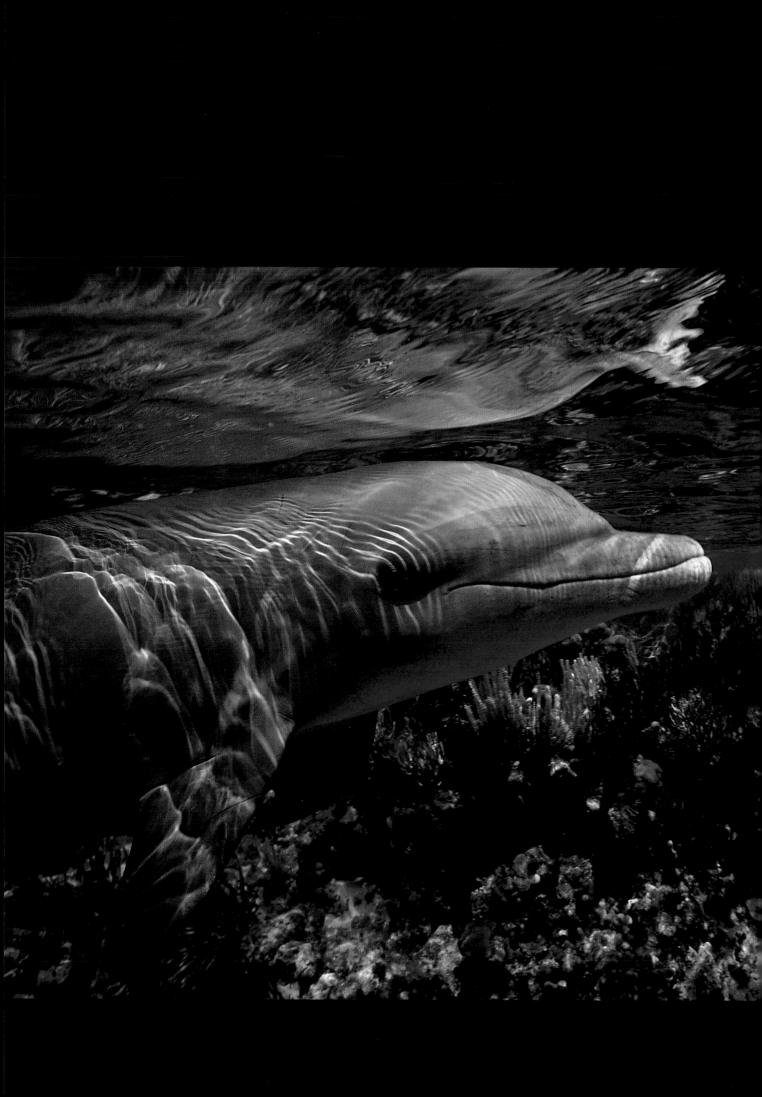

Appendix I: *Commercial Applications for Underwater Photography*

I've learned as much, if not more, from my unsuccessful photographs as from my successful ones. After one of my first assignments to the Caribbean for the first incarnation of *Sport Diver* magazine I sat in a darkened room with the art director and photo editor while we went through my initial edit from a Cayman Islands trip. The marine-life photos I'd selected were all quite satisfactory, but the wide-angle shots were pretty monochromatic, a fact that I was certainly aware of, and nervous about, before going into the projection critique. I hadn't shot much wide-angle at the time, and I'd made the typical novice's mistake of judging distance with my eye to the viewfinder. Consequently, I was usually farther from the subject than I had perceived, and as a result there was too much cyan seawater between my strobe and the primary subject for dramatic colors.

Fortunately, there were enough keepers to make the story happen, but it was embarrassing to throw so many marginal images up on the screen. I remember my editor as being polite and constructive with his criticism, but two of his words have stayed with me ever since: "Color sells!" With those two words I was challenged to learn the techniques of underwater photography well enough to be able to deliver consistently the color and detail so prevalent on the coral reef and to render marketable images on demand.

The first part of the equation really involves more than just color. It is a matter of technical excellence, with vibrant color being just one critical component. Other elements, including resolution, composition, perspective, and lack of backscatter, are fairly easy to master through diligent practice and a reasonable amount of talent. The second part, marketability, is more abstract and is the determining factor in deciding whether photographs are seen by the public and earn money or languish in little yellow boxes in a closet.

There are multiple markets for underwater photographs, certainly far more now than when I began taking underwater photos. There is an ever increasing awareness and appreciation of the world's oceans, and more books, magazines, posters, greeting cards, and CD-ROMs are being published in recognition of the expanding sales potential. But there are also more photographers trying to break into the marketplace. With improved technology in imaging equipment, film technology, and the popularity of dive travel, there are plenty of wonderful underwater images being created. The competition is tough, but there will always be a place for a photographer with talent, ambition, and business discipline.

Editorial Photography

The majority of the outlets for underwater photography is in the realm of editorial use. The most obvious market is in dive publications like *Skin Diver*, *Ocean Realm*, *Rodale's Scuba Diving*, *Sport Diver*, *Scuba Times*, and *Discover Diving*. Each issue of each of these magazines is full of quality underwater photography, but aside from occasional portfolio presentations, rarely do the publishers purchase photos exclusively on their own merit. Most often the photos are used within the context of an article written and photographed by the same person, and usually the topics are assigned rather than speculative. The budgets for these publications don't normally permit both a writer and a photographer to travel on location, so the photographer who can write is at an advantage.

For me, photography has always come first, but I realized early on that creating words is the price I pay for marketing images. Sometimes the subject is compelling and the words come easily, but more often I feel chained before a blank computer screen by the anxiety of a fast approaching deadline.

My first articles were about the technical aspects of underwater photography, which was good in that it forced me to learn and refine my craft. Later I began to write more about dive destinations worldwide, and I began to think more about conveying "reasonable expectations" in these photographs, that is, what the readers could expect of the coral reef, dive boat or hotel, and local ambiance should they embark on a similar dive holiday.

The underwater editorial message is best communicated in wide-angle, the big picture that allows readers to envision themselves swimming along the same reef or wreck or wall. The most popular application of this type of photo will involve a dive model as an element of composition. The star of the photo is still the underwater scenery, but the model gives a sense of scale and makes the reader feel a part of the scene through psychological projection.

It's nice to be able to use couples in this scenario, for divers should always dive with a buddy and couples also help sell the romance of the experience. However, it is often difficult to round up two models on location and harder yet to direct a

149

couple once underwater. A single model is therefore more conventionally used, the implication being that the photographer is the dive buddy, so safety rules are still intact.

The editorial bias toward including models in the photos sometimes ignores what has become one of the best-selling subjects for stock photography, the colorful reef scenic. Many clients ask for a shot of a healthy coral reef with brilliantly colored schools of tropical fish in the foreground. They have yet to learn that many schooling fish are silver in color, like horse-eyed jacks, glass minnows, or barracuda, or that many of the colorful species of the reef tend to be loners. No matter, being able to show the typical content of the coral reef is an important editorial subject that will serve well in terms of future stock photo sales. If a dive ever presents a reef scenic complete with "colorful schooling fish," shoot plenty of film. You'll be glad for the shots later.

Personally, I have made more money over the years with wide-angle photography than with marine-life photos, and certainly more than with either macro or underwater abstracts. Yet for the sheer fun and challenge of making images, marine-life photography is probably my favorite form of photography, and it certainly should be a part of any destination portfolio. A very few underwater photographers make their living almost exclusively with marine-life portraits through book projects, cards, posters, and magazine articles outside the dive industry, but it is a competitively difficult niche.

Still, mastery of this form of photography is crucial for anyone hoping to make a career of photographing the sea. In general, the environmental portrait is a more effective illustration than a very tightly cropped fish identification shot. Most publications will prefer to see not only the animal that typically inhabits the reef but also something of where it lives and how it behaves.

I'm sure most of the dive publications would readily admit that they don't expect their contributors to get rich on their page rates. However, a good relationship with a dive publication helps generate the travel that makes the photos happen and allows an interested audience to see the results of the shoot. That relationship is typically cultivated by sending a query letter describing your background and the content of your photo files, as well as a sample of your writing skills, if available. Most magazines prefer not to receive unsolicited photos, especially originals, for then they have to be responsible for the safe handling and return of the materials. Your query letter should offer to provide a sample of duplicate transparencies for inspection on request. If the magazine is currently looking for contributors, you might receive a favorable reply. If not, a well-presented letter of inquiry will probably be kept on file for future consideration.

The most important advice I can offer to free-lancers who secure an assignment from any magazine is: meet your deadlines! Monthly magazines are produced on rigid timetables and editors cannot work with excuses like "the dog ate my slides and my kid erased my floppy disk with the refrigerator magnet," both of which could conceivably happen at my house. Editors only care that quality materials are submitted on time and that the assigned writer/photographers conduct themselves in a professional, businesslike manner while on location. Even though you are functioning as a free-lancer, the magazine and its travel clients perceive you to be a representative of the publication. Excessive drinking and partying, egotistical behavior, unsafe diving practices, environmental disregard, or unrealistic expectations of the services to be delivered will be noted and almost certainly communicated back to the magazine.

Magazines outside the dive industry are increasingly voracious consumers of underwater photography. A very few, most notably *National Geographic*, keep staff underwater photo specialists on contract occupied with creative and exciting projects relating to the world's oceans. However, they, too, will hire free-lancers and buy stock photos for their book division and various magazines. Photo magazines like *Outdoor Photography*, *Popular Photography*, and *Petersen's Photographic* occasionally commission "how-to" articles and equipment reviews for underwater photography, but most others derive their photo illustrations from the ever expanding stock photo marketplace rather than through assignment. It is less expensive to buy a stock image than it is to mount an expedition to shoot a specific topic. In addition, with stock there is no ambiguity about the image: it is a known quantity from the start. With all the variables that go into underwater photography, including water clarity and the presence of the targeted marine life, stock is usually a much safer bet.

Stock Photography

Stock photography is the sale, or more typically the lease, of existing photos to a client for a specific use. The license fee is negotiated according to the form of the published matter, the size it is used, whether black-and-white or color, the circulation of the publication or number of pieces printed, and whether it is intended for the editorial or advertising market. The photo might be wanted for a calendar, textbook, poster, trade or consumer magazine, postcard, jigsaw puzzle, artist's reference for T-shirts, slide show, or a brochure or ad to promote a product or destination. Recently the market has been expanded along the information superhighway with CD-ROM and desktop publishing applications for underwater photography. Whatever the ultimate product, photography is an intellectual property and a valuable commodity of commerce, the rights to which are guaranteed the creator by the United States copyright law.

The Copyright Act of 1976 confirmed that photographers own the copyright to the images they shoot, except when those images were made as an employee or when the photographer conveys the copyright to another party via a signed written agreement as in "work for hire." This law assures the owner of the copyright legal control of the reproduction, distribution, copying, public display, or derivative use of the photo, as well

as the right to sue for unauthorized use of the photo. That right begins the moment the shutter is tripped, affixing a latent image onto the film, and does not depend on registration with the copyright office in Washington, D.C., or even placement of the copyright notice on the image. For maximum protection under copyright law, it is best to register a work on publication.

If a photographer were to discover that someone had illegally used an image (an infringement), before any legal redress could be initiated the copyright would have to be registered with the Copyright Office in Washington, D.C. The registration can be made after the infringement is discovered, but unless the registration occurs either before infringement or within three months after the first publication of the image (even if this is after the infringement), suit cannot be brought for statutory damages. Statutory damages can amount to $100,000 per infringement plus legal fees, while "actual" damages—the amount of money lost due to the infringement—are harder to prove and more ambiguous in terms of reward.

For more information about copyright and photographers' rights in general, a good contact is the American Society of Media Photographers (ASMP) at 14 Washington Road, Suite 502, Princeton Junction, New Jersey 08550-1033. Its ASMP *Copyright Guide for Photographers* and ASMP *White Paper on Copyright Registration* are excellent reference materials.

Copyright may guarantee ownership of the image, but it is still up to the photographer to create a marketable image and deliver it to the marketplace. At present, the photographic material of commerce tends to be the color transparency. For underwater photographers this is encouraging, because even though the exposure latitude of slide film is narrower than with color negative film, given the high percentage of rejects with any underwater shoot, it is easier to edit and catalogue.

Once the slides are sorted, either on a light table with a good quality loupe (I prefer a Schneider 4X or equivalent) or by projection, the quality images need to be systematically filed. The method of storage should be archival in order to preserve the integrity of the image. That means keeping the materials cool (to slow down any possible effects of fading), dry (humidity increases the degradation), and dark. One good way to bring the fading to virtually zero is to place the slides in acid-free boxes in Ziploc plastic bags and store these in a frost-free refrigerator. However, this is a cumbersome way to handle either large numbers of slides or materials that must be readily accessed. I find it more convenient to use archival slide pages (not the common polyvinyl chloride, or PVC, pages that can chemically damage the transparency emulsion), storing the pages within loosely packed three-ring binders in a constantly air-conditioned room.

Light is especially villainous to archival stability, which is why I try to limit the time originals spend sitting on light tables and never repeatedly project originals. Projection produces eight to ten times more light than direct sunlight on the slide. In fact, Kodak tests show an Ektachrome slide will fade as much as 10 percent after 720 fifteen-second projections, and Kodachromes will fade 15 percent. These tests were conducted in the mid-1980s, and both Kodak and Fuji claim improved archival stability with their new generation of E-6 films, but it is still prudent to allow no more than twenty minutes of total projection time for a Kodachrome original and no more than an hour for E-6 films to assure no perceptible fading. Instead, for projection, use duplicate transparencies. Then if they fade, become scratched in the projector, or are lost, new dupes can be made from the protected original.

Once the slides are archivally protected, they need to be organized for quick access. Our system includes shelves built along the wall of a specially constructed concrete, air-conditioned room. Here we store rows of three-ring binders, the books divided into either topside or underwater and further categorized by destination. The underwater books have their own order, with Caribbean marine life broken down alphabetically by common name (as in Angelfish, Barracuda, Coney, Drum, Frogfish, and so on) and marine life from other parts of the world filed by destination. Wide-angle underwater photos are kept in destination-specific files.

Our logic is that it might not matter too much whether a squirrelfish was shot in the Florida Keys, Grand Cayman, or Belize because they will all look much the same, but each of these destinations is significantly different in terms of typical reef structure, as is evident in their wide-angle representations. If a client calls looking for the underwater Bonaire, we would not sell them underwater Saint Lucia, and by keeping the books separate we are better protected from inadvertent mistakes.

The worst mistakes come about when photo researchers who have no knowledge of the marine life indigenous to a destination select photos, sending an ad agency, for example, pictures of a Red Sea emperor angelfish to sell the diving at a resort hotel in the Caribbean. The result is that the ad has no credibility among its target market, scuba divers.

In our system, each of the books has a code number, and each of the slides its own identification number, which reflects the book it came from and where it might be found in the book. For example WA27C-285 might refer to slide number 285 in a wide-angle book (hence the WA) shot in the Bahamas (assigned code number 27, C being the third book in the series). Coding the slide is important because we also take pictures of every slide page that gets sent out to a client, which in turn gets assigned a date and delivery memo number. By inspecting the code numbers on the picture we know exactly which photos are out on which submission.

We simply set the page of slides on a light table and shoot the whole page of slides with a macro lens and slide film. We affix a Post-it indicating the date and the client on the page, so the resulting slide shows us which slides were sent, their code number, the date of submission, and the client. The processed slide then goes into another page in a three-ring binder and the date and client is written on the slide mount. The delivery memo will have a date and the number of slides shipped. By

finding the corresponding date in the chronological record of photos of slide pages, we will know exactly which slides were shipped.

This works for us because we send out a high volume of slides and process film every day. For those with fewer submissions and the need to send out film for processing, it might take too long to shoot the roll and get it back from the lab. These photographers often use an inexpensive personal copy machine with a 200-watt bulb shining from above. The slide page is placed face down so that the slide and information on the slide mount are both recorded by the copier. This sheet can then be stapled to the delivery memo and filed. Unfortunately, this procedure will not work with every copy machine; in fact, with more expensive office machines the sensor passes too quickly to document the film, although the writing on the slide mount will record.

There are several software programs for slide management functions, some of which are sophisticated data bases. Our caption-writing program assigns sequential numbers, but we could also take advantage of its bar code capability so that we could quickly scan a record of every slide that goes out. The best programs not only assist in logging slides out, they also research where a particular slide might be in the archive. This is particularly important for the files of a general stock agency, which might have millions of slides on file covering hundreds of different subjects.

The information that comes out of the computer is, of course, only as good as that which is initially input, and inputting the data can be an awesome task. For us, with a collection of several hundred thousand slides, the chore of assigning search parameters to every slide to integrate it into new software would be a full-time job for someone for several months. But for a photographer just starting out with a more manageable number of images, it is crucial to develop a system to grow with. Research the available slide management software (look over the ads in *Photo District News*, 1515 Broadway, New York, New York 10036, 212-536-5222), buy a good program, carefully caption and file any slide worth keeping, protect it archivally, keep meticulous records of where it might be going and when it is expected back, and provide the appropriate paperwork that protects your rights and assures proper use fees.

There are two basic ways an individual might sell a stock photograph, either by servicing a photo request personally or working with a stock photo agency. If the intent is to handle the photo request in house, the first obvious question is, How does the client know to call you? Are you a reasonably well-known photographer, do you advertise the fact that you have stock photos for sale, and would a potential client know how to contact you? If you feel there is some compelling reason the client can and will call, the next step is to service the request. This happens in several steps.

Step one is taking the request, which generally comes by telephone or over the fax or mail in the form of a "want list." We use a phone request form to assist our researchers to ask questions to facilitate an accurate submission, as well as prompt them to get the correct address, phone number, Federal Express number, and deadline requirements. A word about deadlines here—most clients want their submission immediately, if not sooner. It doesn't matter if, as often happens, the slides will probably sit on an art director's desk for the next several weeks, they still want it tomorrow. The system has to be sufficiently streamlined so that once a call is received, the correct images can be found quickly and shipped promptly.

Step two is the selection. Sometimes the request is specific, such as "a great white shark from South Australia, preferably vertical," but then again it might be something vague such as "an image suggesting power, danger, strength, an icon of the wild beauty of the sea." The researcher will extract as much information as possible from the client, but often the client has only a concept, and it is up to the researcher to put an image to the concept. Once the images are selected, they must be accurately logged out and prepared for shipping.

Step three is the shipment. A delivery memo is prepared outlining the terms and conditions of submission, as well as setting a value should the slides be lost or damaged while in the client's possession. There may be a research fee to cover administrative costs of the submission (generally seventy-five to one hundred dollars, deducted from the resulting sale). If so, that invoice will be included with the submission. For a guide as to an appropriate format for a delivery memo, I again refer to the American Society of Media Photographers. Its *Stock Photography Handbook* from 1984 is dated in some respects, particularly in its suggested pricing guidelines, but it is still a valuable reference to the business of marketing stock photography.

Step four is the delivery itself. Presently we are using the traditional method of slide delivery, that is, physically packing the slides and sending them to a client via some courier. However, undoubtedly in the very near future the industry will rely more heavily on electronic transmission of photography. Slides will be scanned onto Photo CD or CD-ROM disks (which in turn will be shipped, rather than sending the actual slides) or transmitted via modem directly to clients' computers, where they can then be used directly for layout presentation or production.

If the slides themselves are being shipped, they should be securely packed and shipped via a courier that provides some means of tracking the submission. Federal Express is our preference because we can determine where the shipment is at any given time, as well as who signed for it at the other end. Of course, such security comes at a price, which we prefer the client pay.

Step five is the follow-up. A few days after the client receives the slides, a call should be placed to determine if they are suitable. If so, a fee will be negotiated. If not, the expeditious return of the material should be requested. The photographer or researcher should always know at least an approximate date when the slides will be returned, and if slides are held irresponsibly, holding fees should be imposed (the

terms of which have been outlined in the delivery memo).

Step six is the negotiation. Assuming a usable image has been delivered, a use fee will have to be determined. To do so, the photographer or agent must first determine what the intended use and circulation might be. Once the parameters of use are clear, a fee can be suggested according to either experience in such matters or guidelines like Jim Pickerell's 1994 reference, *Negotiating Stock Photo Prices*, reflecting average prices gleaned from surveys of photographers and stock photo agents. Another pricing guideline I find useful is the computer software from the Cradoc Corporation (PO Box 10899, Bainbridge Island, Washington 98110, 206-842-4030) called *Fotoquote*, available in either Mac or PC formats.

These sources provide a starting point for negotiations. The price quoted may be too high for the client's budget, in which case you may lower your price or refuse to sell. We have done both in the normal course of business. However, it is very important to consider how much it costs to create the images being sold and to assure reasonable compensation both according to personal and industry standards. The relationship between the client and photographer should not be adversarial but based on mutual respect, and handling all aspects of the transaction, from request through delivery and on to negotiation, in a professional manner will help foster respect from the client.

Knowing how much the client will pay leads us to step seven, the invoice. Some clients issue purchase orders that specify the preferred format of their invoices, other clients are less rigid. In either case, the exact rights being purchased, the duration of the rights granted, and the amount of the sale are integral aspects. This leaves only the final two steps, getting paid and getting the photos used back in the file without having incurred damage. Sometimes these final two steps are the hardest of all.

Step eight is collection. Invoices are typically structured as net thirty days, and once in a while the client will pay within this parameter. More often it will be a magazine that pays on a prescribed schedule following publication or an ad agency that might wait to get paid by its client before it pays its vendors. This will stretch it to sixty days, which is acceptable in this industry, or to ninety days and beyond, which is not acceptable. We have had rare occasions where clients simply did not pay, despite a purchase order and having used the photos, and we ultimately had to use a collection agent as a last resort. Usually a few phone calls to the accounting office of a slow pay account is sufficient.

The ninth and final step is getting the slides back without damage. In some cases the slides are duplicates, but in many cases the rush nature of the photo request or the superior reproduction quality required forces us to send original transparencies. Whether original or duplicates, the client is obligated to return the slides safely and in a reasonable time frame. Some clients need a reminder to return the slides, but most are considerate.

Occasionally a slide will be lost or damaged beyond repair. This is an awkward scenario in which no one wins. The photographer wants to be compensated for the loss, and the client probably feels badly but knows it was an accident and is reluctant to pay. Still, there is ample legal precedent for a standard award of $1,500 per transparency for lost or damaged slides. An attorney familiar with the photo industry and skilled in copyright matters is the best reference, and a call to the ASMP can suggest such a practitioner in your geographic area.

The advantage to selling stock yourself is that you realize 100 percent of the profits. That assumes that you do all the work yourself as well. If you'd rather be out taking pictures, to stay in the business of selling stock you'll need a photo researcher on staff. This means considerable overhead, and if you aren't certain of adequate return relative to overhead, you should consider working with a stock photo agency. These agencies usually take 50 percent as their fee, but they work hard for their commission. They advertise and bear the expense of the telephone lines and research staff necessary to fulfill their clients' needs. Having been in the business for a long time, both as a photographer and as one of the principals of a stock photo agency (WaterHouse Stock Photography), I'd say that for most photographers working with a reputable stock photo agency is a better way to handle the business.

Our agency is a member of the Picture Agency Council of America (PACA), as are most mainstream stock photo businesses. You can request a roster of its membership by writing to PO Box 308, Northfield, Minnesota 55057 or phoning 800-457-7222. There is a minimal fee for its directory, but it is the first best step toward researching which agency is best for your needs.

Some agencies are huge, with multiple offices, foreign affiliates, and annual billings in the millions of dollars. Others are smaller "boutique" agencies that might specialize in particular subjects or geographic areas. Which is right for you? This is a difficult decision that requires considering geographic proximity (although this isn't too important, as you will only occasionally visit your stock photo agency), ability to sell your specialty, reputation for honesty, and in-house competition. You should take a hard, honest look at your images; if they are better, more unusual, or, most important, more marketable than the other images likely to be on file, you will make money with that agency.

Remember that any relationship with a photo agency is a two-way street. You expect them to make their best effort to sell your photos, but you can't expect to send in a couple of hundred shots and wait for the checks to roll in. This should be a long-term marriage of convenience where you continue to send new images as they become available and they continue to suggest what their current needs might be.

It is also important to send your very best images if you expect to succeed. One of the problems with underwater photography is that it is very challenging to get a really outstanding shot, and it is rarely possible to shoot numerous identical

153

photos of the same scene (known as similars). The environment, subject, and photographer are always moving, the light is constantly changing, and the percentage of strong images is necessarily low, all of which conspire to make underwater photographers covet the images that work.

Most photographers are reluctant to part with their very best photos after so much hard work went into their capture, but sending anything less to your stock photo agent makes it difficult to compete in the marketplace once the slide gets sent to the client, or even within the agency itself, when its staff is searching for slides to send out. One option is to send duplicate transparencies to your agent. This way the prime image can be replicated. Unfortunately, no duplicate is presently as good as the original.

The resolution of dupe film is not as high as conventional films, and often the contrast increases slightly in the duplication process. With underwater subjects, enhanced contrast is not necessarily a bad thing, and color can be matched accurately by a good lab technician. Even so, a dupe will never be as sharp as an original. I keep hoping that film recorders will advance to the state that originals can be digitized and the files replicated on conventional slide films with no loss of quality. That may happen in the near future, but for now dupes represent an inevitable decrease in resolution relative to the original.

Having only duplicates on file with a stock photo agency is further complicated by the fact that most domestic agencies now have relationships with foreign stock photo agencies whereby they in turn duplicate their files to be marketed abroad. As bad as dupes can be, dupes of dupes are usually awful. Stock photo agencies needs good original slides from which to work, and it is a nuisance for them to have to call photographers to get the originals from which dupes might be made.

Yet with some images, like one-of-a-kind photographs of mating humpbacks, perhaps the original should go in a safe and only duplicates put into circulation, despite their lower quality. As those kinds of photos are probably only a small percentage of any photographer's portfolio, they may be duped and submitted, and the agency can then decide whether it wants them on file. They should be clearly marked as "duplicate." The agency is then put on notice that a use fee for the original might possibly be sold by the photographer, and should unusual rights be negotiated between a client and agency, the photographer must be notified so there is no potential conflict in future rights guarantees.

The whole relationship with a stock photo agency needs careful consideration before signing a contract. Some agencies want exclusive contracts (meaning the photographer is prohibited from placing work with any other stock photo agency). The logic is that some clients may want exclusive rights to a photo, and if the same or similar photos are on file with other agencies, there is no control over what may be conflicting rights being sold. On the other hand, the same stock photo agencies that want exclusivity of the photographer are not likely to limit their own rights to recruit other photographers with a similar specialty. My feeling is that no single photo agency dominates the market, and there is no compelling reason to sign an exclusive contract. Our agency does not expect it of our photographers, and other affiliate agencies I work with, both domestic and international, do not require it.

In any case, whatever agreement is deemed suitable for you, the agency should pay your commission promptly. Even a few years ago most agencies issued quarterly commission checks, which meant they sat on the money (hopefully in an escrow account rather than an operating account) earning interest that rightfully belonged to the photographers. Now the more accepted norm is to pay on a monthly basis as sales are made.

Assignment Advertising Photography

Occasionally there is an underwater subject that exists in the mind of an art director that has not already been shot and is not available as a stock photo. It is the job of the commercial underwater photographer to bring the concept to life. The subject may be a product or a person, or perhaps it is a subject that has to be shot with a particular type of film or lighting. It may even be a relatively mundane subject that ordinarily would be available as a stock shot, but special design or compositional elements in the layout require that it be shot on assignment.

Such a project generally begins with a call from an art director or client. They will have seen the work of the photographer somewhere and hope it is suitable for their project. With the first assignment they will usually ask to review a portfolio to determine the shooter's talent and personal style, which is normally sent out the same day via courier. If the job works to the client's satisfaction the portfolio presentation may not be needed in the future, but at least for initial contacts a few portfolios should be prepared so that they can be shipped on short notice.

The portfolio can be in the form of slides, prints, tear sheets, or any combination thereof, but the presentation must be professional. My portfolio is primarily tear sheets of ads and editorial projects I've been involved with over the years, but photographers just starting out may be more inclined to have high-quality color prints or enlarged duplicates as part of their portfolio. A page or two of 35mm duplicates in a manila folder rarely suffices. You must inspire confidence at first glance, not only in your ability to take wonderful pictures but also in your serious, businesslike approach. For further information and guidance, there are numerous manufacturers of portfolio presentation cases and portfolio consultants who advertise in trade journals like *Photo District News*. Examine the options and find what works best for your budget and existing body of work.

Assuming the art director likes what is seen in the portfolio, a layout will probably be faxed or a shoot list described. From this the photographer is asked to provide a price esti-

mate for the job. A good guide to the creation of an estimate is found in the 1994 ASMP *Business Bible*. The expenses incurred and the creative fee determine the total cost of producing the shot. The expenses include the cost of film and processing, assistants, insurance, location scouting, prop rental, shipping, travel expenses, boat charters, gratuities, and model fees. The creative fee consists of the shoot fee—that is, the basic photography fee per day multiplied by the number of days proposed for the assignment. There is considerable disparity in day rates among professional photographers. In a survey by a West Coast ASMP chapter, the range of estimates for a hypothetical advertising illustration assignment given by its membership fell between $600 and $4,000. Individual photographers will have to come to their own conclusion as to their worth in terms of a day rate and factor that into their estimate.

Another factor is the usage multiplier, which may be relevant when licensing specific usage rights. For example, if the client wants standard one-time rights, the usage multiplier might be a factor of 1 and no additional fee shall be imposed. But if the client wants exclusive worldwide rights for three years, the multiplier might be a factor of 2, or double the day rate. There are no hard and fast rules in determining either day rates or usage multipliers, but advertising is generally far more lucrative than editorial assignments, and the estimate is expected to reflect this.

If the assignment comes through, and it involves significant up-front expenses like model fees, boat charters, or transportation charges, an advance (usually 50 percent of the expenses) may be requested. In any case, a purchase order should always be issued to the photographer by the client before the job begins.

I find that one of the factors I am selling along with my photography is my familiarity with dive locations around the world and dive operators. I know what the probable weather will be like on location that time of year, what sorts of marine life might reasonably be encountered, and what diving services can be counted on to help deliver the shot. All of this is valuable in enhancing the odds of a successful advertising mission, but as often as not, luck plays a big role as well.

Often, I travel with the product and shoot to a specific layout without agency staff along. It is hard for someone other than the photographer to direct an underwater shot, and extra divers on the scene may complicate the photo by stirring up the sediment or potentially scaring off the marine life. On other assignments, the art director was a diver and joined me on the shoot. These are probably the most fun and creative projects; the ad is more often conceptualized as something that could really happen underwater, and with the art director on location, any disruptive factors like weather or water clarity can be considered and layouts changed if necessary. In a best-case scenario, both the art director and client are divers who understand the potential and limitations of underwater photography in product illustration.

While editorial photographs are commonly accompanied by a photo credit (© year photographer's name), advertising photographs are rarely so adorned. There is usually a specific product that is conceived as the star of the ad, and the space is fully utilized for copy and product illustration. The final ad is a collaboration of art director, copy writer, account executive, model, photographer, and, of course, the underwater world. Even though advertising photographers may labor in greater anonymity than editorial shooters, there is tremendous satisfaction in being a part of a successful advertising campaign.

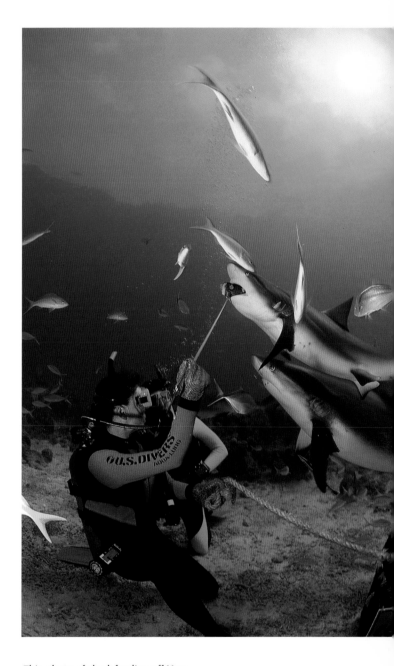

This photo of shark feeding off New Providence Island bears relevance for editorial markets, by selling the concept of the Bahamas dive adventure, as well as advertising utility, by illustrating U.S. Divers equipment in use. Nikonos RS, 13mm lens

155

Appendix II: *Vendors and Suppliers*

I. Photo Equipment Manufacturers

Anthis, U.S.A. Inc.
144 Railroad Avenue, Suite 206
Edmonds, WA 98020
(206) 775-3359 fax (206) 775-4076

Housings for Nikon and Canon land cameras.

Aqua Vision Systems
7730 Trans Canada Highway
Montreal, Quebec, Canada H4T1A5
(514) 737-9481 fax (514) 737-7685

Underwater housings for Nikon and Mamiya RZ67 land cameras.

Gates Underwater Products
5111 Santa Fe Street #H
San Diego, CA 92109
(619) 272-2501 fax (619) 272-1208

Underwater housings for various video cameras and custom housing design.

Hasselblad
10 Madison Road
Fairfield, NJ 07004
(201) 227-7320 fax (201) 227-4216

Medium-format land cameras and limited production of underwater housings for certain Hasselblad cameras.

Helix Camera and Video
310 South Racine
Chicago, IL 96804
(312) 421-6000 fax (312) 421-1586

Assorted land and underwater cameras; photographic books as well as travel and diving books. Distributor for various equipment manufacturers listed already; assorted photo accessories.

Ikelite Underwater Systems
P.O. Box 88100
Indianapolis, IN 46208
(317) 923-4523 fax (317) 924-7988

Lexan underwater housings for most land 35mm SLR cameras and video cameras; underwater strobes; assorted underwater lamps and compasses.

Marine Camera Distributors
11717 Sorrento Valley Road
San Diego, CA 92121
(619) 481-0604 fax (619) 481-6499

Underwater housings for Hasselblad. Distributor for Subal underwater housing.

Nikon Inc.
1300 Walt Whitman Road
Melville, NY 11747
(516) 547-4200 fax (516) 547-0309

Nikonos underwater cameras. Nikon cameras, as well as land and underwater strobes, lenses, and photo accessories.

Pioneer Research Company
216 Haddon Avenue
Westmont, NJ 08108
(609) 854-2424 fax (609) 858-8695

Point-and-shoot underwater cameras, EWA Marine housings (bag-type housing) for cameras and videos.

See & Sea Underwater Photography USA, Inc.
2105 Camino Vida Roble #1
Carlsbad, CA 92009
(619) 929-1909 fax (619) 929-0098

35mm underwater cameras, housings, strobes, lenses, and accessories.

Tussey Underwater Systems
5724 Dolphin Place
La Jolla, CA 92037
(619) 551-2600 fax (619) 551-8778

Underwater housing for Nikon 35mm SLR cameras and strobes.

II. Underwater Camera Repairs

Southern Nikonos Service Center
9459 Kempwood
Houston, TX 77080
(713) 462-5436 fax (713) 462-5449

Underwater Photo-Tech
16 Manning Street #104
Derry, NH 03038
(603) 432-1997 fax (603) 432-4702

III. Underwater Photo Tours

Adventure Express
650 Fifth Street
San Francisco, CA 94107
(800) 443-0799 fax (415) 442-0289

Aggressor Fleet Ltd.
P.O. Drawer K
Morgan City, LA 70381
(800) 348-2628 fax (504) 384-0817

Go Diving Inc.
5610 Rowland Road
Minnetonka, MN 55343
(800) 328-5285 fax (612) 931-0209

Island Dreams
8582 Katy Freeway #118
Houston, TX 77024
(800) 346-6116 fax (713) 973-8585

Peter Hughes Diving
6851 Yumuri Street
Miami, FL 33146
(800) 9-DANCER fax (305) 669-9475

Poseidon Venture Tours
359 San Miguel Drive
Newport Beach, CA 92660
(800) 854-9335 fax (714) 644-5392

See & Sea Travel, Inc.
50 Francisco Street #205
San Francisco, CA 94133
(800) DIV-XPRT fax (415) 434-3409

Tropical Adventures Travel, Inc.
111 Second North
Seattle, WA 98109
(800) 247-3483 fax (206) 441-5431

WaterHouse Photo Tours, Inc.
P.O. Box 2487
Key Largo, FL 33037
(800) 272-9122 fax (305) 451-5147

IV. Underwater Stock Photos

WaterHouse Stock Photography
P.O. Box 2487
Key Largo, FL 33037
(800) 451-3737 fax (305) 451-5147

: Index

INDEX